BEATON
IN VOGUE

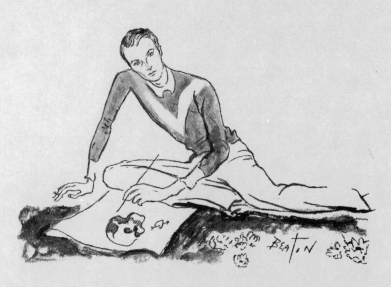

Beaton by Beaton, 1936

IN VOGUE

JOSEPHINE ROSS

Clarkson N. Potter, Inc. / Publishers New York

DISTRIBUTED BY CROWN PUBLISHERS, INC.

Acknowledgments

The photographs, articles and drawings in this book are taken from British, American and French *Vogue*, 1924-1980. For their help in supplying prints for reproduction, we are grateful to Miss Eileen Hose; Philippe Garner and Lydia Cullen of The Cecil Beaton Archive at Sotheby's, London; The Trustees of The Imperial War Museum, and their staff; and Diana Edkins, Archivist of The Condé Nast Publications in New York. In a few cases, where original negatives and prints could not be traced, it was necessary to reproduce photographs directly from the magazine: this accounts for slight variations in the quality of the illustrations. Most of the articles reprinted here have been edited and cut, for reasons of space.

I should like to express my thanks to Alex Kroll, who brought this project into being; and Beatrix Miller, Editor-in-Chief of British *Vogue*, who gave me invaluable advice and help. I am also deeply grateful to Elizabeth Wickham, the designer, for her imaginative collaboration at every stage; and to Robin Muir of Condé Nast, who researched, indexed, and co-ordinated operations with an enthusiasm and efficiency which made all our tasks easier. Others at Condé Nast to whom I owe special thanks include Miss Lillie Davies; Elaine Shaw; Jane Ross; Katharine Hall; Jane Mulvagh; and my excellent team of vacation assistants, Victoria Harper, Timothy Hyde and Manuela Zervudachi.

Designed by Elizabeth Wickham

Published in the United States of America in 1986 by Clarkson N. Potter, Inc., 225 Park Avenue South, New York, New York, 10003.

Originally published in Great Britain by Thames & Hudson Ltd., 30 Bloomsbury Street, London WC1B 3QP.

CLARKSON N. POTTER, POTTER, and colophon are trademarks of Clarkson N. Potter, Inc.

Manufactured in Japan

Library of Congress Catalog Card Number: 85-29699

ISBN 0-517-56233-2

10 9 8 7 6 5 4 3 2 1

First American Edition

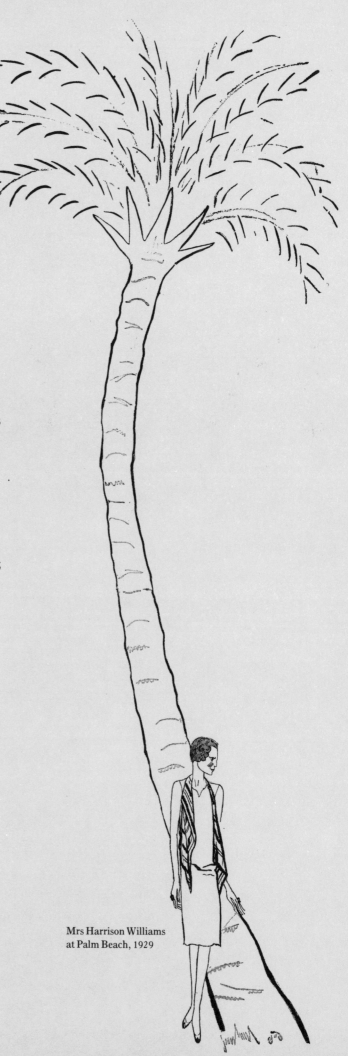

Mrs Harrison Williams
at Palm Beach, 1929

Contents

I WAS AN undergraduate when my first contribution appeared in *Vogue*. It was a slightly out-of-focus snapshot of Webster's Duchess of Malfi (portrayed by the distinguished English don Mr George Rylands), standing in the subaqueous light outside the men's lavatory of the ADC Theatre at Cambridge.

Miss Dorothy Todd, then Editor, finding few local fashion personalities worthy of promotion, peppered the somewhat sparse pages of this fascinating magazine with the names of Lytton Strachey, Virginia Woolf and Raymond Mortimer. It was a great day for me when Miss Todd accepted my picture and wrote that she felt I had the makings of quite a good photographer.

It was, however, as a caricaturist that I first appeared regularly in *Vogue*, with Mrs Alison Settle a most encouraging headmistress. Condé Nast, however, later gave me a contract as a photographer. 'Colour is what we need,' he reiterated, as he went through a batch of black-and-white pictures. He did not mean colour photographs, but explained: 'Contrasts of light give colour. Now look at Steichen! With your ordinary camera you can't get colour. Go out and buy professional apparatus.'

I cursed Condé Nast as I battled, in Hollywood, with cumbersome paraphernalia and crawled under a black velvet cloth the better to see Janet Gaynor lying among the dandelions. By degrees I reconciled myself to photographing on 8 inch by 10 inch plates and on my return home I tried hard to portray the London fashions—a tough job in those days, when hats looked like plumbing and shoes were surgical supporters. Dauntless editors would go out into the highways and byways of Mayfair to find stimulating materials to show their readers, but we were all still explorers floundering in the South Pole of taste. It was a treat when Hartnell produced his first wedding dresses and I photographed them in a grotto of Cellophane and blossom rigged up in the drawing-room.

Occasionally a reprimand would come from New York regarding my efforts: 'At the instigation of Mrs Chase I am writing to suggest that you refrain from posing any more models in the act of ecstatically sniffing flowers or holding blossoms à la Blessed Damozel. We are all weary of these postures and hope you can find some other means of expressing grace or charm or what you will. Leave the flowers as passive elements in the décor. Thank you.'

However, my enthusiasm was undaunted; a vast amount of my work appeared without further serious complaint.

Cecil Beaton 1958

Vogue's Beaton

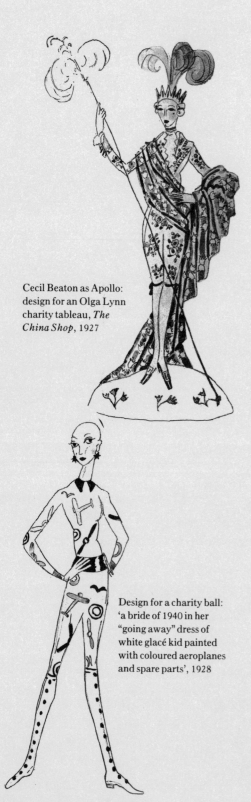

Cecil Beaton as Apollo: design for an Olga Lynn charity tableau, *The China Shop*, 1927

Design for a charity ball: 'a bride of 1940 in her "going away" dress of white glacé kid painted with coloured aeroplanes and spare parts', 1928

'THE MAN who could have run *Vogue* single-handed was Cecil Beaton. He was a superb photographer, wrote and drew beautifully and had all the right contacts. He was profoundly professional too. There were other photographers as good, but he had an all-round talent and approach and was everything *Vogue* wanted, being the perfect balance of Inside *Vogue* and Outside World. I seem to remember he used to drive up to the office with a Negro chauffeur and chinchilla rug. He was a barometer, the first to understand new trends, and had a wonderful sense of humour. I enjoyed seeing his photographs "before and after". He'd re-draw on the proofs, or yell, "slice the hips, that sag must *go*" and the retouchers worked overtime, so that his subjects would ring up and say, "*The* most divine picture – I want twelve more prints".'

Lesley Blanch, interviewed by Polly Devlin in Vogue, 1966

Cecil Beaton (1904-80) worked for *Vogue* for over half a century. As a Cambridge undergraduate, in April 1924, he contributed two blurry snapshots of a student production of *The Duchess of Malfi*; at the age of seventy-five, less than a year before his death, he photographed the Paris couture collections for the last time for French *Vogue*. In the decades between he was by turns social columnist, war correspondent, fashion illustrator and travel writer; he photographed his friends, from Edith Sitwell to Mick Jagger, wrote about his houses, reported on his work in theatre and cinema. 'Cecil Beaton's camera', wrote British *Vogue* in 1941, 'has come to represent a sort of *Vogue's* Eye View of the years.'

Though Beaton had been an enthusiastic photographer since childhood, taking snaps with a small box Brownie which his sisters' nanny then developed in the bath, he first worked regularly for *Vogue* as an artist. His 'Portraits in Passing' – witty sketches of society figures such as Margot Asquith, Lady Diana Cooper and Mrs Sacheverell Sitwell – began to appear in the summer of 1927, and were an immediate success. The Editor, Beaton wrote later, 'liked my spidery efforts, explaining that they looked as though I was trying to do them as badly as I could'.

To accompany his drawings, Beaton began writing articles on such topics as 'The London Season' and 'The Fun of Dressing-Up'. In the social column, 'How One Lives From Day to Day', he described concerts at Lady Cunard's, parties in Syrie Maugham's all-white ballroom, bottle parties, first nights, private views, fancy dress balls and endless charity pageants (costumes by Cecil Beaton). Still using a small Kodak, he photographed his fashionable friends such as Lady Ottoline Morrell and the Sitwells against backgrounds of silvered netting or painted spots – with grainy, but

striking, results. Some of his work was reprinted in the parent magazine, American *Vogue*; and when, at the end of 1928, the young Cecil Beaton sailed for New York, he received a warm welcome from American society and a regular contract from *Vogue*'s publisher, Condé Nast.

It was Condé Nast who persuaded Beaton to abandon his 'toy' camera. Accustomed to 'running up and down ladders, clicking the Kodak as the hair-cutter clicks the scissors', Beaton resisted, but Nast was adamant: he demanded the highest standards of technical excellence from *Vogue*'s photographers. Beaton was to say later that Condé Nast's criticism had been invaluable; however, in an article for *Vogue* in 1933 he looked back with some nostalgia on his early photographic experiences:

'Cecil Beaton in New York paying deep, but hasty, homage to El Greco, Carl Erickson, the Ambassador Hotel, and himself', 1929

'A continuous battle wages between you and the camera as to who shall be master. When you discover in your pictures that your subjects are invariably featured at their worst, you begin to embark on a lifelong career of watching various lights playing on the surface of the face. By degrees you become conscious of when and why people are looking their best, and whether consciously or not, you will view people from the best photographic angle.

'I was ensnared early in life and, as a child poring over the pictures of musical-comedy actresses in magazines and on picture postcards, tried with a Brownie to emulate the then fashionable studio portraits, hanging a sheet in the garden behind the sitter's head. I became more ambitious: time exposures were taken indoors. Click – one, two, three, four, five, six, seven – click. But, unfortunately, the sitter was generally nearer the lens than the focus of the Brownie permitted. Sometimes the results, unintentionally blurred, when mounted on paper looked extremely artistic, and the signature in the right-hand bottom corner of the mat gave the final fillip.

'It was impossible to get that certain effect of lighting with daylight, so one would hold up a ribbon of magnesium wire. There would be great difficulty in lighting it, but, eventually, it burnt with a blinding blue flame. Click – one, two, three, four, five – click. As time went on, a powerful lamp was bought. There was no retreat then. Now, so long as I possess a camera, there will be no rest, and I will understand why the mere moving of chairs and heavy tables does not deter Lady Colefax in her enthusiasm to acquire a unique record of her interesting friends; and I will have great sympathy for Toni Frissell, while her eyes sparkle, her hair becomes disarranged, and beads of perspiration appear on her upper lip in her struggle to get the best picture.

'You regret the lost opportunities and sigh, "If only those pictures had come out" – the one of Lily Langtry, your Aunt Matilda, Sarah Bernhardt, or whoever it may be. But the light was weaker than you thought, and how silly it was of you to believe you could hold the camera still enough to take a time exposure the day D. H. Lawrence came over! Everyone must pass through the various stages of "Oh, I have used the wrong stop"; the "Oh Heavens, I have put the film in the wrong way"; the "I tried to develop them myself, but the hypo must have been stale." After a time, when you have missed recording Boldini in his studio, Cocteau on his divan, and Mae West in her swan bed, you will have acquired a technique with your snapshot camera, and you will have a billion further chances.'

'Here is Cecil Beaton drawing New York skyscrapers from a window-seat on the eighteeenth floor of his hotel', 1929

Beaton's success in New York confirmed his reputation both in the Outside World and Inside *Vogue*. He became a friend of the Vanderbilts, the Harrison Williamses and the Lunts (whom he photographed in Condé Nast's famous Park Avenue apartment); he drew the stars of Hollywood and the black cabaret performers of Harlem; he wrote

Mr Cole Porter, 1932

of fashion, parties, theatre, people and his impressions of New York – 'the fabulousness, the kindness, the brightness, the "all-there-ness", the smartness'. He visited, and wrote about, Palm Beach and Mexico, Haiti and North Africa. American, British and French *Vogue* overflowed with his work, and Cecil Beaton himself became one of those personalities whose glamorous private lives were of interest to readers.

Innumerable *Vogue* photographs of house parties at Ashcombe, his house in the country, showed Beaton and friends such as David Herbert and Tilly Losch dressing up, picnicking or making scrap-albums – one of Beaton's favourite pastimes. On one occasion they devoted an entire weekend to making a film of 'The Sailor's Return' by David Garnett, with Cecil Beaton in the title role and John Betjeman playing a Low Church clergyman. The setting for all these events was described by Beaton in a 1932 article for *Vogue:*

'You arrive at an archway of pink brick faced with stone. Through this, you drive to find yourself at Ashcombe, which is the name given to the two small buildings that are all that remain of an important mansion that was built during the reign of Henry VIII and was torn down and rebuilt in the time of William and Mary. Only sixty years ago, it appears, this mansion was demolished, and all that is now left is the little dairy-house and part of the stables, the cobblestone courtyard, a garden wall, a grotto, some broken columns, and the ilex-trees.

'From that moment a year ago when, after exciting adventures in search of this enchanted spot, I walked under the arch and stood spellbound at the romantic beauty of the place, I was determined that Ashcombe should be mine. Though quite small, it is extremely elegant and the stable building is formal in its architecture. It looks rather like a dwelling to which some royalty has been banished in a fairy story. It is unique in England.

'Let me skip to the night in the dead of winter when the builders had made their thousandth alteration, had applied the last coat of paint, and the first lorry, having lost its way many times, finally tottered through the arch into the little courtyard, where it belched forth its treasures in the moonlight. Out came the baroque and early Victorian chairs and tables, the silver goblets and white china urns that I had, during the months just before, collected with thriftiness and excitement in Vienna, Venice, the most unexpected spots in London, and all the other places where my work of sketching and writing for *Vogue* had led me.

'Without airing my views on interior decoration, I must tell you that although Ashcombe is built on a small scale, I have not permitted a piece of chintz or old oak. Its decoration might be considered "bogus", for many of the effects are created from things never intended for the purposes to which they have been put.

'Let us start with the square little story-book house. The doorway has been ornamented with stone, from a design by Rex Whistler. The hall is entirely white, with a stone floor, a silver console table, mirror sconces, and silver wooden candlesticks. (The house is entirely lighted by candles.) We pass through a white arched corridor On the same floor is a small guest-room with a four-poster bed done in daffodil-yellow satin, spotted and striped in scarlet. The carpeting is of tiger skin, and the curtains are of imitation deerskin, bordered with a series of steel wool pot-cleaners, which give the effect of a bright metal galloon braid. The walls of the adjoining bathroom are decorated with the outlines of the hands of all the visitors to Ashcombe, outlined in ink. In some cases, the nails are painted red, with the signatures scrawled

across the palm. Here, as you lie in the bath, you can muse on the various characteristics revealed by the shapes and can compare Siegfried Sassoon's thumb with Sacheverell Sitwell's; Elsie Mendl's wrist with Clare Beck's. This room is decorated with the gold-spotted paper with which my "Book of Beauty" was bound.

'My sisters' bedroom has walls and ceiling in the pink of raspberry ice cream. The carpeting is made of the fluffy material sold by fancy-dress costumers for cowboys' trousers, dyed cedarwood pink. My bedroom is not yet complete. There is painting to be done, when I return from my annual visit to America, for the walls are to be frescoed with clowns and plumed horses and hung with ribboned hoops – since it is to be a circus room.

'The atmosphere of poignant beauty still pervades Ashcombe – the same atmosphere that we felt so vividly when we first trespassed through the arch and were told by the gamekeeper that if he were seen so much as talking to us he would be sacked. But then it seemed dead, and now, with its bright colours, trimmed grass, statues and fluttering white doves, it is alive.'

Among Cecil Beaton's most famous work for *Vogue* in the 1930s was his coverage of the wedding of the Duke of Windsor (the former King Edward VIII) and Mrs Wallis Simpson. His social life had frequently brought him into contact with Wallis Simpson, and late in 1936, when her relationship with the King had become widely known, he was invited to sketch her. The resulting drawings, together with a short Beaton article, were published in American (but not British) *Vogue*. Shortly before the wedding, he was granted an exclusive photographic session with the future Duchess at the Château de Candé in France; characteristically, he softened her sophisticated image with a group of romantic outdoor shots, posing her in billowing organdie amongst long grass. At the Duke and Duchess's wedding, on 3 June 1937, Cecil Beaton was official photographer, and in addition to his photographs, *Vogue* carried Beaton's first-hand account of the proceedings.

Beaton's romantic, theatrical style and inventive use of props, the hallmarks of his fashion photography in the 1920s and early 1930s, were not always admired. There were complaints from the French office in 1933 that there was too much Beaton in *Vogue*; and Mrs Edna Woolman Chase of American *Vogue* forbade him to photograph any more models sniffing flowers or 'hanging on hatracks with their arms in distorted positions'. However, Beaton wrote later, 'my enthusiasm was undaunted; a vast amount of my work appeared without further serious complaint'.

There was, however, one 'serious complaint' against Beaton at the end of the decade, which was of such gravity that it caused his ties with *Vogue* to be completely severed for a time. The 1 February 1938 issue of American *Vogue* contained an article by Frank Crowninshield, entitled 'The New Left Wing in New York Society', in which, for the first time, the phrase 'café society' appeared in print. Crowninshield's article, which was illustrated by Cecil Beaton, set out to analyse a new social trend:

'In the past year or two, a new kind of confusion concerning our society has become general, due to the appearance of a newly formed, colourful, prodigal and highly publicized social army, the ranks of which are largely made up of rich, carefree, emancipated, and quite often, idle people.

'This recent and widely discussed army of the Left, and the schism which it is supposed to have caused in the ranks of our good society, have called forth a remarkable volume of publicity . . . to one effect: namely, that society here has become, not

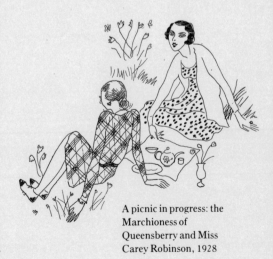

A picnic in progress: the Marchioness of Queensberry and Miss Carey Robinson, 1928

only democratized, but disintegrating; that all the old rituals have broken up, and the old barriers broken down; and that, to be more specific about it, three hundred or more fashionable people have become so intolerably fed up with what they thought the pomp, stuffiness, and retarded tempo of traditional society that they seceded from it, en masse, and created an integrated and perfectly functioning social cosmos of their own. Into the maelstrom of this world, they have also managed to draw a goodly number of actresses, authors, editors, bankers, movie favourites, sportsmen, theatre managers, playwrights and publishers of renown.

'This colourful social group has now everywhere become known as café society, for the reason that so many of its activities – daily and nightly – take place in our better-known cafés and nightclubs.'

Surrounding the text were marginal drawings by Beaton, depicting the contrasting interests of traditional society and café society. Into the latter, in minute but legible print, he inserted some offensive slang references to Jews. His reasons were never satisfactorily explained: fashionable, spiteful levity seems the most likely cause. But whatever the explanation, the outcome was in no doubt. Condé Nast instantly terminated Cecil Beaton's contract, and his career with *Vogue*, it appeared, came abruptly to an end.

It was largely through his work in the Second World War that Beaton was able to restore his relationship with Condé Nast and *Vogue*. Employed by the Ministry of Information in London, he became an official photographer, recording the war at home and abroad – the bomb damage on the streets of London and the night operations on RAF stations; injured children in hospital and wounded men in the desert; WRNS officers at Greenwich and Gurkha snipers on the Burma Front. Cecil Beaton was an outstanding war-correspondent, and from 1940 onwards his photographs and articles appeared regularly in both American and British *Vogue*.

Beaton had already demonstrated his abilities as a travel writer; now, on tours of duty for the Ministry of Information, he reported from such contrasting locations as Shepheard's Hotel in Cairo, the forward areas of the Chin Hills in Burma, and Viceroy's House, New Delhi. Among the many snapshots of desert scenes which appeared in *Vogue* were one or two of Beaton himself in makeshift uniform – riding a camel, or flanked by Glubb Pasha's Arab Legionaries, in their flowing headdresses. Even amid the hardships of war, Cecil Beaton retained his extraordinary sense of theatre; and he was able to apply it to scenes of destruction in a way that heightens the shock – as in the surreal image of tank fragments at Sidi Rezegh, or the fashion shot of a woman in a tweed suit amid the wreckage of the Middle Temple.

As the war drew to an end, Beaton visited Paris to report on the conditions there since the Liberation and to find out how his friends such as Cocteau, Bérard and Picasso had fared. He was now forty-one, and the gadfly days when he had lamented in *Vogue*, 'Will cocktails pull one through to the end of the season?' were past. In the post-war years, Beaton's photographs of eminent people of the twentieth century – artists, writers, intellectuals, politicians – revealed a new maturity.

One friend whom Beaton photographed for *Vogue* soon after the war, with dramatic consequences, was Greta Garbo. Like Lily Elsie, Lady Diana Cooper and, later Audrey Hepburn, Garbo was a recurring theme in his reflections on feminine beauty; he wrote of 'the pain of her beauty', the 'chiselled sensitivity' of her features. Constantly elusive, even in a close relationship, Garbo eventually allowed Beaton to take her

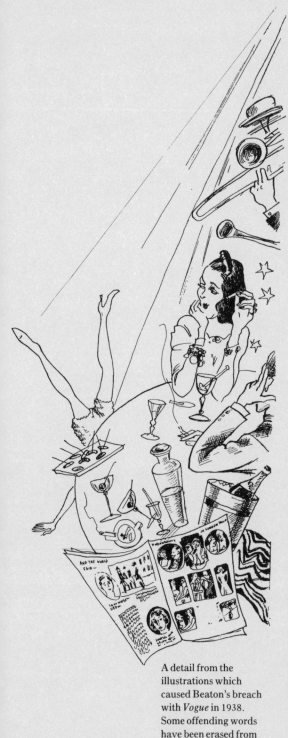

A detail from the illustrations which caused Beaton's breach with *Vogue* in 1938. Some offending words have been erased from the right-hand page

picture, and actually agreed that the result should be published in *Vogue*. A rare and remarkable two-page spread was laid out in American *Vogue* – Garbo in profile with hair flying, Garbo in pierrot hat and ruff, Garbo holding an armful of flowers. Just before the magazine was due to come out, news of the photographs reached her, and she was horrified; she had believed that only one would be published, and would permit no more. All Beaton's efforts to prevent publication were hopeless at such a late stage, and it was many months before Garbo forgave him.

The record of people and events which Beaton's work formed in *Vogue* over the decades included portraits of three generations of British royalty. The timeless image of Queen Elizabeth, now the Queen Mother, a serenely romantic, Winterhalter figure, was perfectly expressed in Beaton's photographs; and in addition to the formal studies, he captured more personal royal scenes – the children of the Duke and Duchess of Kent plane-spotting with their father; Princess Elizabeth laughing with the two-year-old Prince Charles. At the time of the Coronation of Queen Elizabeth II, in June 1953, Beaton recalled his experiences photographing members of the Royal Family in a 'Royal Album' for *Vogue*'s Coronation Issue. A month later, *Vogue* published Beaton's official photographs of the new young Queen taken at Buckingham Palace, along with a series of notes and sketches which he had scribbled in Westminster Abbey during the actual Coronation ceremony. Few more immediate impressions of such a ceremony exist.

The mid-1950s saw a brief lull in Beaton's career with *Vogue*. Not yet a Grand Old Man, but well past his golden youth, his style was regarded by some as old-fashioned and stagey, and for a time it was as a designer, rather than a great photographer, that he was best known. *Vogue*'s readers were kept abreast of his work in theatre, ballet and films, however; and he contributed articles on the ravishing new star Audrey Hepburn, and on the making of *Gigi*, with Leslie Caron, in Paris and Hollywood, as well as one or two travel pieces. By the early 1960s, however, Beaton was back in *Vogue* – and that decade saw him re-established as one of the most stylish, talented and fashionable figures on the English scene.

Over the years, *Vogue* often invited Beaton and his fellow artists or photographers to portray one another. Penn, Rawlings and Blumenfeld were among those who photographed Beaton for *Vogue* in the 1940s. In 1963, David Bailey, 'twenty-five-year-old New Wave photographer', snapped Cecil Beaton, while Beaton gave his views on Bailey to *Vogue*'s Features Editor, Peter Laurie. The results gave an insight into both photographers:

'David Bailey is super. While he was taking his pictures he kept up a continuous stream of encouragement – "Marvellous, darling, super, a bit to the left Chief, that way doll, great, marvellous, marvellous. . . ."'

'When I began, a photographer had no sort of social position at all; he was a sort of inferior tradesman, and even the servants used to be surprised at one. And one had to be so terribly polite to everyone. But now photographers can go anywhere at all. I hate people who are obsequious; David Bailey isn't a bit like that.

'I had the slightest suspicion that I was watching him more than he was watching me. Perhaps he's the tiniest bit too definite and arrives with a preconceived idea of what you are like and makes you conform to that. I don't for the world want to criticize him. I just feel that this is a valid point. I think I would have given the sitter more time to reveal himself.'

'The great Garbo', 1931

The painters whose portraits of Beaton appeared in *Vogue* included Christian Bérard, Patrick Procktor, and David Hockney, who drew Beaton in 1969 in one of his wide-brimmed hats, while Beaton photographed Hockney and wrote about his 'champagne ice' hair and 'spectacles as large as bicycle wheels'.

In the 1960s, as in the 1930s, Beaton's life, friends and houses were frequently featured in *Vogue*. In 1963 he wrote an article for American *Vogue*, 'My Two Houses':

'Perhaps, to have a house in London and another in the country is a great extravagance. However, since I am like a juggler spinning plates in the air, and trying to carry on simultaneously four or five different professions, it would be almost impossible to operate from under one roof. Reddish House, in Broadchalke, Wiltshire, is really where I live, and where I paint, design and write. When I regret a London invitation by saying I will be in the country, friends imagine that I am enjoying a carefree weekend. But it is at Reddish that much of the real job is done.

'In London, it was clever of my mother to find this small Regency house, in a quiet and leafy oasis of South Kensington. Some of the objects, bits of sculpture and pictures that are in the house today are among those I bought very early on in my life. (The Alberto Giacometti light hanging at the foot of my bed was one of my first possessions.) The Atlan, bought by me under the aegis of Gertrude Stein directly after the liberation of France, was until recently in my country-house bedroom.

'A typical day in this house – like today, for instance – starts early. Rebecca West comes early to lunch to talk about a plan to perpetuate the memory of the late Syrie Maugham by presenting a picture in her name to her favourite museum. We both loved Syrie Maugham and have reasons to be grateful to her. We discuss Swiss doctors, the English theatre, and the Lunts. Would that lunch could continue all afternoon, for there are few conversationalists today to compare with Rebecca West. But she must depart to report on the latest spy tribunal, while the Covent Garden Opera House wardrobe and model room are awaiting me for instructions about my designs for the new ballet and the presentation of *Turandot*. . . .

'Reddish House in Broadchalke was built in 1662; its façade, with stone pilasters and bust of Roman poet on the pediment over the front door, is extremely formal. My neighbour, Lord David Cecil, the essayist, called it "A pocket edition of a three-volume novel". In its decoration the house seems to demand a certain respect, and I had to discard all the "amusing" rubbish with which my previous country house was furnished.

'Since I bought the house twelve years ago, it has evolved itself into being essentially English in character in spite of much of the furniture being French or Chinese eighteenth-century. It is filled with old rose chintzes, Regency carpets, astrolabes, folding library steps, and everywhere a jumble of books and beloved objects picked up on my journeys abroad. The pictures comprise late Impressionists, Victorian still-lifes, Boldini and Helleu; sketches by Graham Sutherland and early Dalis. The house goes nap on charm.

'In the country I am able to work for hours on end without interruption. Here I have a large library filled with "research" and from these shelves I shall hope to find inspiration for my next project, the film of *My Fair Lady*.'

Beaton's 'next project' was to be one of the triumphs of his career. The sets and costumes for *My Fair Lady*, for which he won an Oscar, harked back to his favourite Edwardian era, 'the days of wine-glass waists and palms', of plumes, parasols and

button boots, which had often figured in words and drawings in his *Vogue* articles. When the film came out in 1965, Beaton's photographs of his designs – including Audrey Hepburn's costume from the famous black and white Ascot scene – filled many pages in *Vogue*.

In 1968, under the aegis of Roy Strong, whom he had photographed a year earlier for *Vogue*, Cecil Beaton's portraits became the subject of the first photographic exhibition to be held at the National Portrait Gallery. The exhibition, which included many of his *Vogue* photographs, was highly successful with both the critics and the public. A knighthood for Cecil Beaton followed two years later.

Though the volume of Beaton's work diminished as he grew older, the range of his interests did not. He wrote pieces for *Vogue* on Turkey, on gardening, on Mae West and Lady Diana Cooper; he photographed Jean Shrimpton and Twiggy, Mick Jagger and Edward Fox. His 'Outside World' social life was almost as busy as it had been in the 1920s. In 1968 Arabella Boxer recorded his views on entertaining for British *Vogue*:

'Cecil Beaton seems to regard party-giving in theatrical terms, rather as one might think of mounting a new production. He provides the setting and assembles the cast, then expects the actors to do their bit. One is conscious of this, feeling uneasily aware that more is expected of one than just to look nice and behave well. As he says, "guests themselves have to participate, and by providing a stage for them you have done something constructive".

'Going to a party in his London house in Pelham Place is not unlike taking part in a command performance. Those appearing vary considerably from year to year, with a few exceptions. A few years ago, Cecil Beaton completely redecorated his London house; the rooms almost inevitably remind one of elegant stage sets. The walls of the drawing-room are covered in black velvet outlined with braid. The floor, an elaborate inlaid parquet, was transplanted intact from a former Rothschild house in Piccadilly. The furniture consists mostly of circular armchairs, modern and extremely comfortable, with tiny cushions like jewels, made from Japanese obis. The only recognizable remainder from the former décor is a portrait of Cecil Beaton himself, as a startlingly beautiful young man, by Bérard.

'Food itself holds no special interest for Cecil Beaton; he seems to be as surprised by its appearance as any of his guests. On one occasion a main course – veal cutlets cooked in paper bags – came up accompanied by a type-written note from the cook, giving a brief history of the dish, which was alleged to have been invented by Madame de Maintenon.

'Being a guest at Cecil Beaton's house always demands a certain standard of behaviour. "I don't want genteel politesse, but I do think there are limits to which people's behaviour should conform. I don't mind people arriving early; I'm rather flattered. I regret their being late; I'm afraid one of my friendships came to an end because they always arrived unconscionably late. Apart from oneself, it's disturbing to the cook. Then I can't bear people losing their tempers – it's as bad as being drunk. I hate people being stoned: it embarrasses me. I don't know which part of them to look at. I would make a very bad barman."'

A serious stroke in 1974 left Beaton unable to use his right hand. Nevertheless, whilst on holiday in Tangier, he began to paint again, using his left hand, to fulfil a commission from *Vogue*. Some of his left-handed paintings – a view of the drawing

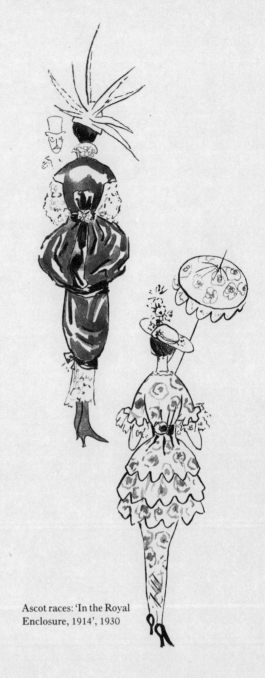

Ascot races: 'In the Royal Enclosure, 1914', 1930

room in David Herbert's house, and a study of lilies in a pond – were remarkably successful.

When, in the spring of 1979, the Paris couture collections proclaimed 'a return to elegance', it was naturally to Cecil Beaton that French *Vogue* turned, for forty-six ravishing pages of photographs. With women such as Paloma Picasso, Loulou de la Falaise and Princess Caroline of Monaco as his models, Beaton re-evoked the mood and style of his fashion photographs of the 1920s and 1930s. The 'retour derrière les spotlights', as French *Vogue* put it, of the great Sir Cecil Beaton, was a triumph, more commissions followed; and Beaton's portraits of eminent Britons, from the Bishop of Southwark to Patrick Procktor, appeared in the August issue of French *Vogue*.

A new era of Beaton in *Vogue* seemed to have begun. But Cecil Beaton did not live to record the 1980s. He died on 17 January 1980, three days after his seventy-sixth birthday. In a 'My Day' article for *Vogue*, a decade earlier, he had written,

'With ghoulish curiosity I look at today's obituaries . . . I wonder what my notice, if any, will be like? Pretty savage, I should think. "Achieved a certain notoriety in the thirties." "He never really delved deep enough." It was poor Hugh Walpole who first got pole-axed for dying. Before that it was all sweetness and praise. But save me from the well-meaning friend whose grief is drowned in clichés, or the amateur who wrote of the performer Gwen Farrer: "She loved dogs, was very like a dog." Anyway, perhaps there'll be a newspaper strike the day after I croak.'

In *Vogue*, Beaton's 'notice' ran to eight pages. It included quotations from other obituaries: Lord Snowdon, in the *Sunday Times*, had written, 'I regarded him as the biggest figure in photography this country has produced this century'; Richard Buckle, in the *Observer*, described Beaton as 'a Cocteau with a camera, a Brummell with a pen, the Dali of Fashion'. For *Vogue*, Roy Strong wrote, 'I know of no one else with an eye so attuned to the visual nuances of an age, who calendared them so brilliantly in his own work from neo-Edwardian to surrealism, from neo-Baroque to Op and Pop. For over half a century he distilled the essential images of successive decades through his camera's lens and by this means shared them with us.'

Yet Cecil Beaton had little need of obituaries. Were nothing else of his work to survive, the vast and unique archive of photographs, drawings and articles created over the fifty years of his brilliant collaboration with *Vogue* would serve to confirm his reputation as one of the most versatile creative talents of the twentieth century.

Cecil Beaton, portrait by Patrick Procktor, 1976. Procktor described the sitting for *Vogue*: 'The sitter may speak when his mouth is not being painted; manual gestures and facial expressions are so far as possible suppressed. The painter for his part is supposedly abstracted by his profound meditation as to where to put the feet'

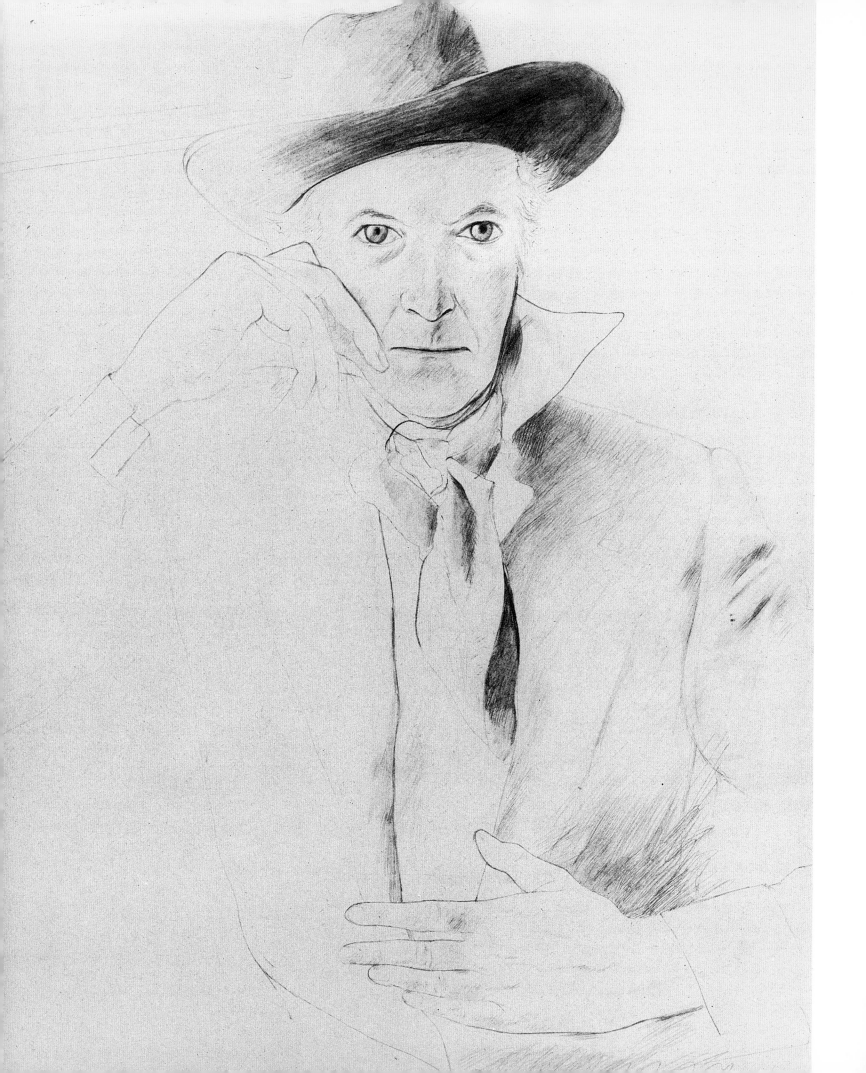

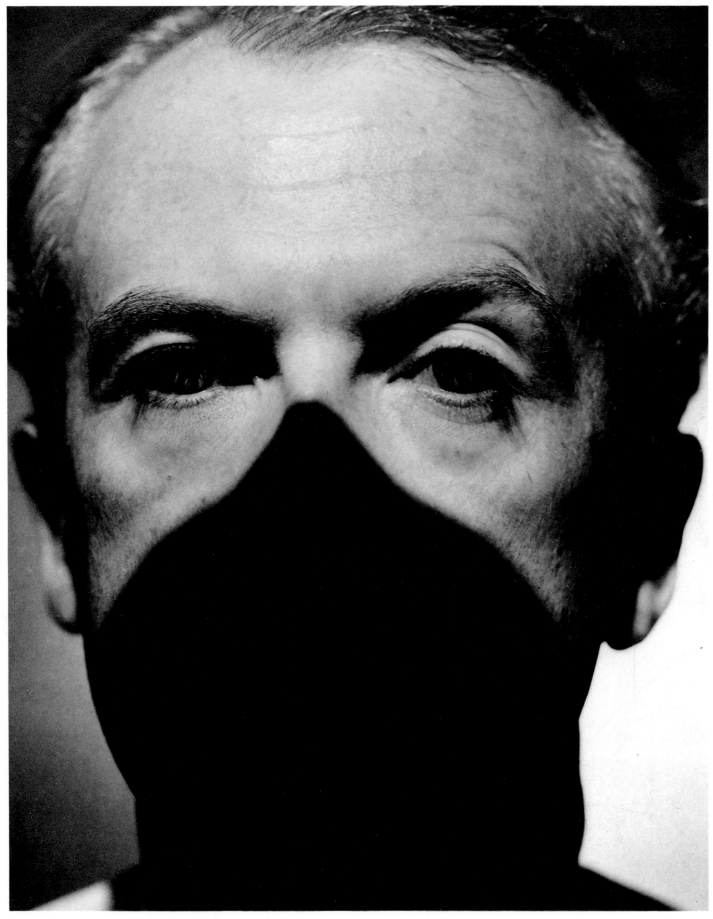

Beaton by Blumenfeld, 1946

Beaton drawn for *Vogue* by David Hockney,
1969

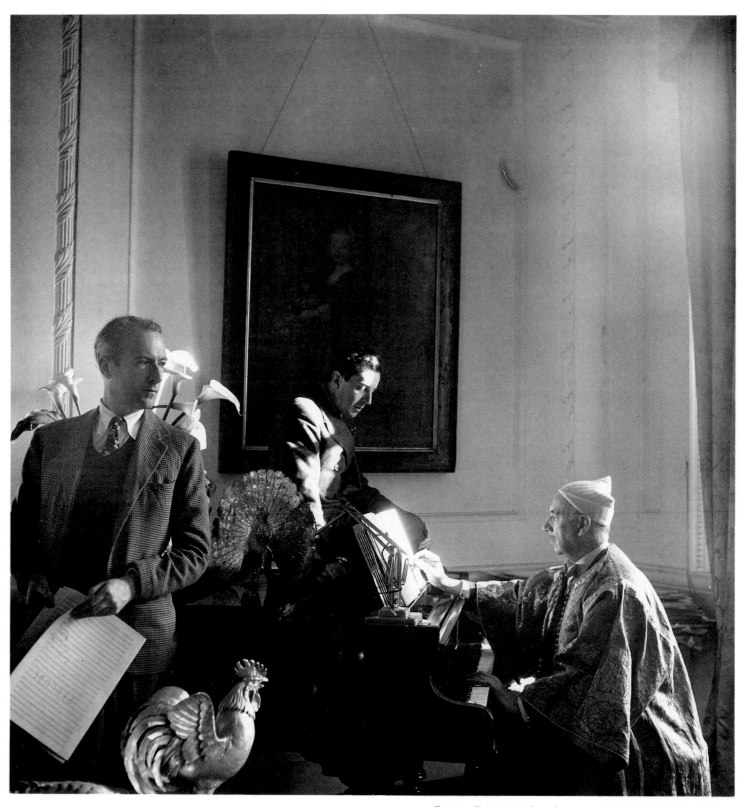

Beaton discussing plans for a new ballet with his friends the choreographer Frederick Ashton (*left*) and the composer Lord Berners, 1947

Beaton at Home. Ashcombe, his house in Wiltshire, 1932 (*above*). Clockwise from right: Beaton with his scrap albums, 1937; Beaton dressed as Lady Mendl, 1934; Tilly Losch, 1934; picnicking at Ashcombe, 1936; Augustus John with Beaton, feeding the doves, 1933

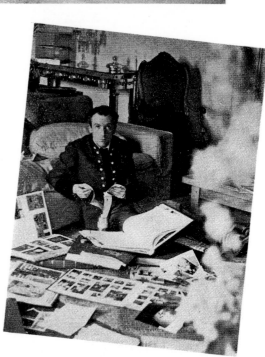

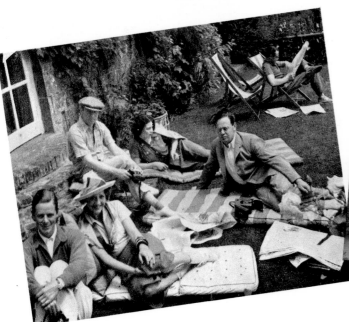

Photographers' Gallery. Portraits of Beaton by George Platt-Lynes, 1945 (*above*); John Rawlings, 1945 (*above right*); Horst, 1949 (*below*); Louise Dahl-Wolfe, 1945 (*right*). Beaton said of the Dahl-Wolfe sitting, 'The very photographs I'd have chosen myself . . . This is the midsummer way I'd like to look'

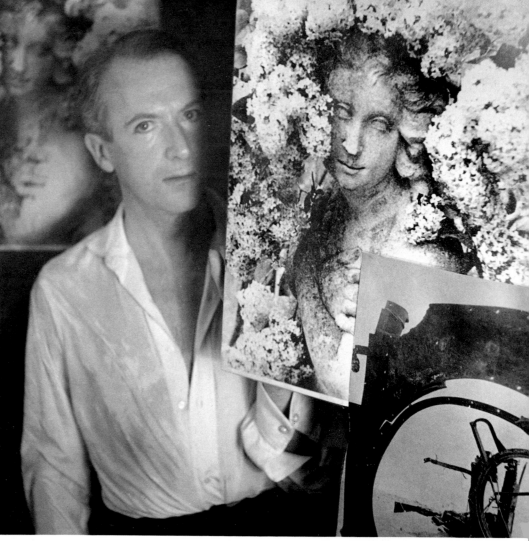

Beaton by Penn, 1951 (*opposite*)

22

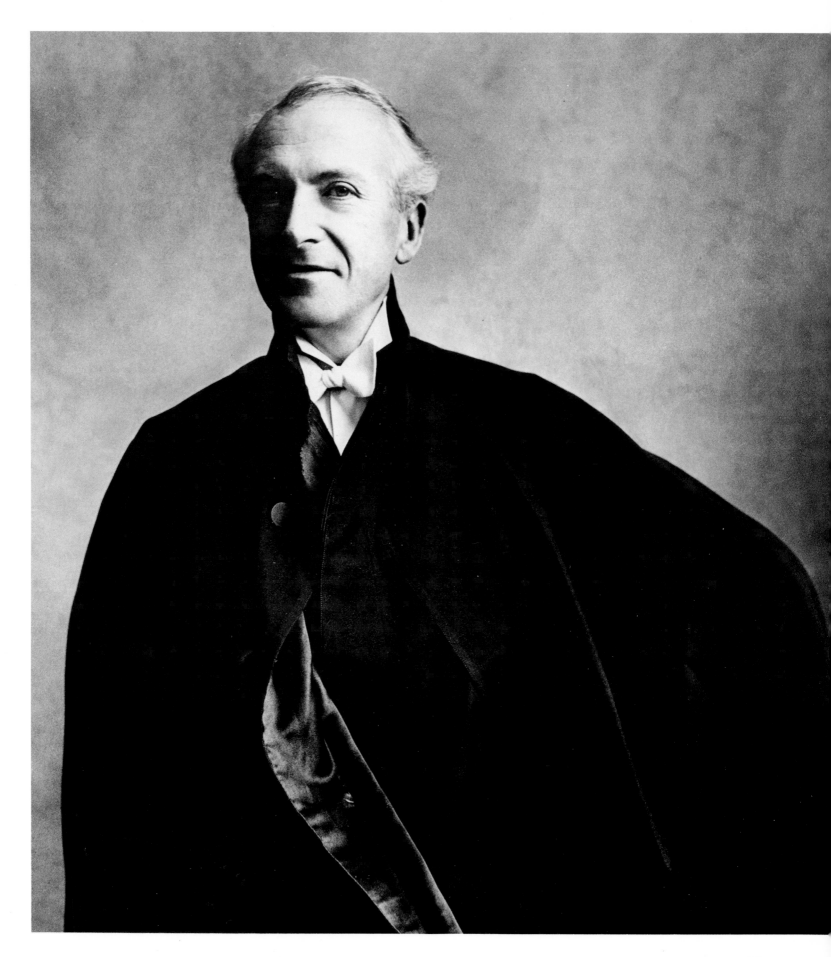

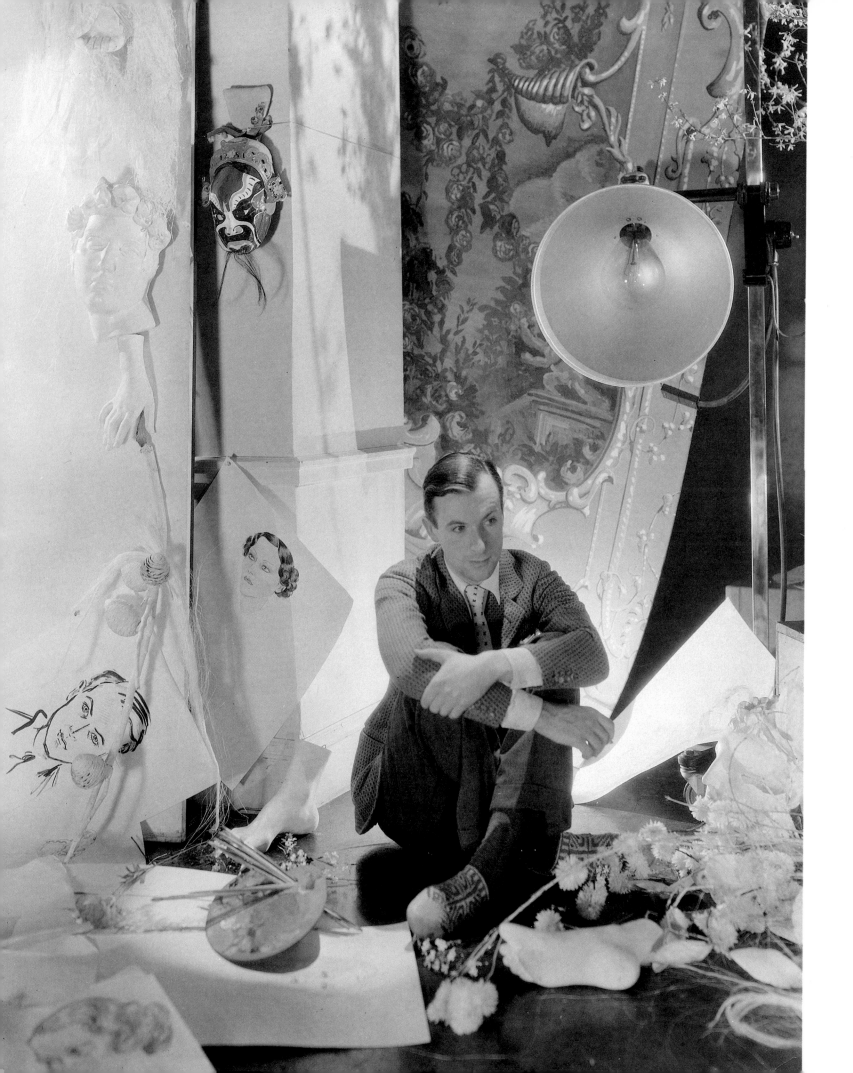

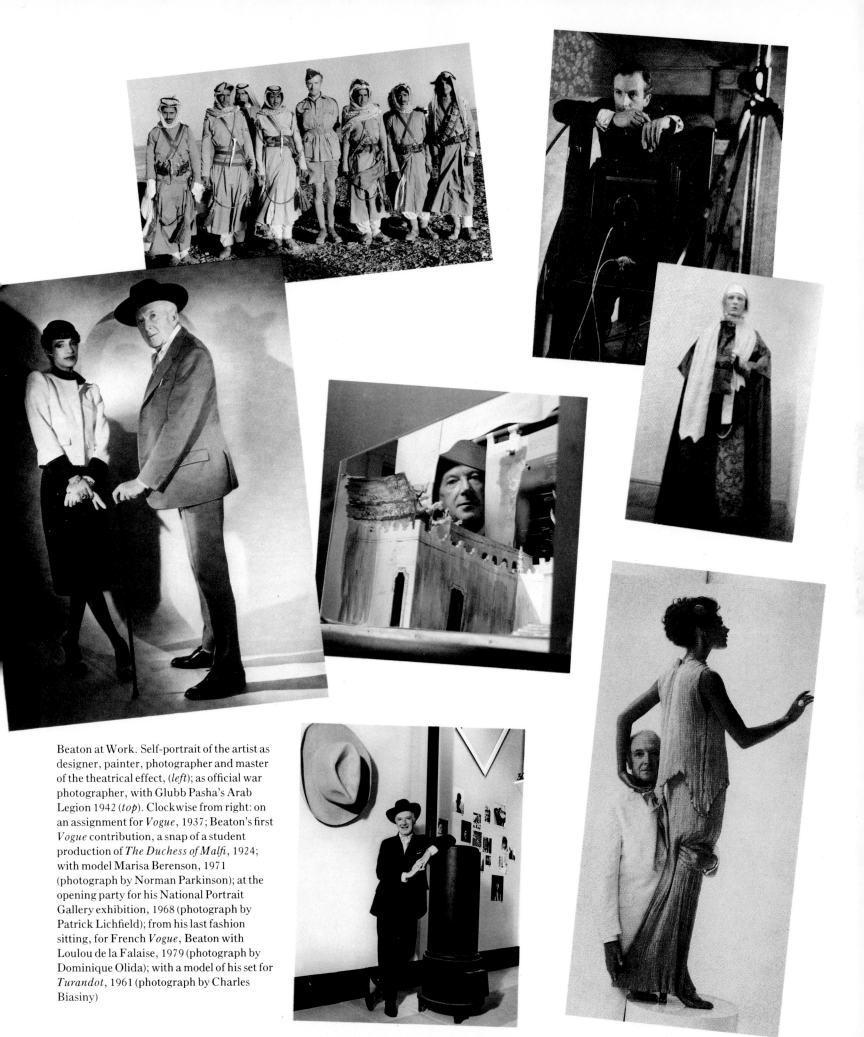

Beaton at Work. Self-portrait of the artist as designer, painter, photographer and master of the theatrical effect, (*left*); as official war photographer, with Glubb Pasha's Arab Legion 1942 (*top*). Clockwise from right: on an assignment for *Vogue*, 1937; Beaton's first *Vogue* contribution, a snap of a student production of *The Duchess of Malfi*, 1924; with model Marisa Berenson, 1971 (photograph by Norman Parkinson); at the opening party for his National Portrait Gallery exhibition, 1968 (photograph by Patrick Lichfield); from his last fashion sitting, for French *Vogue*, Beaton with Loulou de la Falaise, 1979 (photograph by Dominique Olida); with a model of his set for *Turandot*, 1961 (photograph by Charles Biasiny)

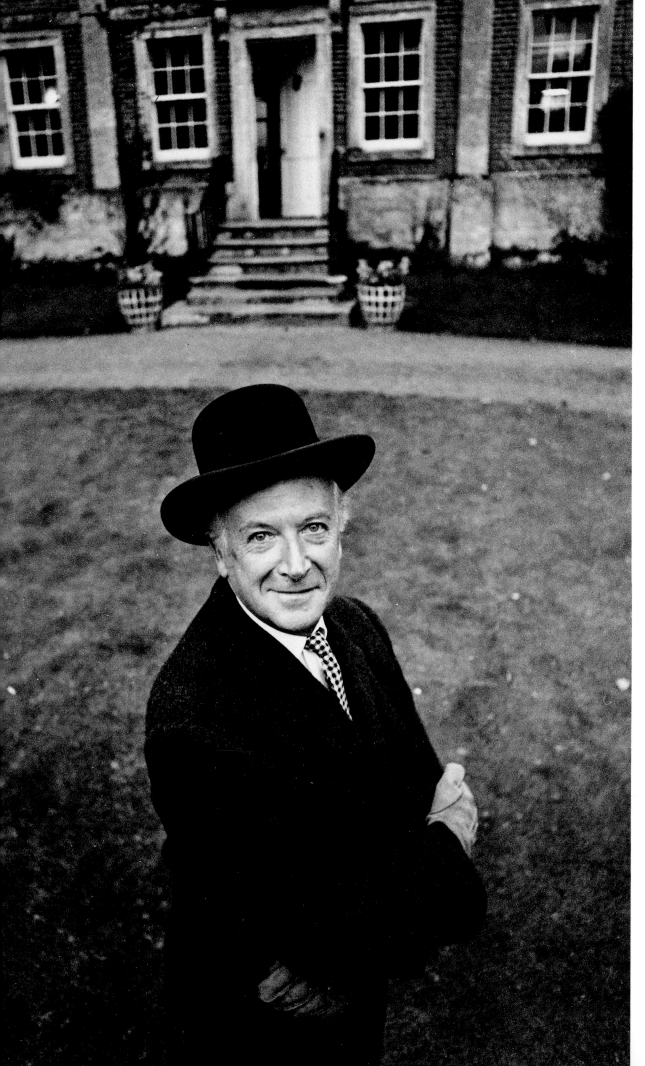

Beaton at the second of his two country houses. Reddish House, Broadchalke, Wiltshire, 1965 (photograph by Ronald Traeger); Beaton in his conservatory at Reddish, 1963 (photograph by Ray Williams)

Overleaf: Cecil Beaton, 1968 (photograph by Manfredi Bellati)

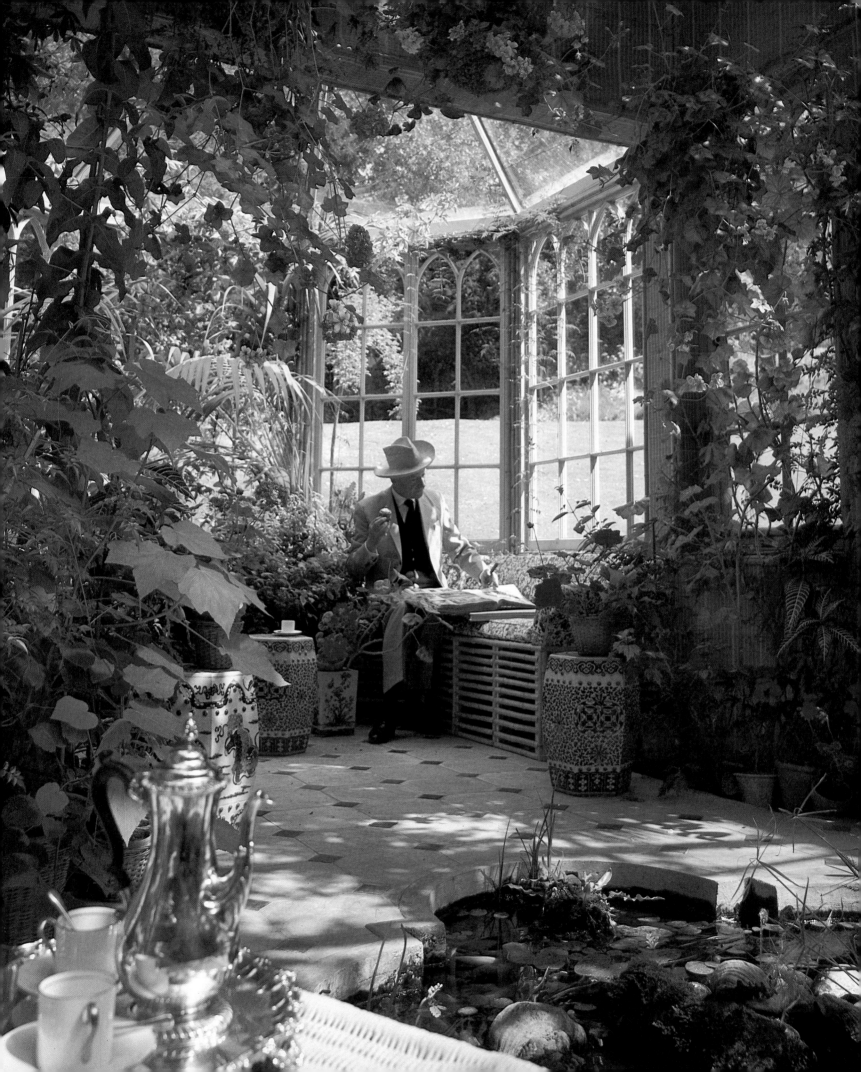

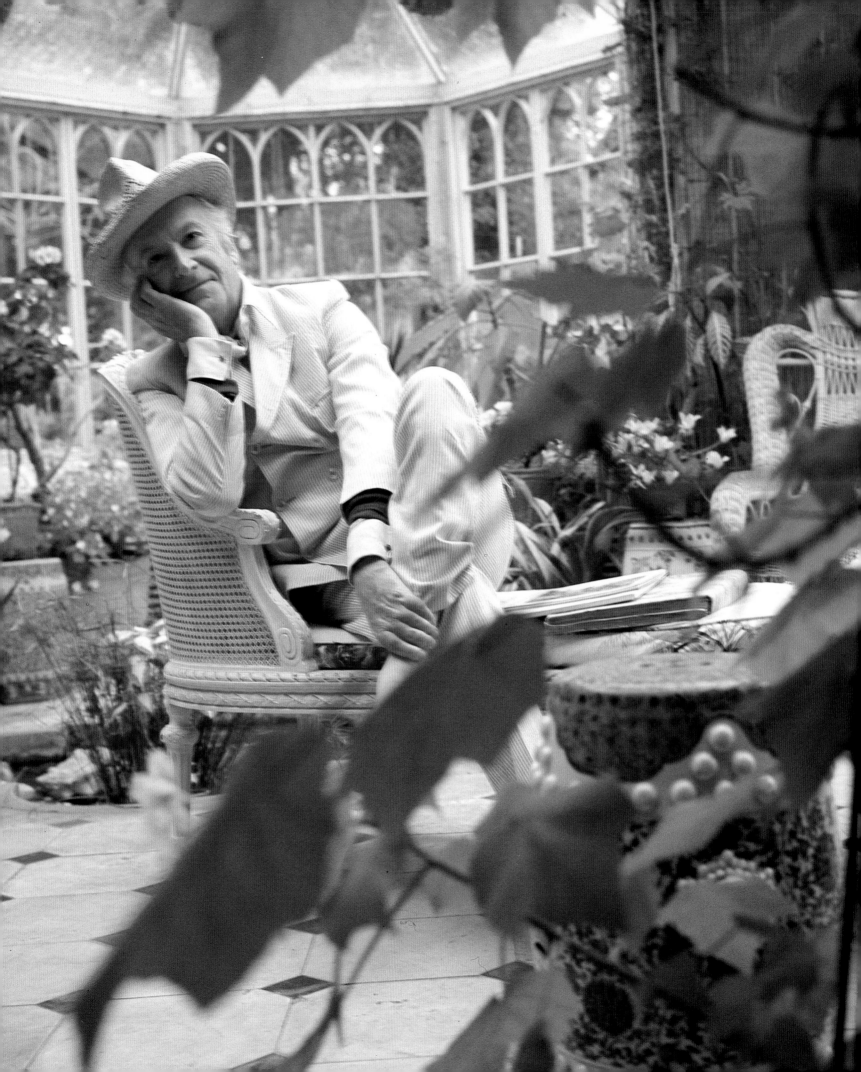

1 · How One Lives

Mrs Sacheverell Sitwell at home
in Northamptonshire, 1929

The London Season (1928)

THE PARK is like the setting for the first act of a musical comedy. The swelling bushes of rhododendron blooms make a riot of colour, the lawns are huge stretches of emerald velvet, the fountains play, the children play.

The Mall is lined with flushed and expectant debutantes in their Court feathers, with arms bulging over their long white kid gloves. Bond Street is jammed with sparkling limousines in which are propped yawning and anaemic beauties. Tweed trousers are the smartest thing for men to wear with their black morning coats, but, nevertheless, everything looks much the same as it always has before.

Will cocktails pull one through to the end of the season? One has a sneaking dread that they will not, for this year those who indulge in a London Season are being 'put through it' harder than ever.

There are always three or four different varieties of parties each night to choose from. There is the conservative – and grand – 'coming-out ball', with all the lovely debutantes, the bored and eligible young men. There are heavily tasselled curtains, very polite conversation, fronds of smilax, wired roses, and, at the buffet, a slight perfume of methylated spirit and molten silver.

There is a more Bohemian and exciting, though none the less elegant party given the same night, very likely by Mrs Somerset Maugham, and here, in her exquisite all-white ballroom, will be found all the interesting celebrities of the day. Lady 'Cimmie' Mosley, the lovely socialist, Lady Mendl, in short white gloves, Lady Louis Mountbatten, Adolphe Menjou and his new wife, who has a white face and a coiffure of bright yellow curls. And here, every now and again, the old Viennese valses will be played, and the couples will swirl to *The Merry Widow*, while Lily Elsie, ever lovely, swoons in Noël Coward's arms to this melody that she made famous, and he is heard to say, 'This is the loveliest time of all.'

Then there has been an overwhelming number of informal parties, perhaps the most enjoyable of all. No party was more triumphant than Mrs Frederick Lawson's when she invited her intimates to be filled with caviar and champagne and to sit on her drawing-room floor while eight pairs of hands played the piano for us to sing old time favourites – 'Oh I Do Like to Be Beside the Seaside!' 'There's Something About a Sailor!' 'Alexander's Ragtime Band'. Lady Diana Cooper in an Ospovat garment sang, 'If You Were the Only Boy in the World', and our charming hostess did brilliant imitations of certain friends.

There have been millions of dreadful charity balls with the organizer, her shoulders swathed in tulle, rushing madly hither and thither and interested merely in the sale of tickets. There have been 'sailor' parties, pyjama, end-of-the-world, Judgment-Day, 1880, dress-as-some-living-person Bottle Parties, and great fun they have been! With

'A sailor for a night' – the Marquise de Casa-Maury, 1929

so much private party-giving one is too busy to do other than scorn public places, even night-clubs, but nevertheless, if you go to the Embassy after the play, you will very likely find a score of your friends enjoying themselves hilariously, and besides, stage stars with their shoulders burdened with orchids and tiredness showing under their painted faces will be seen having supper with overdressed beaux.

Lady Inverclyde at a night-club, 1929

To feed and to dance, always to be moving, that is the thing. We must move on. We must miss nothing. We daren't risk more than an hour or two in sleep, in case something happens while we aren't there. Has a new night-club grown up, and it was twelve hours before we knew of it? Dreadful! Has a restaurant lost its vogue or gained a new one and we not know of it for a whole day? Unthinkable. We hate the blocks of traffic all down Piccadilly and Bond Street, all down Regent Street and Haymarket, because while we are held in them something may have happened, so quickly does popularity pass.

Tonight it is Sovrani's we are going to, the bright little crystal restaurant with the green doors in Jermyn Street (you mustn't mistake it for Fortnum and Mason's and go and buy your sports clothes and a ham there: this is a restaurant). Three men in the band; a tiny room for those who dress; a tiny room for those who don't. And there is Sovrani, who has shaved his moustache to make more room. And there is Lady Louis Mountbatten, who is to a restaurant what the lion is to hall-marked silver. And Mrs Lionel Tennyson, and the Marquis de Casa-Maury ('Oh! I wish he were my *ghinkie*!. . . Oh! Isn't he sweet?. . . Oh! What lovely eyes!. . . Oh! Does he sell cars? Perhaps I'd know him if I bought one,' a girl is breathing in a hoarse Cockney whisper to her partner as we dance tight-packed: those we think we love are *ghinkies* at the moment).

Wouldn't it be awful if Taglioni's, the little Italian place in Soho where we lunch, were to go out of fashion before the coffee? Wouldn't it have been awful if we hadn't known that the Café de Paris bounced into a revival of chic and Lady Cunard had a party there, and the Duchess of Sutherland, and Casa-Maury ('Oh! I DO wish he were my *ghinkie*!. . .')

'The mode and manners of Lady Louis Mountbatten should be studied by the aspiring beauty', 1928

All day long the telephone rings incessantly: a lunch party, a cocktail party, a request from a fashionable photographer, a pathetic appeal from an obscure one, a committee meeting, an invitation to have tea over London in an airplane. The Imperial Airways advertises a thirty to forty minute cruise every Friday afternoon, with tea served while in flight – an attractive innovation. Then there is always a charity matinée. The prime reason for this function is dressing-up, the official excuse a maternity hospital. There is no rehearsal, but as the whole of the British aristocracy believes itself to be histrionically gifted, this deficiency in no way interferes with the riotous pleasure of the performance. With what satisfaction does one know that the dressing-up panic scenes are taking place in three hundred Mayfair bedrooms! Screams, curses, threats! The telephone, the powder upset over everything. The greatest fun of all is the making-up, which takes at least six hours. Lady Lavery, as Lady Hamilton, rushes to the electrician: 'Take out those amber lights. They are hideously unbecoming – nothing like plain white chorus-girl lighting!' She knows all the tricks.

Incidentally, the play to which everyone goes this season, is Cochran's revue written by Noël Coward. It is said that everybody goes there every night. The new night-club, known as The Hutch and run by Leslie Hutchinson at the back of The Savoy, is more like a Parisian Boîte de Nuit than the rather old-fashioned London night-club.

Every night throughout May, June and July, the footmen's little lamps swung, the red carpets glowed darkly and the awnings stretched outside the houses of Mayfair, Belgravia and Westminster. No matter what the weather, London will enjoy a season as bright and lively and active as has ever been; and the whole world seems to unite to give its exuberant approval of the London season.

After London, New York (1931)

WELL, IT SEEMS that the market for elegance has been ruined, and you might just as well throw away your doilies right now. The elegantes in London, Paris and New York who paved the paths of distinction have ruined them by running after the humble fun of hoi polloi.

In Paris, always a more elegant capital than any other, dinners of the utmost formality and elaboration are still given, causing the inevitable criticism of the placement by the variegated guests. But even in Paris there are now those who, though most importantly seated at the grand parties three nights a week, spend the remaining four playing backgammon, watching the sights at the Enfants Terribles – simply bumming around.

In London nowadays, the activities of our friends are not confined within the small radius of Mayfair. Beyond the squalors of Euston, picking up bargains at the Caledonian Market, where almost anything from a baroque bed to an old pair of boots can be bought for a song, you will see Lady Diana Cooper eating chestnuts freshly roasted on a wheel cart. Please don't let's mention the names of those you will see eating fresh ham sandwiches with straw shopping baskets on their arms, but you would know them if we did. Gramophone records are bought from Levey's, in Whitechapel; silk stockings in the Berwick Market in the slums behind Shaftesbury Avenue. And, at the Circus, you will see what the gossip writers would describe as 'the most distinguished audience in town', for, in spite of the smell, the glamour and magic of the Circus in London are more potent than ever. There are riotous cheers at the antics of the spangled clowns, uproarious applause for the performing white horses, with their aigrettes of ostrich plumes, and hair-raising anxiety and thrill when the acrobats pivot in mid-air. The side-shows are irresistible, and on the roundabouts, rocking-horses and giant racers, you will recognize the same people as on the Blue Train and the Golden Arrow. Chauffeurs are no longer amazed to be told to drive to the lowest music-halls over the river at Lambeth or to the Elephant and Castle. And, at Charlie's Bar in Limehouse, you will see a group of bright young people and Lady Eleanor Smith dancing to the music of a penny-in-the-slot mechanical piano. The boxing in Whitefriars on a Sunday afternoon is as fashionable as church parade used to be before the War, and Mrs Baillie-Hamilton shrieks with the throng, 'Go to it Ginger – sock him hard!'

Travelling to America, one notices again this revolt from formality. In New York, it seems that new, expensive jewellery is designed and worn more for black crepe than

Edwardian church parade – 'and now they go to Sunday boxing-matches', 1929

for gala lace. Expensive dining out is perhaps not quite so glamorous and sparkling as it used to be. Mrs Irving Berlin, for one, has realized the excellence of the vegetable soup and steaks at Dinty Moore's, and many others are partial to the exquisite immaculateness of Childs' for supper and have discovered that there is real talent to be found in the vaudeville houses way up- or way down-town, where the tickets cost a dollar and the jokes are crude. Everyone is getting much less pompous, and there is no need for tentative enquiries on points of etiquette. Take comfort, all of you who, wishing to be correct, have written our Editor asking from which side of the chair the dinner-table should be approached and which French words should be pronounced as English. Be calm and be yourselves, for to behave now is to be completely natural. Life is difficult and crowded enough without doilies.

So THESE are my rooms! I open the windows that look onto the patio. A fountain plays, birds tweet and sing and flit from tree to tree, scarlet and pink hibiscus thrives abundantly, and it all seems strangely peaceful here after the hectic rush of New York life.

Palm Beachistory (1931)

But how artificial and theatrical it all is! The ladies, like chorus ladies, in huge picture hats and flower-printed chiffon dresses; the men like chorus men in white flannels and elaborate shoes. The birds in their cages warble like prima donnas, darkies propel spotlessly white basket chairs, the sun blazes with the brilliance of a thousand million arc-lights, and, at night, the scene is equally idyllic, a triumph of romantic artificiality. The palm-trees are illuminated; little tangerines are wired to the branches of apple- and peach-blossoms, and most significant of all, the leaves of the orange-trees are made of green linen. (The hurricane blew off all the real leaves, last year, but the head waiter, undaunted, said 'Let there be orange leaves', and there are.)

Here, where the alligators and crocodiles basked through their lives of a thousand years, now impersonally 'grand' cars wait while their owners are swimming, eating pared oranges on sticks or choosing a cafeteria lunch at the Bath and Tennis Club. The local papers are filled daily with the countless thousands of names of those 'caught in the social stream'. Gigolos, Argentines with pet white mice on their shoulders and beazles with hennaed hair and clumsy jewellery are all 'caught' at the Ambassador Hotel, at The Breakers, or Cocoanut Grove, while others prefer to be 'caught' at some tea or musicale at a house with a Spanish name. Oh, La Carita!

There is the greatest variety of places for every meal. The Patio Lamaze supplies Hungarian music and the best food for lunch. The Marguery cannot be beaten for dinner, and at the Embassy Club, which possesses the best band, a beautifully planned patio looks out onto the twinkling lake. At the Colony, the band is hotter, and young men with gay personalities sing through megaphones that 'Delilah was a flousy'. Balloons are transparent with fairy light, palm-trees become emerald and purple under the arcs, lily-pools are illuminated from beneath. There are whispered secrets about a rat-circus or a whisk-broom band to be imported from Miami, and Miss Mary Brown Warburton in sequin pyjamas is making elaborate plans for the next big party.

It is almost impossible to imagine that the slump has occurred. Although one had thought that perhaps the Hutton household had put an end to all competition in grandeur, it seems that bigger and better houses are still being built. Since last year, Mr Kahn, Mr Harrison Williams and Mr Mike Vanderbilt are all possessors of new

homes. None has, as yet, built a completely 'modern' house, though Mrs Kahn is bravely filling her new Italian house with steel furniture and decorations in keeping with the modern tendencies. But we must not grumble, for, though most of the new houses are Spanish or Romanesque, there is no new 'Nemo's Nightmare', and we must applaud the new Harrison Williams house, one of the loveliest in the world, ideally situated. It is decorated almost entirely in various shades of white, with great distinction and simplicity, with the help of Mrs Syrie Maugham.

Here, against a Chinese wall-paper of incredible beauty and delicacy, our hostess, one of America's choicest treasures, in a bathing costume, gives instructions for the new electrical fittings to be taken down, moves an 'occasional' table from one end of a white corridor to the circular hall, with results to one of her little toes. White lilac against white walls, a sunset that is like every picture postcard! What could be better? What more can one ask of life?

The existence of those that prefer rest and quiet here is ideal. There are the swimming-pool and the ocean to choose from, there are the meals at home, for six or possibly eight; there is the boxing on Friday nights, the bridge table, the backgammon-board. For those who prefer the Club swimming-pools, Mr Bradley's gambling saloons – for those, in fact, who enjoy Deauville, Le Touquet, Cannes and other luxurious resorts – this spot is surely Paradise; but for those poor wretches who are neither restful nor simple souls, for those who imagined that Life was meant for higher things, this place is Gehenna.

Debutantes – English and American (1932)

'The English Rhoda is still wearing pigtails . . .'

UNTIL SHE IS SIXTEEN, the English girl is rarely seen. Beribboned with pink bows, she may be produced as a sort of cabaret turn at the end of tea, but certainly she is never heard. Ordinarily she wears black woollen stockings and a white blouse under a navy-blue serge uniform, low heels and a tight pigtail; and she may wear a plate clamped over her front teeth. Her life is one long, hard labour term of notebooks and histories of England, and she lives in a world of her own in the nursery and schoolroom, with toffee made in the saucepan, the 'School Girls' Own Magazine' and Angela Brazil boarding-school stories. Her social life exists in Hyde Park when she is out walking the dog; and, of course, there are Miss Vacani's dancing classes.

The birthday cake is brought in, and there are seventeen candles on it, and so Rhoda is shipped off to the Continent to be 'finished'. She returns to England under the impression that she has acquired 'that final polish', but she possesses little chic or savoir-faire. Her hair is suddenly permanented, with too many crinkles; her face is totally dusted with powder. You can spy some silly little trinkets, and charms on a chain. In the family there are terrific jokes about this sudden metamorphosis. The poor little wretch stands gawkily in her silk stockings, rather saggy at the knees. 'Fancy Rhoda being a grown-up woman!' But outsiders see that Rhoda is only thinly disguised in this role of a young lady about town.

Rhoda is given her coming-out dance. There are lengths of red carpet laid to the curb in Belgrave Square, red-and-white-striped awning, a lot of gold chairs imported for the occasion, a lot of bullet-hard cold chicken and a good deal of champagne, smilax and roses entwined on the buffet, and the silver candlesticks, and there is a terrific crush on the staircase. A monotonous din from the band, and in *The Times*, the next morning, in minute print, a list of the guests stretching the whole length of a column.

So Rhoda is launched, and her first season goes by. Now, at the end of summer, she is travelling to Cowes for the yachting, and we switch to the American debutante – who wears a sophisticated dress from Augustabernard and is as different from her European counterpart as root beer is from beer.

In America, even though the girl and her mother consider the whole routine is the bunk, it is necessary to conform to the definite formalities to enjoy the title of 'debutante'. When the child is thirteen she attends the Junior Holiday Dance, Miss Benjamin's Get-Together Dance, and Miss Robinson's. At fourteen there is the Senior Holiday Dance, very important, and this gives way to the Metropolitan Dance, known as the 'Met'. There is a committee that ponders deeply whether Susie shall be permitted this chance or not. If Susie does 'make it' to the Met, she is practically out of the woods, for it is almost certain that her name will be put up for the Junior Assembly Subscription Dance, the most important event of her career.

'. . . while her American cousin is going to dances', 1932

To be a fully qualified American debutante means a gruelling existence. Besides the glut of parties, committee meetings, incessant sittings for her picture, she is a member of the Junior League, which necessitates her being interested in welfare work. She must be seen wearing the flowers of her escort's college at all football games. She must have a 'swell' time at the Yale prom. It is her business to be a social success, and she must be perpetually chased by the stags.

By now, this young person is capable of facing these problems unflinchingly, for she has been in training for this racket since she was a child. At seventeen there is not a subject upon which she cannot talk, with, at any rate, 'bogus' wisdom. She has acquired great chic, is beautifully dressed, with immaculately manicured nails and perfectly cut shoes that show off her delicate ankles.

Let us end with a few comparisons. The American debutante waits for the young man to open the door for her. The English debutante makes a fumbling pretence of opening it herself. The English girl moves badly and smokes with apparent difficulty. Many English debutantes are rather clumsy with rouge. Many Americans, to European eyes, look lividly pale.

But soon all that we are saying may go for naught! The changes during the past year have been great, and the 'after-the-slump' debutante is such an improvement on the 'boom' debutante that she is scarcely recognizable.

Remembrance of Things Proust (1972)

IT REALLY HAPPENED. Everyone said the days of such nights were over. But the impressive cards were sent out with an engraving of the Guy de Rothschilds' great sprawling castle built by Paxton: a party to celebrate the centenary of Proust's birth – a *soirée du Côté de Ferrières*, 350 to a sitdown dinner, 350 more for supper. Women to be in headdress array, the men in white ties. It couldn't happen – not in France today. There would be demonstrations: nails sprinkled on the roads from Paris to puncture the purring automobiles bringing the elite. The much-heralded film star would certainly be waylaid and plundered of her rocks.

The preparations were as for a great film. For days lorries lined the courtyards and drives: carpenters, decorators, electricians, caterers, florists. The dark panelling of the dining-room was being covered with palm trees, ferns and maidenhair to be seen, brilliantly green-lit, behind the glass panes of the newly-erected squares of trellis.

The hostess, as cool as the cucumber salad from which she was making her lunch at five o'clock in the afternoon, was giving orders to the twelve secretaries for their plans for seating, their lists of distinguished names, juggling with the latest cancellations (Bardot) and additions (Princess Grace). Surely order could never come of this chaos? Yet all was planned and carried out as for a military campaign.

The long, pitch-pine panelled corridors were lined with scarlet-liveried flunkies holding candelabra. The early guests, looking self-conscious if not downright alarmed, walked the gang-plank of drugget to face the flashes focused on them. Hardly a smiling matter, it was all very serious and grand – until they reached the drawing-rooms. These remain just as they were when first furnished with late Victorian brocades, heavy pelmeted curtains, ottomans, pouffes, the *guéridons*, palms, early upholstered Rothschilds in golden frames.

'Everyone' is already here: the Duchess and all the pretty lights of café society, the visitors from Rome, New York, London, few of whom have ever opened the first pages of *A la Recherche du Temps Perdu*. The ladies are confidently laughing since they have received compliments on their heads elaborately dressed with aigrettes and jewels. They wear long dresses with trains, but why no long white gloves? Even the ladies'-maids, the parlourmaids and housemaids have had their hair coiffed *à la brioche* by Alexandre, and wear long, voluminous skirts.

The *sommeliers* and waiters in *Louis Quinze* liveries, are now manoeuvring the Rothschild dishes through the tightly packed chairs of the dining-room, transformed to look like the Princesse Matilde's winter garden. It is said that the quality of a chef can be judged by the consommé. This pale, hot chicken broth is our hostess's special recipe. It took the chef three months to learn how to attain the required perfection. Follows *quenelles de sole* with slices of lobster and a lobster sauce. Then the *pièce de résistance*: a huge boned duck stuffed with *foie gras* and *foie de canard*. The vast silver dish is adorned with pineapple, little onions like peas, small mirabelles, orange, egg fillets, cherries, and a prune jam of unimaginable richness. This is served with a crisp green salad. It is a perfectly balanced menu, and the wines of the best Rothschild *cuvées* are followed by Château Yquem.

Everything is working with precision. Below, in a large white mediaeval-looking hall, over a hundred chauffeurs are having their Bruegelian supper: sausages, cold meats, salads, wines, beer and hot coffee. Elsewhere, the jewels are flickering in guttering candlelight, the nodding plumes of osprey and birds of paradise creating an Edwardian barnyard. Only the French would do something on this scale with such dedicated attention to detail. It is a scene that was painted by Guernotte, Beraud, Tissot, Sargent, Boldini.

Another phase of the evening over, the new arrivals are being announced: mostly young, the *jeunes filles en fleurs* add a fillip. A gargantuan buffet appears. An orchestra plays waltzes, gipsies dance, sing and play guitars. The guests dance formally, or survey the more extraordinary sights. It is five o'clock in the morning, and the activity continues unabated. The entertainment may not have been entirely Proustian in atmosphere, yet the host and hostess produced an evening of beauty, worthy of being described by the honoured absentee.

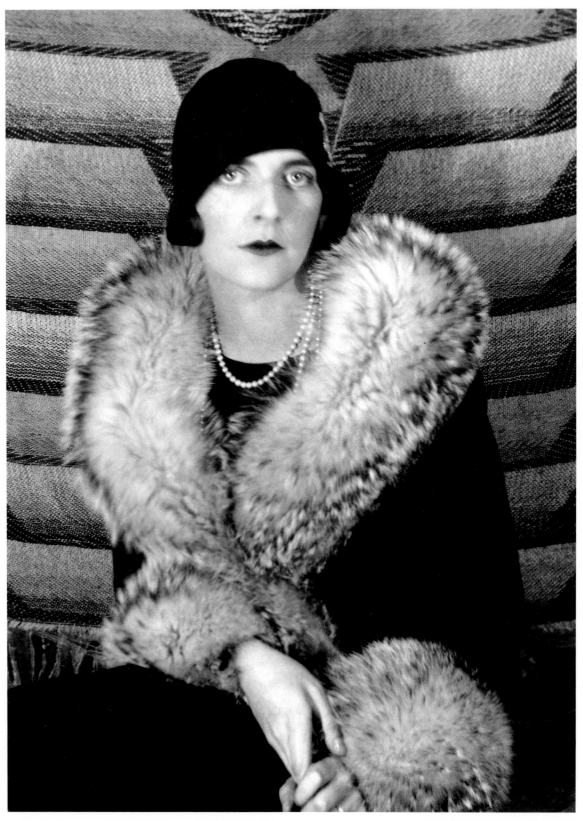

Lady Louis Mountbatten, 1928

Debutantes of 1928. A behind-the-scenes glimpse of the photograph opposite: the debutantes are (*left to right*) The Hon. Georgiana Curzon, Miss Nancy Beaton, Lady Anne Wellesley and Miss Deidre Hart-Davis. In attendance (*this page, left to right*), Viscountess Curzon, Piggie, Beckie, Marchioness Douro, Mr Guppy, Miss Stevens, Mr Cecil Beaton, Nanny (*up ladder*)

'One of the season's glorious crop of debutantes is the exquisite little Lady Anne Wellesley, who has the perfect complexion and the neatest little legs and feet in the world'

'Sir Gerald du Maurier's eldest daughter Angela is a very charming person, seldom to be seen at parties for the simple reason that she does not enjoy them'

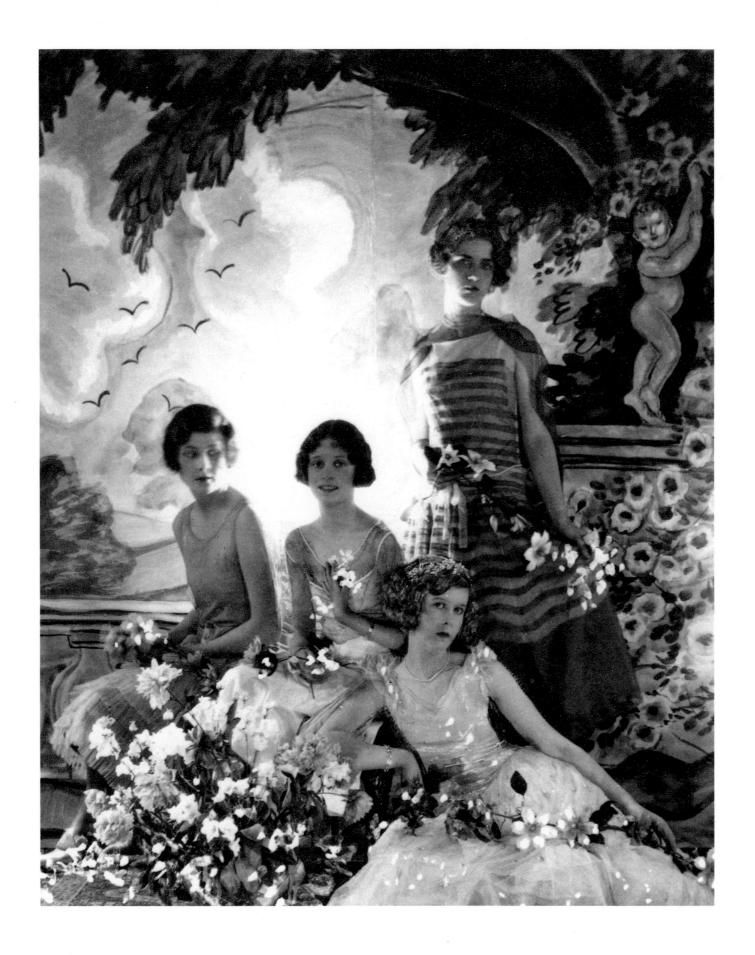

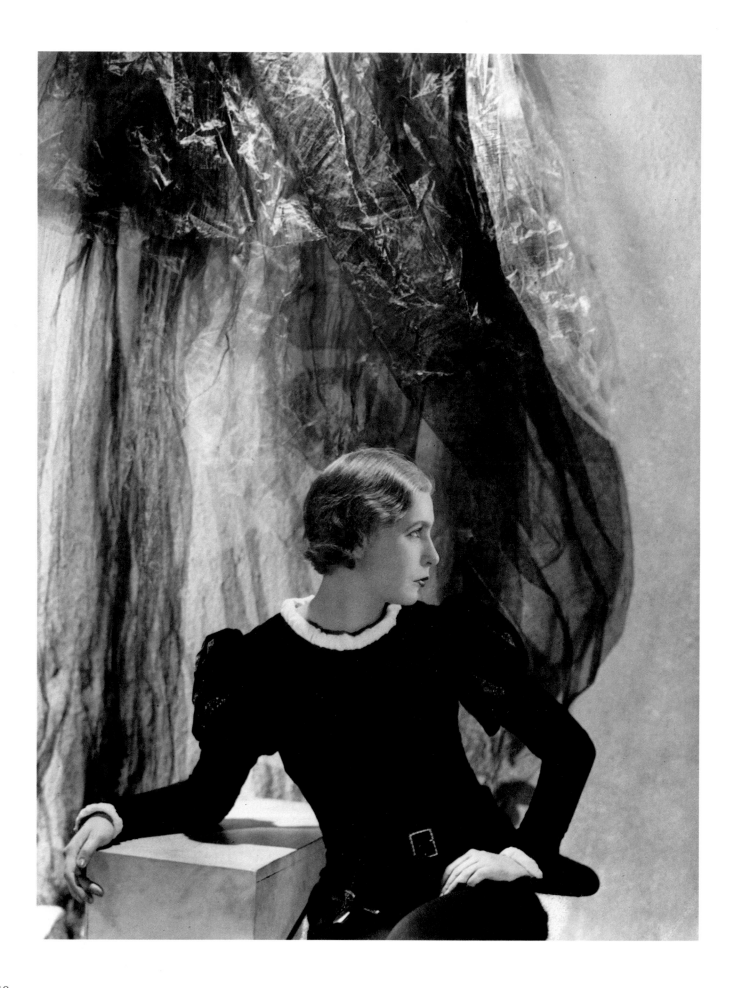

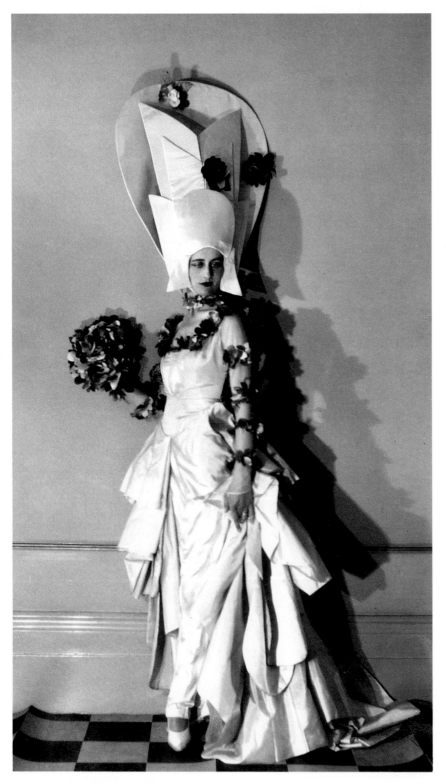

The Fun of Dressing-Up. Lady Abdy as Hamlet, 1929 (*left*); The Hon. Mrs Inigo Freeman-Thomas in fancy dress, 1929 (*above*); Beaton design for a Surrealist costume, 1937 (*top right*); The Hon. David Herbert as Lord Camoys, 1933 (*above right*); Miss Nancy Beaton in eight-yard-long 'train-de-luxe' at the Catalan Ball, 1929 (*below*)

Portraits in Passing. Cecil Beaton portrays 'that little group of the celebrated and the chic in whom all the world is interested'

'Miss Nancy Cunard lately came to London to buy more barbaric bracelets', 1929

'Miss Jennie Dolly seen at the high table at Le Touquet, harnessed in the most amazing sets of diamonds, emeralds and turquoise', 1928

'Mrs Oswald Birley being painted by her sister-in-law, Olive Snell', 1929 (*below*)

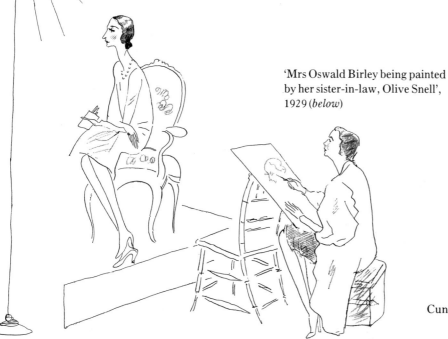

'A pink gardenia was Lady Cunard's choice of flower for her beige coat', 1927

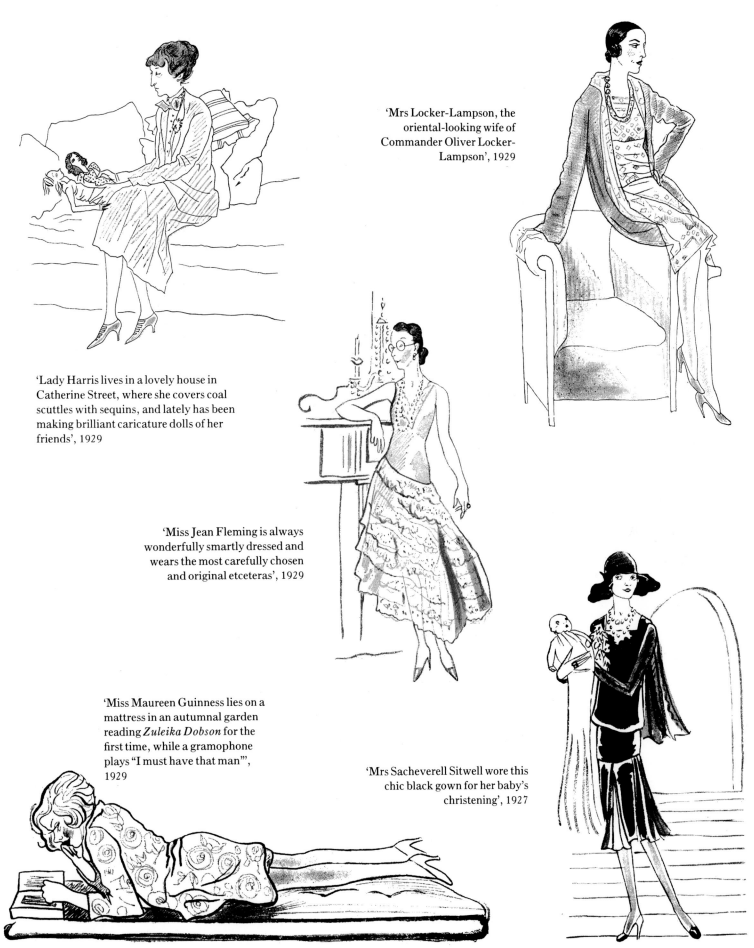

'Mrs Locker-Lampson, the oriental-looking wife of Commander Oliver Locker-Lampson', 1929

'Lady Harris lives in a lovely house in Catherine Street, where she covers coal scuttles with sequins, and lately has been making brilliant caricature dolls of her friends', 1929

'Miss Jean Fleming is always wonderfully smartly dressed and wears the most carefully chosen and original etceteras', 1929

'Miss Maureen Guinness lies on a mattress in an autumnal garden reading *Zuleika Dobson* for the first time, while a gramophone plays "I must have that man"', 1929

'Mrs Sacheverell Sitwell wore this chic black gown for her baby's christening', 1927

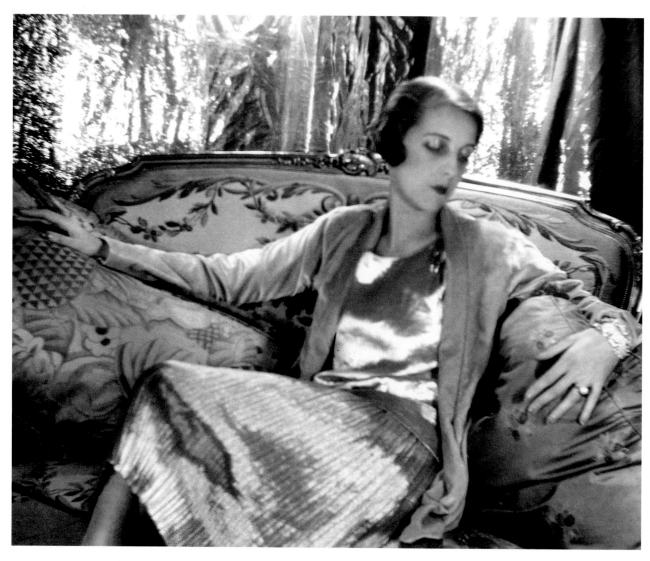

The Marquise de Casa-Maury, formerly Miss Paula Gellibrand, 'the first living Modigliani I ever saw', wearing a Worth model of supple gold lamé, 1928

The interior decorator Elsie de Wolfe, best known as Lady Mendl, 1935

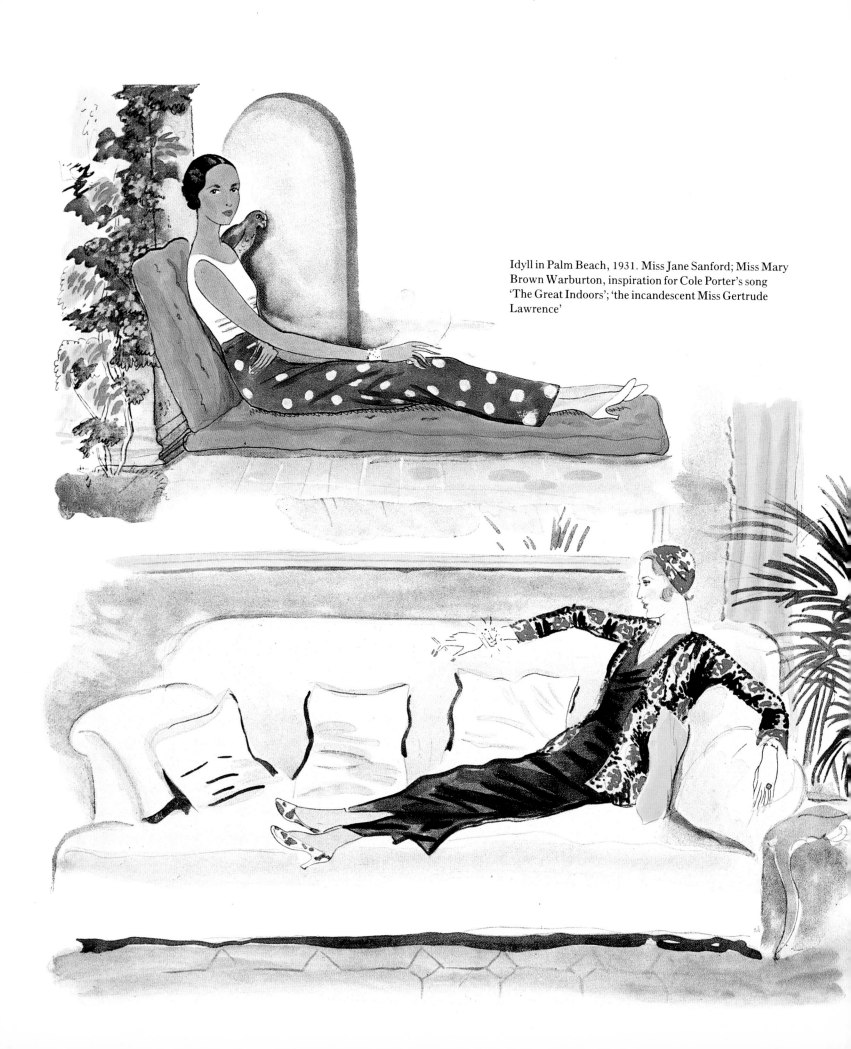

Idyll in Palm Beach, 1931. Miss Jane Sanford; Miss Mary Brown Warburton, inspiration for Cole Porter's song 'The Great Indoors'; 'the incandescent Miss Gertrude Lawrence'

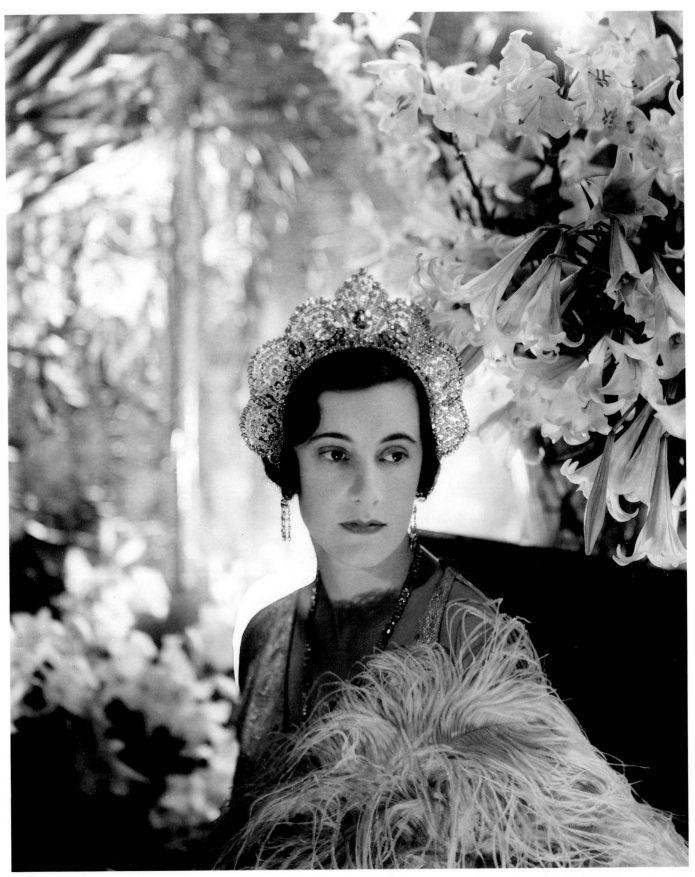

The Duchess of Westminster, formerly Miss Loelia Ponsonby, 1931

Mr and Mrs Harrison Williams in their Palm
Beach house, 'one of the loveliest in the
world', 1937

49

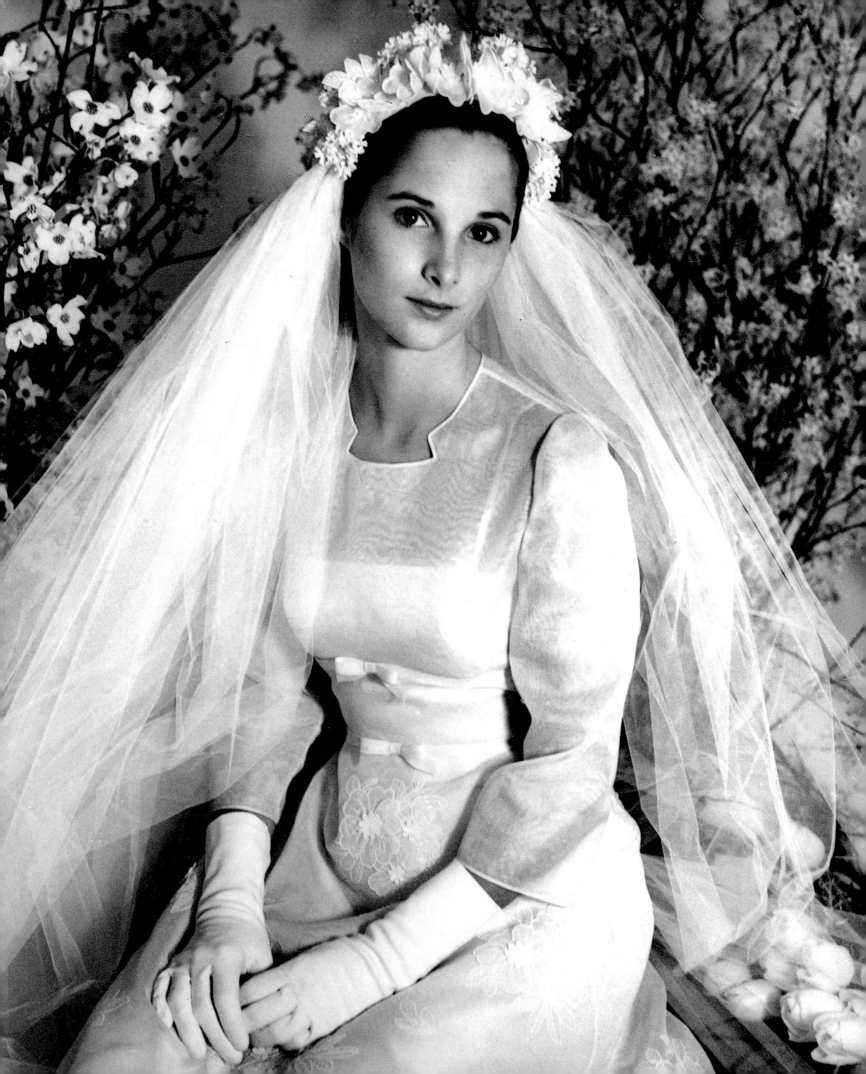

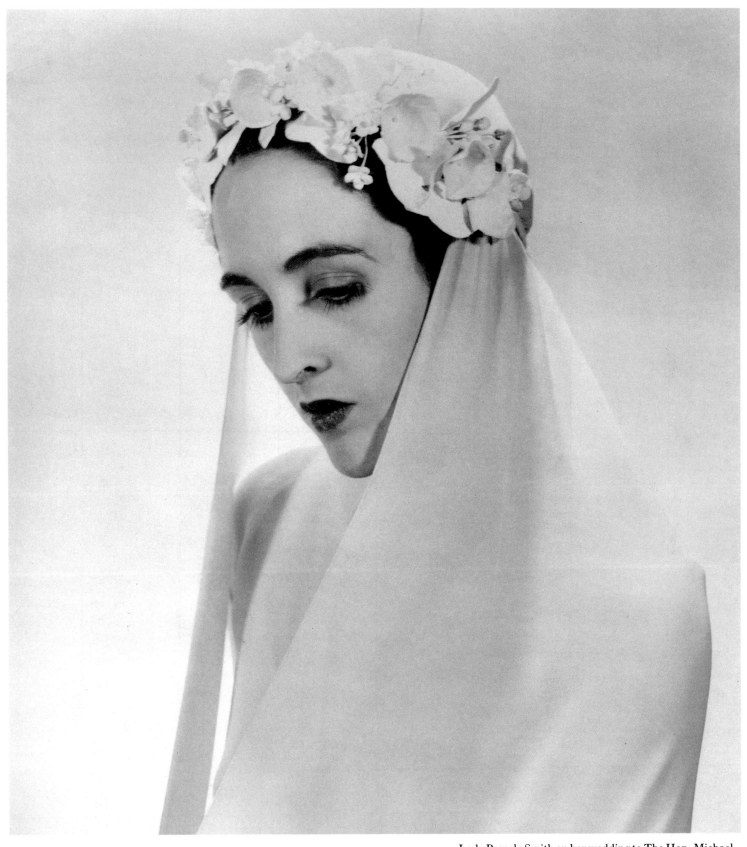

Lady Pamela Smith on her wedding to The Hon. Michael
Berry. As Lady Hartwell, she became a celebrated political
hostess

Miss Amanda Jay Mortimer, the bride of Mr
Shirley Carter Burden Junior, 1964

Overleaf: 'The dark flower, Princess Karam Kapurthala
asleep', 1934 (*left*); Mrs Harrison Williams, 1936 (*right*)

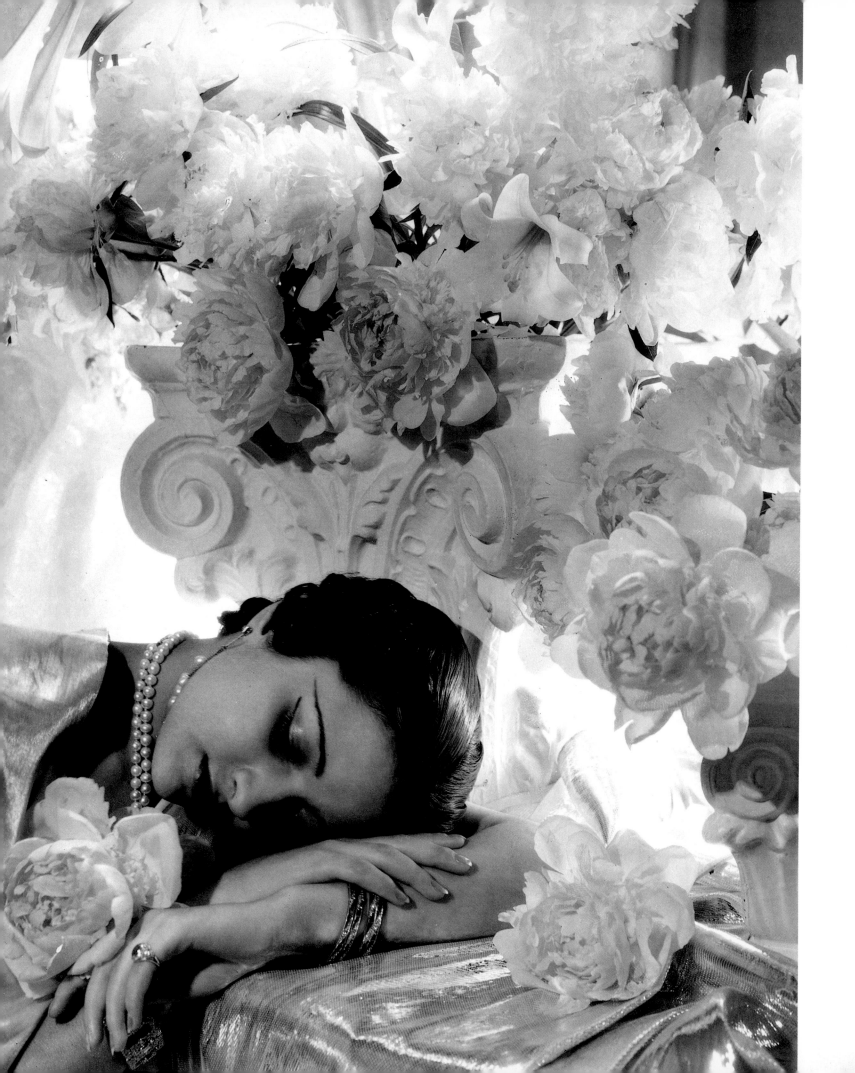

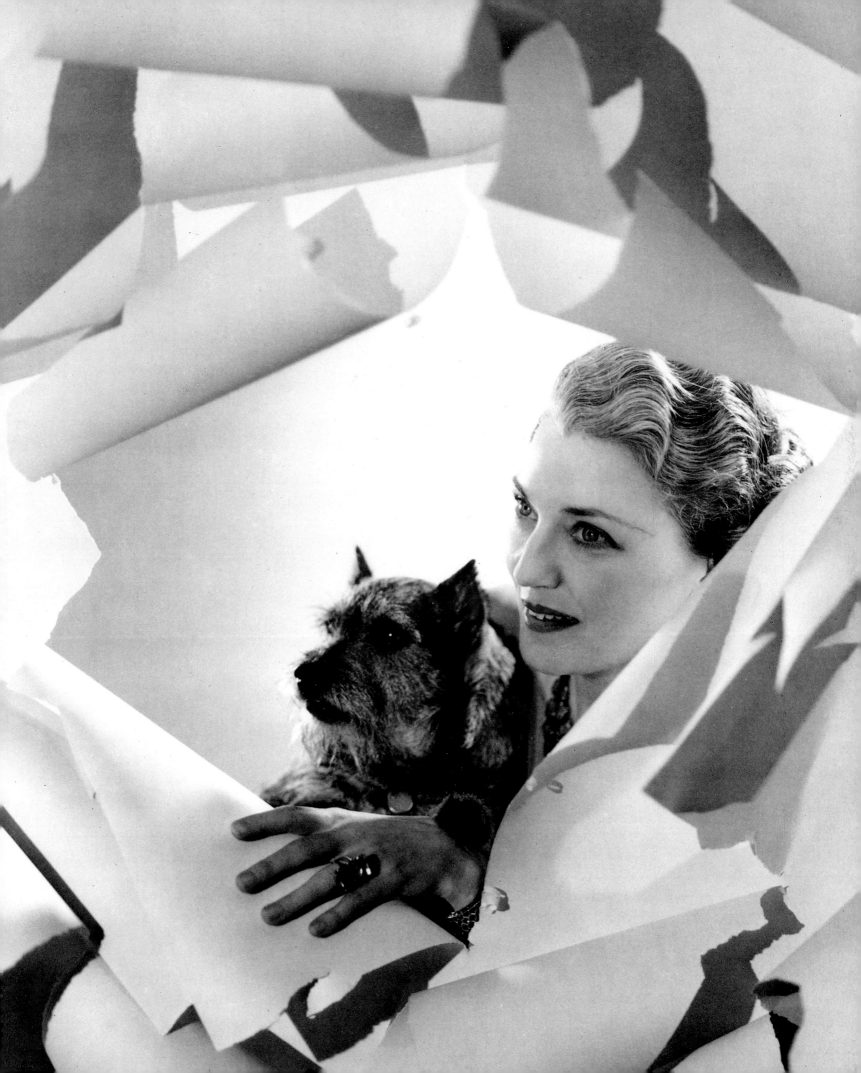

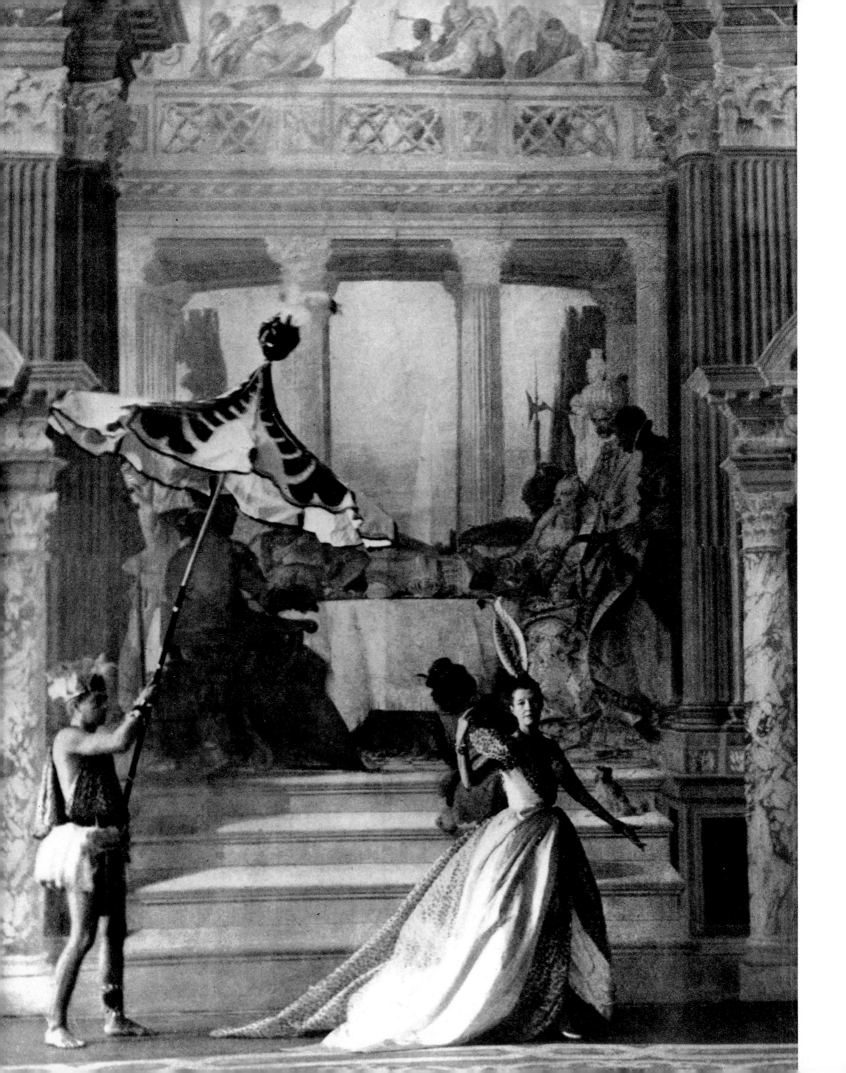

The Venice Ball, 1951. 'A scene such as Guardi might have painted' – M. de Beistegui's eighteenth-century ball, held in the Palazzo Labia. Mrs Reginald Fellowes as America, with a headdress of lyre-bird plumes, and leopardskin sleeves and train, with Tiepolo's *Banquet of Cleopatra* fresco in the background (*left*); Mrs Arturo Lopez, rehearsing for the most spectacular entrée of the ball (*below*)

The Guy de Rothschilds' Proust Ball at Ferrières, 1971. Marisa Berenson, Schiaparelli's granddaughter, as the Marchesa Casati, 'a butterfly glittering on a fountain of feathers and a bright red wig, flour-white face with black-rimmed eyes and scarlet lips'

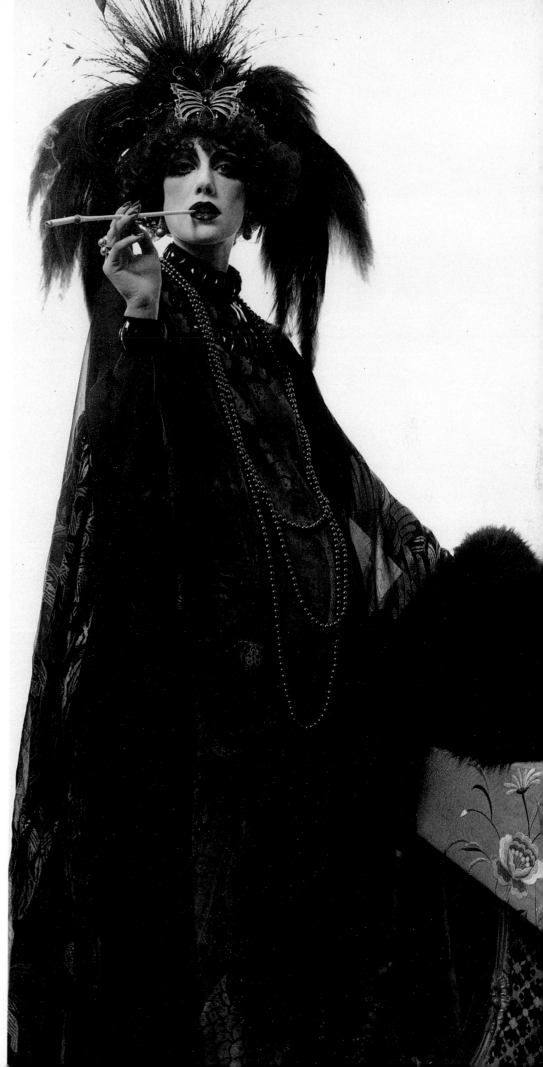

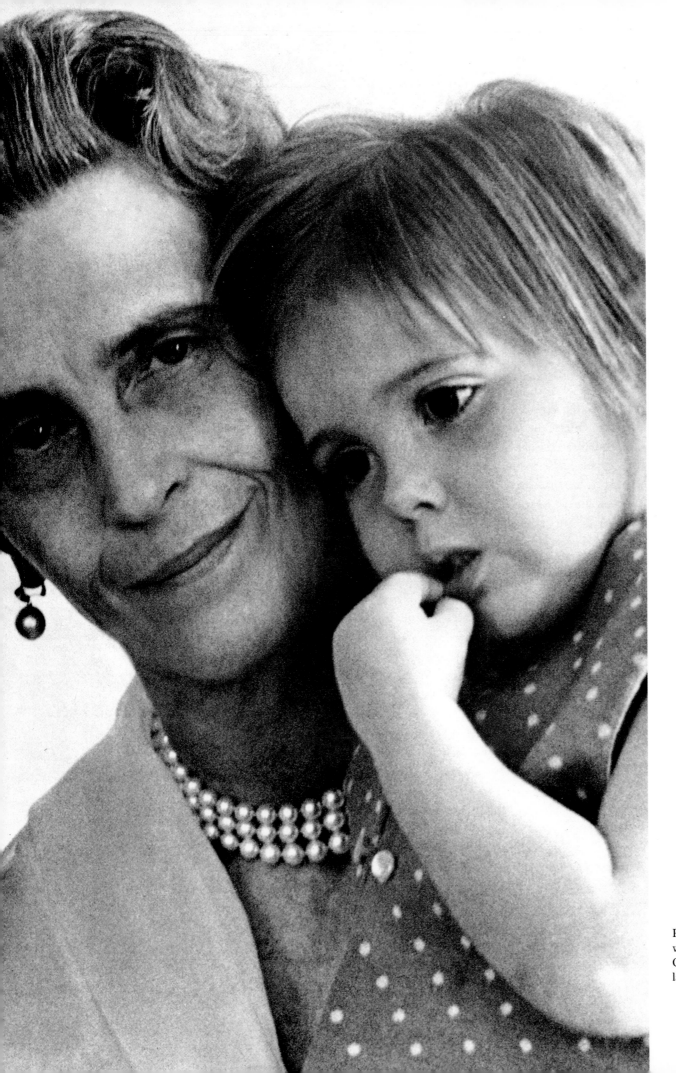

Princess Paul of Yugoslavia
with her granddaughter,
Catherine Oxenberg (the
later star of *Dynasty*), 1966

2 · Beaton at War

'Mrs Gilbert Russell files
evacuees', 1940

The Scars of London
(1941)

THE LUFTWAFFE has an eye for good architecture. The number of ancient and beautiful buildings destroyed in London is astonishingly high. There seems to have been an especial desire to obliterate the plans of the great architects, Wren, Nash and Gibbs, to shatter the carvings of Grinling Gibbons, the painted ceilings of Sir James Thornhill, the sculptures of Roubillac and the work of countless anonymous, but nonetheless exquisite craftsmen of the seventeenth century.

Ten Wren churches went in one night; the Jacobean Charterhouse and the fabulous roof of Westminster Hall have been burned. St Paul's has suffered, and St Bride's Church in Fleet Street is now gutted. The Bow bells of St Mary le Bow and the orange and lemon bells of St Clement's have crashed to silence, and the lovely oasis that was the Temple is now a modern Pompeii. Middle Temple Hall, where the man Shakespeare performed *Twelfth Night* to Queen Elizabeth, is now a piteous sight.

Dickens' world of chop-houses and bookshops around Ave Maria Lane and Paternoster Row is lost to us. The graceful arcs of the Regency crescents in Regent's Park have been broken. Even such obscure targets as Hogarth's House at Chiswick, the Observatory at Greenwich, and the little Chelsea church where Henry James was buried have been singled out.

This vandal desecration has only renewed in each heart a devotion to England. We now know the dangers of a trespassing enemy, and these ordeals have given birth to a stubborn resistance that adds to our strength.

However frightening the aerial bombardment may be at the time, it is less difficult to endure than the contemplation of it. As the planes hover above – a drone of deathly bees in our highly trained ears – most of us feel that it is our own home that is being singled out as the next target. With a noise of a sheet being ripped from end to end, a bomb tears through the night sky, and the ARP workers are heard running in the direction of the all too well-known 'crunch' that follows. Walls shudder and sway. Windows have been blasted, and all the burglar-alarms are ringing heedlessly down the street. The atmosphere is peppery with smoke. In a heat-quivering glow, sparks are eddying, hoses play, instructions are shouted, and there is ever to be heard the tinkle and grinding of glass.

In the half-light of dawn, when the chaos has subsided, the spectacle before you is something you will never forget. For months to come you will think continuously about this nightmare. Each time you ride in a taxi or bus, you peer with gruesome interest and heavy heart at these sickening Forum-like ruins.

Sometimes quite remarkably spectacular Piranesi effects of ruin are achieved, but it is heartrending to potter among this frightful desolation, unrecognizably squalid in its covering of colourless dust, exuding its horrible smells of charred wood and the sickly,

deathly damp smell of cement and brick dust. The poignant trivialities of domesticity revealed to the public gaze are an all too familiar sight. The private houses, with the fronts cut off, look like dolls' houses, with pictures still hanging on the walls of the stairless staircase. It shocks one to find houses that one knew, where one talked with friends late into the night, danced, or was brought up in from childhood, with their innards gaping to the street below.

Many familiar London glimpses have gone: the exquisite Fountain Court in Dean's Yard; the brightly coloured scene, like something from a toy theatre, of Paillard's, the hairdresser's in Curzon Street, with its turquoise painted façade. Among the debris, the waxen heads of painted ladies, their Grecian curls straightened by the bomb blast, lay staring ghoulishly.

But there are signs among the debris that the Phoenix will rise again. Amid the mounds of rubble of the Temple the postman still collects at the scarlet letter-box. The baroque statue of Lady Grace Pierrepont has never looked more beautiful as she prays fervently in the shell of St Anne's Church, her voluminous draperies now sprinkled with silver from the molten roof. Among the charred remains of the Master's House, the blossom trees, the roses, and the honeysuckle are all in flower again. The little angel still trumpets triumphantly through the shattered roof of St James's, Piccadilly, heartening us to face with resolve any disasters the winter may bring, together with the confidence that not only can we 'take it', but we can fight back.

Modern Times (1944)

JUST AS ONE FORGETS relative stages of ill-health, we forget how we have felt at different times during the last years. Let us try to look at the transient things of these days, and at life in England in the fifth year of this war.

As soon as the 'patching' of the big cities begins, shall we forget the beautiful vistas created in some of the most crowded areas by the demolition squads who so quickly tidied away the bomb wreckage? Perhaps some unexpected snapshot will remind us of those glimpses, reminiscent of Venice, of water repositories among the shopping arcades. Who, once the rebuilding of the crowded centres begins, will remember that in 1943 the roar and rumble of Oxford Street buses mingled with the gentler sounds of hens and ducks from the farm in Berners Street, or that pigs slept peacefully in enclosures improvised among those bomb ruins?

Do we realize the shabbiness our towns have acquired during the four years in which no building has been repainted? Do we notice that the shop-windows are boarded, save for a small square of glass displaying a poverty of wares that no longer strikes us as curious or depressing? Accustomed to ever-increasing poverty, we look back to the past year always as a period of comparative richness. We can hardly believe those days were so recent when the customer was always right, or when, without fear of a stinging retort, we went confidently into a shop to buy a box of matches, a roll of photographic film, or a bottle of soda-water. As Vic Oliver asks, 'Do you remember razor-blades?'

If we have much to be proud of, let us be permitted to grumble at the little things. One day, shall we look back with tolerance upon wartime manners, which are so bad that old ladies write to *The Times* to say they have been offered a seat in a crowded train or bus? Shall we remember how the standard of honesty in small things declined

'Mrs Sacheverell Sitwell and Mrs Peter Rodd [Nancy Mitford] listen to the news', 1940

so that gloves, umbrellas and rationed articles seldom found their way to the Lost Property Office?

Shall we remember the tyranny of taxi-drivers? I have never been one to sentimentalize in BBC fashion about the London cabby. The forlorn cries of 'Taxi!' have become as much part of wartime existence as the droning of airplanes above.

Shall we remember the strange metamorphosis of Piccadilly Circus? How in the long twilights of 'double summer' evenings, the one-time glittering centre of the metropolis came to resemble a sort of Arab market-place, with American soldiers (who in the Middle West spend their evenings watching the life of their home town) here lolling or squatting along the walls, on the sandbags, or cross-armed, quizzing the passing pageant of Piccadilly, which by their presence acquires a cosier, more intimate, village-like atmosphere.

Shall we remember that nine o'clock at night was considered a sacred time, when everyone stopped, as for the muezzin in Mohammedan countries, for the evening news? Many people consider it an offence if you should telephone at the hour of the bulletins. As you walk down the street at news time, the same voice bellows though all the windows, telling in stilted terms of the tremendous happenings in the world.

In London, every language is spoken. Hampstead has become a refugee colony. Many Mayfair districts are now entirely Americanized. On the doorsteps of Green Street mansions, there are dustbins and 'trash cans' hung upon the railings for what was called rubbish but is now known as 'Salvage'. Parts of Victoria have been annexed by Poland. Which of these things are here to stay? Which will be the first to be forgotten?

There is much to rile us; nevertheless, in the fifth year of war we have everything to be thankful for. Lord Woolton has done a fine job, and the topic of food has given everyone something to discuss. People in general have become more friendly and, even in the big towns, more neighbourly, due to transport difficulties and black-out.

Many people have appreciated their homes as never before. Many people have more time for reading. And perhaps never again in our history shall we see our towns cloaked in such beauty as now, when lit solely by the becoming light of the moon.

By this veiling of blue and silver mystery all buildings acquire an added beauty; even Burlington House resembles a Venetian palace. Walking home at night through the deserted parks we can imagine ourselves tramping through the forest of Arden. By moonlight these parks are the unchanged primitive forest of Britain, and only the barrage balloon, like a blister pearl in the starlit sky, is there to remind us of the epoch in which we live.

RAF Impressions (1941)

FOREIGNERS and strangers are often baffled by an apparent lack of feeling in the English. They say, rather angrily maybe, that perhaps we don't feel anything really deeply. A casual visitor to an RAF Station would certainly get that impression from the light-hearted way in which the war itself is dismissed: the manner in which being 'bumped off' is only mentioned in the most flippant spirit – and the way the men never again refer to someone once he has been presumed lost. There is an unwritten law that considers it 'letting down the side' to display emotion. But the feeling is there.

To all these men, for the time being, the aerodrome is the orbit of their world. In the evenings they divide into groups of four or five; to drink a mug of beer at the local pub,

or to go to the movies, where they acquire a few additions to their rather naive repertoire of American slang. In the Officers' Mess, the men on whom civilization so largely depends are like serious but eager schoolboys – all trying to learn more about their jobs, exchanging technical experiences, poring over aeronautical magazines of a highly scientific nature, or the newest inventions shown in the *Illustrated London News*, and talking the most exciting 'shop' in the world.

I remember as a child being haunted by the hysteria in the last war: the macabre recruiting scenes, the fanfares of trumpets and the drums that heated the blood, and the military marches calculated to bring about wild deeds of bravery. Such dashing feats of devil-may-care gallantry as may have been applauded then, seem out of tune in this war, so much more serious in atmosphere and sinister in import. There is plenty of enthusiasm, unbounded confidence, but the hysteria is left to the other side. The new type of hero is one whose bravery needs no aids.

England under fire is still an England of understatement. Particularly silent is the scene in that hub of activity, the Operations Room at the Air Station, in spite of the batteries of telephones through which come information, orders and enquiries to the Controller, where the cypher messages from aircraft on patrol are received, and maybe word is had of a German convoy creeping past the coastline. For stark drama nothing compares with the tranquil scene in the Control Room, where the radio messages come through from fighters in action. So that the enemy shall not locate their aircraft, the bombers rarely send these messages on the outward journey, but it is often possible to hear the fighter pilots talking from their radio sets to one another. 'Look out on your right', you hear them say. 'What's that to the left?' Always it produces a shiver down the spine and a dryness in the mouth of those that hear the cry 'Tally Ho!' as the fighters dive to engage the enemy.

It is not always easy to hear clearly, and therefore messages are sometimes repeated. 'Raid successful, raid successful – plane losing height over Alps, plane losing height over Alps. Love and kisses, love and kisses.' Or the heart must stop when the 'ears' hear, 'Bombs released on target. Baling out now, over sea. Good morning, brother.'

With the dawn the bombers return. The long vigil is over and anxiety is shaken off as a nightmare on awakening. At a large table covered with maps, the Senior Intelligence Officer sits in the Interrogation Room. The crews with hair awry, chins stubbly, peel off layers of gloves and pull at a cigarette as they enter. Their eyes are wild, but, at least, they can relax. Still in their 'hot suits' and 'Mae Wests', gulping at large cups of tea, wolfing sandwiches, the young warriors relate in team their adventures with surprising relish. They are highly keyed, all restraint spent, after the hours of blind blackness, of being buffeted by hostile vibrations in their cramped metal confines.

Someone asked one of these men if on the trips taking eight or ten hours, he was not bored most of the time. The reply was honest. 'You're rather too frightened to be bored.'

We have heard a lot about the team spirit of the Air Force. Without it, the RAF could not fly. The whole Force on land and in the air is bound with a link of unity, from the Station Commander to the ground crews, lying in their bunks near the Dispersal Hut, waiting to welcome back their flight. The fighter pilots, though they fight alone, think as a squadron, linked together in spirit.

'Lord Kinross, a cog in the Air Ministry', 1940

American Eagles (1942)

TWO YEARS AGO, during England's invasion crisis, the first Eagle Squadron of the Royal Air Force was formed. Thousands of young American flyers set out for Canada, went on to Britain. Now there are three Eagle Squadrons, and they don't want to be amalgamated. They are like separate schools.

It is the spirit of adventure that has inspired these young men to join the Eagle Squadron and to come here in search of excitement. They are fighting for the fun of it. When America entered the war they behaved with calm and accepted the fact as a fait accompli, realizing that only an unnecessary wastage would be brought about by their repatriation. They were already on operations here. It would be some time before they would reach that stage in America.

The men come from every section of the States. One pilot-officer, a quiet youth from the West, before the war a truck driver in New York, brought his aircraft back to land with the tail-plane shot away and a seagull in the engine. Another, from Florida, with flashing teeth and a Ronald Colman moustache, admits he likes war: 'I am lucky to have been born twenty years ago so that I now have a war to take part in.' A third, from Alaska, says, 'I know London is dull, that there are no bright lights now, but I am glad I've seen England in serious mood.'

Many of these men only like talking about aeroplanes: their Brewster Buffaloes, Airacobras and Grumman Martlets; parachutes, dinghies. Others talk of world problems and social difficulties that will arise after the war. They like their British Commanding Officers, and work well with them. Their great complaint is lack of action – they want to be in on every big sweep.

The parcels of cigarettes, candies and peanuts which they get from the States are the pivot of their lives on the ground, and a precious link with the old life. Of course, letters from home are a special pleasure, and because many of them come from the same towns and know the same people, they are often read aloud.

They wish to know about English history; they are enthusiastic to see Nelson's Column and the interior of Windsor Castle. They complain a certain amount about England: the climate, the lack of heating and the draughts. They bemoan the monotony of English wartime food, and except for Lady Louis Mountbatten, they do not always admire English women. They cannot tolerate or appreciate the charm of the slowness of England, and they become maddened by the delays on the telephone. Yet in general they take everything as a matter of course, accepting easily our strange ways.

Oddly enough they don't complain about the BBC programmes or the London dance bands. They listen eagerly to Bob Hope, they like 'Elmer's Tune' and 'Daddy, You Wanna Get the Best For Me'. They read a lot, but seldom trash. They like Shakespeare, Dickens, Kipling. And they like, of course, to see American magazines.

The English preference for tea is a long-standing joke. They say that even if a big sweep is on everything stops for tea. The Eagles have caught the tea habit and intend to reintroduce it to America after the war. Their friendliness to all and sundry is genuinely warmhearted. They think for themselves more than most young Englishmen do. They do not accept unchallenged certain orders or pronouncements. But, once it is kindled, their admiration is sincere.

It was found in the diary of one of their number, since killed, that when he returned from a holiday in Somerset he had written, 'I am just as proud fighting for England as for my own country.'

THE VAST STIRLING bombers are dispersed around the perimeter of the airfield, where they wait looking like enormous prehistoric animals. This afternoon, the whole camp is in a state of unusually intense activity.

The engineers have finished their work; an engine has been re-adjusted, a jettison sock repaired and the tall metal frames of scaffolding have been wheeled away. Now the ground crews are finishing the Routine Daily Inspection. A WAAF drives up in a van filled with aero cameras. While an engineer from the photographic department climbs high into the front turret of the aircraft to fix the camera into place, she brings out a small hoop covered with linen – her embroidery. An oil bowser is driven up; its long elephant-trunk hoses are coiled over the wings of the voracious monster bomber. Another WAAF drives up with the oxygen tubes. Then the vast cylinder of the petrol bowser comes alongside.

At the bomb dump some older men, having loaded the pale green bombs on to trolleys, are now washing the black grease from their sunburnt arms in gruel-like water. Along a wall of sandbags young men in blue shirtsleeves are bending over the pear-shaped explosives fixing the tail fins or marking in chalk each missile they have fused so that it can now be levered on to a small railway track and drawn to the bowels of the aircraft for the complicated process of bombing up. The rear gunner has come down to polish and pull the guns through – to see that everything is in order.

In the Operations Room the Flight Commander conducts the briefing to the captains of the bomber crews. 'The target for tonight is Milan. It'll be a heavy and concentrated attack.' Outside the Operations Room the other members of the crews are waiting. Smoking, chewing gum, tapping to the radio dance band, they fill the air with noise and smoke. The captains of the crews are now released, to hand on their information, and suddenly, as at school when all the fags run to the bidding of the prefects, the rush starts for the general Briefing Rooms.

'Milan, that makes a change.' The atmosphere is of tremendous enthusiasm. But at dinner in the Officers' Mess there is not much talk. Occasionally someone makes a joke; it is not taken up, and silence is resumed.

Those who are going on the trip hurry out of the dining-room. Around the perimeter of the airfield the crews are already waiting by their aircraft. They are carefully shaved; each wears a signet ring and an identity bracelet. Some of their uniforms are shiny, and a small strip of leather keeps the edge of the cuffs from fraying. Some of them flaunt enormous mustachios. There is a communal determination to maintain a light gaiety.

Many superstitions run subterraneously throughout the RAF. One is that it brings bad luck to photograph an aircraft or its crew before 'take-off'. This evening the navigator said that he did not want to be photographed. 'I'm superstitious.' The rations are doled out: some 'wakey-wakey' tablets, two bars of chocolate, and each man has provided himself with a picnic thermos of hot coffee. 'Once we had an orange and some raisins – but not nowadays.' The rear gunner is putting on his elaborate equipment: the electrically heated undersuit, brown and quilted; the electrically equipped socks; the leather boiler suit and the parachute. Some of the ground crew rather frantically fumble at the hasps, clasps and straps of his elaborate harness, like dressers behind the scenes helping a quick-change artist. Their hair is blown on end and forage caps fly, for the engines are revving up. The rear gunner runs aboard as nonchalantly as if the aircraft were going off on a joyride.

The sky is darkening; there are clouds, but the evening is still and calm. In the watch tower the Controller and his assistants give the instructions to the line of aircraft for the 'take-off'. In the distance, the Stirlings, herded together, look like a concourse of prehistoric elephants. They bounce along slowly with spluttering noises. Surely it is impossible that such a cumbersome, bulky object should take to the air – yet one of these fierce wasp-like craft trundles angrily along the runway, and gaining more and more speed, at last becomes airborne. In turn each aircraft, said to cost £60,000, heavily laden with bombs, makes a run straight down the tarmac and then mounts slowly into the air. One as it rushes forward swerves unaccountably. The pilot over-corrects; everyone's heart stops as the aircraft jumps off the runway and with a huge bump bangs into the air. Before we have recovered from the shock, another angry insect dashes forward, and then another, until the vast expanse of the sky is dotted with planes circling slowly at the outset of one of the greatest raids of the war.

Everywhere on the air station the mood is tense. Every man on the ground watches silently, filled with a certain feeling of suppressed excitement that is shared by the blithe crews above, but they are nonetheless appalled and revolted by this form of warfare. 'But', each man says, 'who started it? What are you to do if the other chap hands it to you?' We are thankful that in England we have been given the time to produce these thousands of bombers; proud of having built up this tremendous air armada. The evening is filled with the sound of the vast machines. The imagination is filled with the horror that has to be brought on the Italians.

With head and tail lights glowing like rubies and diamonds the aircraft are slowly mounting higher in the darkening sky. London is directly on their course tonight. Londoners will be heartened to hear the roar above – Londoners remember that winter when another such roar brought terror to their hearts. The pilots know it is 'nice to give old London a thrill'. On the air station the roar becomes a hum. The Stirlings have become small caterpillars, almost motionless in the sky.

Before dawn so much will have happened. The crews have gone off convinced of their safety. Yet the Stirling bomber in spite of its tremendous armament is necessarily an easy prey in a clear sky for fighter attack. Only a small percentage of the crew from a bomber that does not return are taken prisoner. So heavy and inflexible an aircraft, when hit, is apt to fall like a stone. It is thanks to cloud cover and the vast size of the skies, that so many have avoided their foes.

Already the great dramas of the night have been enacted. In the Watch Room the brightly glowing desks commanding the airfield are buzzing with signs and flickering with toy lights. Already in the distance the hum of the returning planes can be heard. Contact has been made with the pilots over the RT. The Controller taps the desks impatiently, his fingers quiver – he chain smokes. He has in his keeping the crews and aircraft that already are circling and asking permission to land. He must not make a mistake.

The circling lights come into position in the sky to swoop down to their base along the tarmac. One after another the impersonal lights of the flying machine, and its crew of seven human lives, circle in the black sky, then dive obediently to earth.

Meanwhile the first crews to return are already back in the Briefing Room. Chins are a bit stubblier, hair awry, but they come back smiling from the night's ordeal as if from a jaunt to the next village. During these hours they have seen combat, some of their number have been brought down in flames, they have seen Italian towns burning.

They tell their stories, clutching thick china mugs of sweet, syrupy tea. A sergeant sitting on a table says as he scratches his scalp, 'The Alps looked lovely. Brown and white, in the moonlight. But', he continues, 'it's a hell of a way to go. I hope it's the end of Italy.'

The sky is streaked with the light of the new day as the crews go off to the reward of their wonderful egg and bacon breakfast. They discuss the night's achievement in technical terms – quietly – rather bored, or just tired. 'Well now, might as well go to bed,' says the Controller. His job is done. He has done it well. But no one receives congratulations.

The doors swing to and fro as the crews lumber off. These strange, tough, rarefied creatures, whose work is done at night, these youths in slate-grey uniform, make their way back to bed just as others are starting their day's work at the camp.

Already the news is spread – through a Zurich report.

'Milan bombed. Mass demonstrations for peace.'

CAIRO, TEHERAN, Baghdad, Palmyra, Baalbec: these are some of the places I visited during the last three months. It sounds like some magic carpet tour, or pre-war millionaire's holiday. But no, I was sent by the Government to collect certain records and to take war photographs. During the trips I wrote notes in diary form. Here are some extracts . . .

Somewhere in the North of England. We were taken out in a launch to what seemed, in the pearly Whistlerian haze of the first spring day, to be a craggy theatrical-looking coastline, with pointed white precipices surmounted by a fairytale castle. This proved to be the vast camouflaged warship that was to be our home for the next weeks at sea.

Once on board the element of time ceases to exist; the days fade into one another. A submarine is sighted, depth charges dropped; a conning tower sighted for a moment; it is possible that the U-boat, badly shaken, may have got to its base. . . . The ship's company now appear in tropical white kit. Flying fish are seen. The presence of an enemy cruiser is reported – a destroyer leaves the convoy in pursuit – our course is altered again – false alarm.

The convoy manoeuvres into position for entry into harbour. Land! and covered with thick lush tropical vegetation. Natives, incredibly black, come alongside in spearlike canoes, to sell – of all magic things – bananas.

Ashore. The women, carrying mountains on their turbaned heads, walk with downcast eyes, and the dignity of queens. The audacity of their clothes is something even Paris could never attempt. Colours are blended with intuitive artistry: dark liver colour, forget-me-not blue, indigo, crimson, black and lemon yellow are chosen for their draperies, printed in Manchester with designs of cricket bats, Red Cross ambulances, parachutists, winged hearts or sewing machines. The English wear dark glasses and solar topees.

We fly over the coast. From this height the tropical trees are like a carpet of Irish moss. . . . At the end of the day we sleep for eight hours in the centre of the African Desert.

Tobruk. We pitched camp in a Wadi near the sea – almost an oasis, with fig trees, flowering cacti, wild flowers and wonderful birds. The gunfire like thunderstorms.

El Hacheim. Don't mind dirt or discomfort. Am only sorry to leave forward areas.

Official Photographer (1942)

65

Have little appetite for Cairo or Alexandria now, but that is where much of my work is to be done.

Alexandria. As we sailed past Admiral Vian's flagship we saw General Smuts in a topee, waving a baton and haranguing the sailors lined up in spotless white. A grand old man who always does more than is asked of him. This speech was unexpected and impromptu. The men tremendously heartened and thrilled.

Iraq to Iran. Horrible mountains to fly over, especially when the heat pockets bang you about. At last we landed – Teheran. Rows of American bombers were lined up. The American white star to be painted red, then the aircraft are flown over by Russian pilots to Kuibishev.

Transjordania. As the evening sun was sinking and casting long blue shadows on the desert scene, we came across another car. Colonel Glubb, in a khaki-coloured Tajrifa (headdress) was returning with a colonel and two highly coloured henchmen from the camp a few miles on. Thanks to him, we had a thrilling evening being entertained by the Arab Legion in their scarlet, pink and khaki uniforms – sitting in a circle around a charcoal fire.

Palmyra. In the apricot-coloured evening light the 2,000-year-old colonnades stood out against the blue haze. These ruins have an indestructible grandeur. An Australian soldier followed us out to the ramparts of the Temple of Venus – we surveyed the scene of broken columns, gargantuan slabs of fallen masonry and fragments of carved capitals. 'It's a bloody shambles,' said the Australian, disgusted.

HQ. The RAF are doing as many sorties as ever in the desert, though now they have comparatively few landing grounds. German aircraft are never seen by day, and we have aircraft that dive on tanks, firing a gun as big as a Bofors. When these 'Tankbusters' score a hit the tank is not just damaged: it is obliterated.

En route for Home. We got into a flying boat and took off. Silk-lined walls, arm chairs like Pullmans, compartments for eating, sleeping, smoking – this is the aircraft that took Churchill to America. How much longer the return journey seems – how grateful I am to be among the lucky ones on the last lap for home.

Journey to the Orient (1944)

AT THE OUTSET of my journey to the Far East our airplane crashed in flames, and although, miraculously, all of us escaped alive, our possessions were burned. It was only on returning to London to reequip that I realized clearly, as though for the first time, the difficulties besetting the civilians in England in the fifth winter of 'Total War'.

Doubtless the after-effects of my accident had lowered my morale, but it was a greyer, more austere London that I saw. I became more sensitive to the irritating restrictions, to the delays, the scarcity of transport. I discovered the disappointments of shopping even for what were now essentials.

When I left for the second time and arrived at night above a city of twinkling lights, it was to find oneself as happy as the urchins of the nursery story who looked with ecstasy through the windows at the magic of someone else's Christmas party. To stay in even a third-rate hotel in Lisbon was to enjoy a feeling of luxury that is found nowhere in England today.

One had forgotten the pleasure of merely looking into shop-windows filled with goods that one would like to possess: Swiss watches, German cameras, American silk

stockings, crystallized apricots, and nougats. Accustomed to rationing, one had for-gotten that it is neither eccentric nor gluttonous to peel a pear, a couple of tangerines and to skin a banana in addition to eating a handful of raisins and walnuts. Avid as is one's greed, one feels acutely conscious of others at home being denied these treats.

Soon one realized that even Lisbon is not unaffected by the war. Since the Azores Agreement every windowpane is trellised with strips of paper. Though the paper is too thin to be much protection should a bomb fall, the effect appears rustic and strange. The automobiles with their aluminium and silver work coated in blue paint are part of the elaborate 'black-out' exercise. Petrol is limited, and the fuel shortage necessitates the cutting down of electricity, though this does not prevent the cafés remaining open until dawn. Many changes have taken place in Lisbon during the last year. Only a few stragglers linger in front of the Nazi Propaganda Bureau windows. Portugal is now 100 per cent pro-Ally.

Wartime Lisbon, its windowpanes trellised with paper, 1944

After a night spent herded together in the small, dark confines of the aircraft, a comforting strip of blue light appeared gradually between the curtains. Dawn was breaking, and from a distance the Rock of Gibraltar looked ephemeral in the blue transparency. But as we dived in circles and skimmed along the ledges of houses built in the Rock, this impression faded. The rain poured in torrents.

This outpost of Empire on the tip of Spain – by nature, created of such formidable aspect – is made by British might even more defiant: with guns everywhere, the sea littered with the great ships of the British Navy coming and going without interfer-ence, despite the impossibility of keeping secret their movements, and the new air-drome and runway built out into the sea with rows of aircraft challenging air-attack. Inside the Rock itself preparations have been completed for any further siege of Gibraltar. There are bunks for fifteen thousand people along the honeycombing of corridors; there are enormous workshops, and a 'Harley Street' blasted in the dry rock. On top of the Rock, even at this time of the year, palm and eucalyptus were growing, and the steep banks were white with narcissus; hawks circled and rare birds darted about among the Rock-apes whose presence here is said to last as long as the British remain.

Gibraltar at night, with each café chantant overflowing into the already jammed main street, is an amazing hotch-potch of male humanity. The sailors buy tangerines, souvenir handkerchiefs and 'Gifts From the Rock'. The American Marines wear a variety of hair-cut, jersey or vest, the RAF pilots discuss air-traffic. 'Last week I was at Foggia – what a pasting that place has got!' 'I was in Naples; not much got touched there.' 'What happened to Tuppy when I was in Moscow?'

All women must pass the barrier into Spain by 10 pm, so the Gibraltese women waste no time in performing to their appreciative audiences. They will set about playing a variety of musical instruments, will take the floor for an 'exhibition dance'. The audience roars its pleasure – if at nothing else, at the determination with which the spangled skirts are sent whirling, castanets are clicked, and shining teeth are bared. The atmosphere is dense with smoke. There are many fisticuff fights resulting in general hand-shaking. A notice is pinned up by the piano: 'The audience is requested not to climb on to the stage.' By 10 o'clock the last drunken sailor is being escorted back to his bunk.

Gibraltar is a Clapham Junction for the Allied War leaders, and Government House is hospitable to these world celebrities who are dependent on weather conditions. Here

they may remain stranded for days, their complaints heard in voices well-known over the radio. 'Lord So-and-So went by Liberator, whereas Air Marshal So-and-So, infinitely more vital to the total effort, returned by Dakota . . . '

We flew over those parts of the desert in which the last phase of fighting had taken place. We skimmed a few hundred feet above the petrified sea where the tracks of tanks in battle have left an abiding wake. The slit trenches, now abandoned, looked like small liquorice lozenges in the sand. There were skeletons of burnt-out aircraft, tanks and lorries by the score. In England we are apt to be unduly modest and to say we have not touched the German Army in this war, but flying over this desert one realizes the magnitude of the German Army's retreat.

Rain is rare in Cairo, yet in Cairo the rain poured. No preparation is made for rainfall. The streets were flooded with tomato soup, and the Cairenes in their soaked robes were mud-splashed. At the eleventh hour the electricians were unable to fight further with damp fuses, wires and flooded lawns, and Lady Killearn's Gigantic Charity Ball must be postponed.

Cairo, rather than possessing a more jubilant atmosphere since the great victories in the desert, has become more austere than at the time of El Alamein. A 'dim-out' is preserved. Streets are empty soon after 10 o'clock, even the best hotels are without hot water at a time when most people need it. Any small bedroom is made into a dormitory, every attic overcrowded.

The young men who have spent the last year fighting many strange forms of warfare are, despite all difficulties, determined to give a party. So there are parties every night. It is surprising, at first, to see wired crimson roses stretching the length of a Shepheard's Hotel dining-table. But the attempt at curtailing the profiteering in restaurants by levelling the prices of all meals has merely been to lower generally the standard of the cuisine.

Palestine was grey and cloudy; at Basra the wind blew. When we reached Bahrein, where the pearls come from, we felt we had escaped the rigours of winter. But it was only, at last, in Udaipur that we discovered the early morning sun. It shone opalescently on the white palaces bordering the sacred lake of Raj Sammand. Later that day when we flew over Delhi the midday heat caused everything below to quiver, and it revealed the grandiose architectural schemes in unflattering plasticine colours.

We had heard about the overcrowding here as comparable to that of Washington; about all the tents that could not be put up fast enough for the ever-increasing hordes of arrivals of American and English. We had heard that even Delhi, so stigmatized by the stream of feminine war strategists, was at last geared to serious conditions. When we landed at the Capitol I rejoiced to find my friend Major Coats, the Comptroller, with a welcome to Viceroy's House.

At Viceroy's House (1944)

SOME GLIB CRITICISM has been heard about the state in which Viceroy's House is said to be maintained in New Delhi. It has also been suggested that a certain amount of 'panache' is necessary in view of the Indian's love of 'Bhari Tamasha' (meaning 'grand display'). However, having just spent a fortnight living in the vast domain, which is rather a city within a city, I am impressed above all by the style and economy with which the great household conforms to war-time standards.

At first I was immensely impressed, arriving from England in the depths of the fifth war winter, by the sun, glitter and colour; so many flowers – so many servants. Outside, the fountains played, and cascades of stocks, carnations and petunias hung over the pools. Servants of different categories in scarlet, white and gold liveries stood like poppies behind chairs and tables. But soon one realized the 'Bhari Tamasha' was well under control.

In Viceroy's House, 300 servants are employed, but when considering this number it must be realized that there is no man-power problem in India, and that, due to the caste system, different communities are allotted various categories of work and it is impossible for a man to substitute for another; thus six servants are needed to do the work undertaken in England today by one hard-working and aged peeress.

In an effort to alleviate the overcrowding of Delhi, Viceroy's House has taken upon itself to accommodate as large numbers as possible. Major Coats, the Comptroller, sets out to see that all the amenities of Viceroy's House are exploited to the fullest, and that the funds available for entertainment are spent on the greatest number of people. (The problem of where to go for the hard-earned spell of leave is an acute one for the soldier in India.) Five hundred meals are served throughout the month to English, American, Chinese and Indian guests.

In summer, Mr Haslam, the Comptroller's Assistant, must see that damage is checked from 'woolly bears', 'silver fish', crickets and all manner of insects so fond of eating silks, satins and upholstered furniture. During the last twelve months, pigeons have added to his burdens. Since the shooting of them has ceased owing to the Jains (a religious sect) lodging a complaint against the killing, they have increased 50 per cent. Now, confidently inhabiting the circular cornice above the crimson, green and gold draperies of the thrones in the Durbar Hall, they are as much a nuisance in the marble domains as the mongoose, porcupine and stray cattle in the Viceregal Gardens. Certain herdsmen are guilty of driving their cattle into the Mogul Garden for a succulent herbaceous meal.

Since the arrival of Lord Wavell, all ceremonies and formalities have been cut to a minimum, and the Viceroy and his family lead as simple a life as possible in these magnificent surroundings. As King and Prime Minister combined, the Viceroy must work long hours. Each morning he is up before sunrise, and his work continues throughout the day and after dinner until bedtime. Lady Wavell, now prevented by convention from serving behind the counter, still takes administrative interest in the Wavell Canteens which she started throughout India. She accompanies her husband everywhere by air. Already they have visited every province of India.

For relaxation, Lady Wavell enjoys a picnic; not so the Viceroy, who has described these outings as sitting on a nettle and eating a wasp. Whenever engagements make it possible, Lady Wavell, with her daughters and tea baskets, visits the neighbouring sights – relics of the former cities of Delhi, or the tombs of some Mogul Emperor, while Lord Euston, an ADC, reads aloud from a guide book.

The five ADCs are young men who have been wounded and, with excellent war records, have been told now to 'take it easy'. Nevertheless they are kept extremely occupied, each with his particular extra job.

Only on the rarest occasions are the State Rooms now used. Lunch is served in the garden; after dinner (in the Small Dining Room) the family settle down in a room panelled in dark teak to listen to the radio news and read the newspapers and

'Lady Wavell enjoys a picnic', 1944

magazines from home. There are Zoffany portraits on the wall, vases of cornflowers; the atmosphere is as cosy as in the ideal English country house. Conversation is constructive; Lady Wavell makes practical suggestions for the welfare of the troops.

Bed-time is early for all. Tomorrow is another busy, crowded day for the entire household.

Jungle Front (1944)

'DO THEY KNOW we are out here fighting the Japs?' 'What do they think at home about this war?' 'Have they forgotten us entirely?' I was asked these questions continuously by our troops on the Burma Front. It would be hard to admit that these men are neglected, yet it seems strange how little we in England know about this theatre of war. Many of these men, already for three years, have been existing, rather than living, in remote mountain peaks or in fever-ridden jungles; most of them realize they must continue this particularly harrowing, slow and beastly form of warfare long after the victory in the West.

When I visited the forward areas in the Chin Hills, the year was at its best: sun all day, cold at night, the cherry trees in blossom, rhododendrons ablaze, and soon there would be orchids. The vast tropical trees would be transformed by these exotic plants, and the troops would pick the blooms and put them in their large-brimmed hats.

Yet even under ideal conditions, I was aware of the almost insuperable difficulties that have to be overcome or endured by all undertaking this tough job of jungle war: consisting of silent treks, by day, through the coarse undergrowth, or by night, a terrifying game of 'Blind Man's Buff', creeping along with the possibility of at any minute 'coming to grips' with knives. The treks are lonely – at most the men go out in twos and threes and are without the additional strength and reassurance of feeling they are fighting in numbers. The highest degree of courage is called for on the part of each individual. It is a strain to be continuously listening for the sound of a footfall, the crack of bamboo: and even during their sleep, most men are lying with one ear alert.

On the peak of some remote mountain in Burma, I found that the British gifts of improvisation had been fully exploited. Typewriters were buzzing and the most elaborate systems of telephone and wireless were installed at HQ, but living conditions were almost savage. At night the men slept in fox holes dug into the peat-like earth.

With minimum means maximum effect was achieved. Although only a small mug of warm water was available for washing, everyone was immaculately shaved, shoes polished, buttons brilliantly shining in the pristine sun: there was no 'Guerilla' untidiness to be seen, and the romantic bush-hats gave the cavalier touch to every man.

At so remote a location there can be few distractions, no visitors, no entertainment, no ENSA, and very little of extra interest 'to write home about'. When the mails were irregular, some of the men became depressed, and like children, complained of their disappointing Christmas. 'The parcels didn't arrive till later – there were no extra rations – they merely wrapped a piece of pastry around the bully beef,' an elderly man from Merseyside in the Signal Corps told me.

The daily newspaper for the troops, which Frank Owen is editing, reaches the further corners of the line and contains everything the men want to see – War news, items from the Home Front, Nathaniel Gubbins, a pin-up cutie, Quiz and crossword and the popular 'Jane' strip.

Although jungle warfare has its own particular horrors, it has its advantages over desert warfare: there is shade and the rations can be implemented with greater variety. There are roots and growths that are palatable as well as salutary substitutes for fresh vegetables and, occasionally, there is wild game. On the Arakan border, the natives build with great speed basha (huts) of bamboo. These are gold coloured; the complicated texture of the interweavings is delightful and, with bamboo furniture, the messes have the appearance of ultra-fashionable clubs.

Among the paddy rice fields and the more open spaces the fighting has little aspect of modern warfare. The return to importance of cavalry and the mules laden with ammunition bring pictures to the mind of 'Stonewall' Jackson and the Civil War. It is only when one sees the treatment of the wounded that one realizes how conditions have improved. So impressed was the Army Commander by one forward hospital that he made the experiment of showing the troops the elaborate equipment that had been brought on mule-back from 300 miles away, and when they felt the immaculate and reassuring atmosphere, and saw the casualties receiving such careful attention, the unconscious terrors of being wounded were minimized.

Some of the camouflage is elaborate. Faces are 'made-up' with dappled spots of blue and green grease. Tin hats are worn with sprays of tropical leaves threaded through their netting cover. Sikhs appear, as if from a ballet, with their turbans covered with huge woolly tufts of green and blue, and the Gurkhas, patrolling with mobile wireless sets and tall branches like wings on their shoulders, as they lean forward to penetrate the undergrowth, look like a tropical Birnam Wood going to Dunsinane.

Even while fighting, a most primitive form of warfare far from so-called civilization, many of these men are determined to lead the life of cultivated persons. I have spent some agreeable evenings at parties given in a cavern dug in the earth, where a fire blazed and dinner was served as a formal ritual. A small flickering lamp may not encourage reading, but a group of men will remain up late, absorbed in serious discussions that may continue for many nights on end.

I discovered that, degrading as this remote and primitive existence can be, there are compensations and that even warfare can bring a feeling of physical serenity and peace of mind.

Prevailing China (1944)

WITH THE ENEMY in control of over half her important cities, rivers, and railroads; with no access to the sea, and almost entirely cut off from the outside world, it is as impossible for a stranger today to receive from the free territory a true impression of the real China, as it would be unfair for someone wishing to see America to judge the entire country from the confines of the Ozark Mountains of the Middle West.

The life no longer exists that we have visualized from poems and novels, have seen depicted on painted porcelain. There are no Peking picnics, no wealth of peonies from which to choose the one perfect specimen. The prevailing China is reduced to essentials – to the common denominator. More mediaeval than Ming, the sturdy, squat peasant folk in their toil resemble less the chinoiseries of Chippendale than, if such things were possible, pictures by an orientalized Bruegel or Bosch.

The west of China consists of agricultural and mountainous provinces in which transport has always been poor and existence hard. Life in these paddy-fields and small dark villages can have changed little with the passing of the dynasties. From

early childhood till oldest age, from dawn until dark, every day of life, the people of the country labour with the most primitive implements and for minimum reward. Labourers, almost naked but for their enormous Ascot hats, legs as muscular as Nijinsky's and as wide apart as a wrestler's, plant in the swamps the small aigrettes of rice-shoots. The water-treaders, at the wheels by the hour, defy the laws of gravity and cause the water to run up-hill. The river-coolies, wearing the short capes of palm-tree fibre that, although of a fashion thousands of years old, are distinctly modern in appearance, strain at every limb as they fight the elaborate currents and the evil spirits beneath the water. The old women pick the leaves off the tea trees, or tie little bags, against the onslaught of birds, over the ripening plums. With a patient persistence everybody fights against discouragement, and in the face of all disasters their spirit remains unbroken and unbreakable. The Chinese smile with contentment where others would despair, for they are of the Celestial Kingdom.

Throughout free China, for thousands of square miles, the villages resemble one another in all essentials – dark, smoky, with grey walls, black tiled roofs. The inhabitants, wearing the inevitable indigo-dyed cloth that fades through so many varieties of blue to pale grey, move about their business among an inextricable mass of scraggy chickens, pigs, dogs and babies.

Under the microscope of the complicated war situation in China today, Eastern and Western attitudes of mind are shown up in greater contrast. For the British and American soldiers, working with their allies in this country, there is a great deal of re-adjustment to be made. The Westerners have shown a remarkable willingness to adapt themselves to the modes of thought of their Chinese brothers-in-arms.

The Americans have always a particular knack of making themselves at home in the most unaccustomed surroundings. They chum up with all and sundry; they scream from their jeeps at the village children a return cry to the welcome 'Ting Hao' ('very excellent'); they enjoy local rice wines and raw alcohol, and on Saturday nights they have been known to organize rickshaw races, themselves pulling the rickshaws, turning the tables on the coolies, who are made to sit in the place of their usual clients. The race ends with tremendous upheaval of overturned coolies and rickshaws. Thousands of dollar notes are cheerfully brought out to pay for the fun.

The English maintain, in spite of the difficulties, a completely English atmosphere in whatever distant part of China they may happen to make their headquarters. At all costs they must have food cooked in the English style. Conditions are such that allowances (but few judgments) must ever be made.

The cheerfulness of English and American alike is remarkable. The sense of isolation, the remoteness of home, and the mutual difficulties faced in surroundings and in an atmosphere so essentially foreign, have brought about a wonderfully harmonious and sympathetic relationship between the English and the Americans whose lot has been cast in this distant theatre of war.

Air force girls of the WAAF carrying out
repairs inside a barrage balloon, 1941

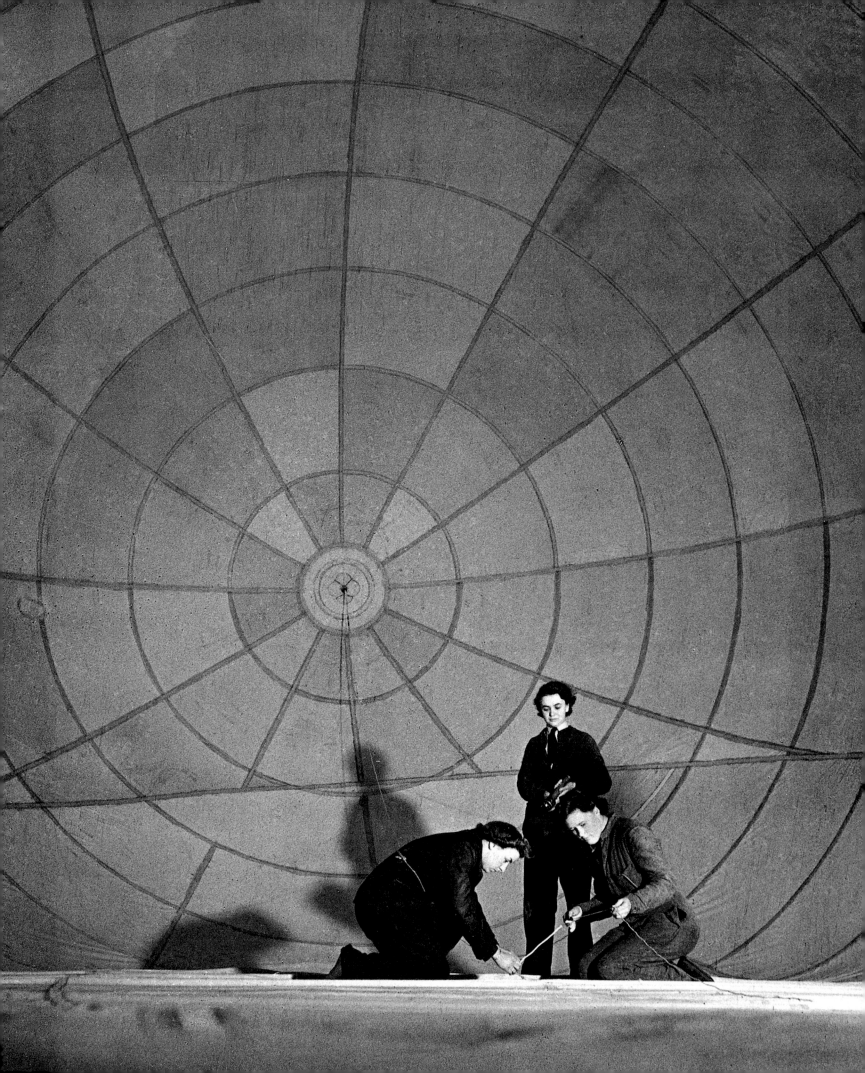

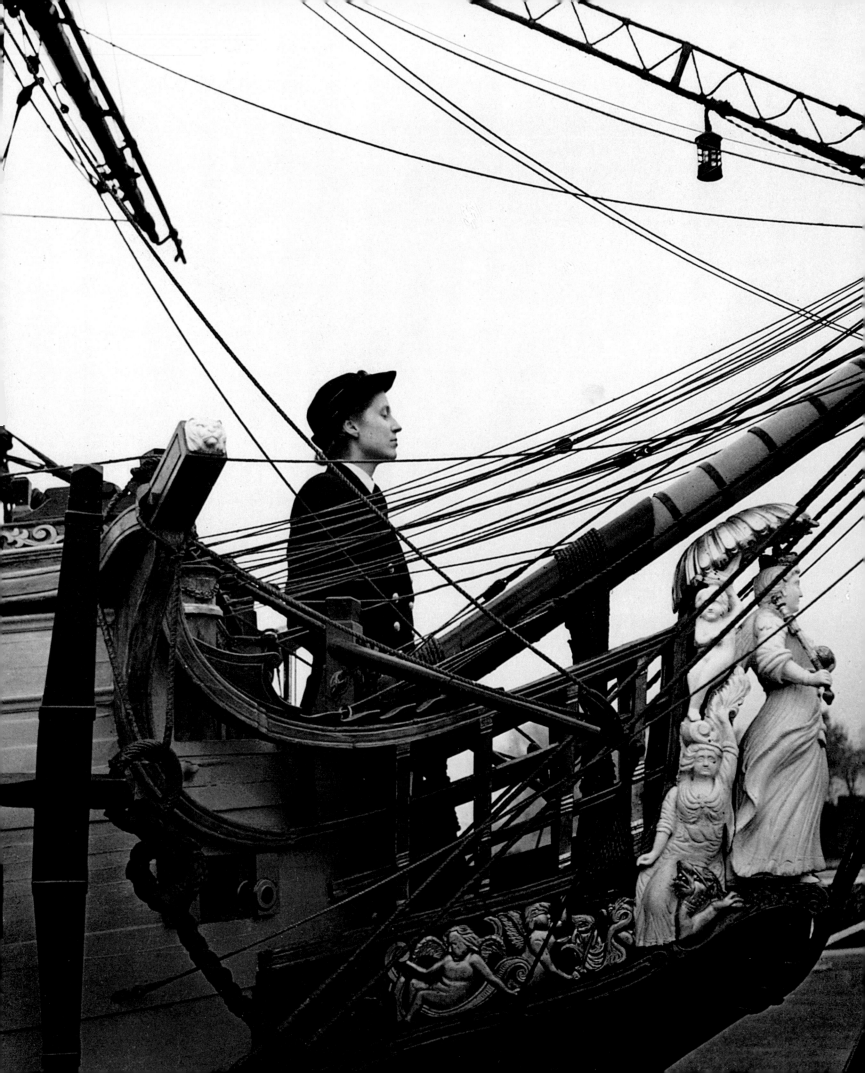

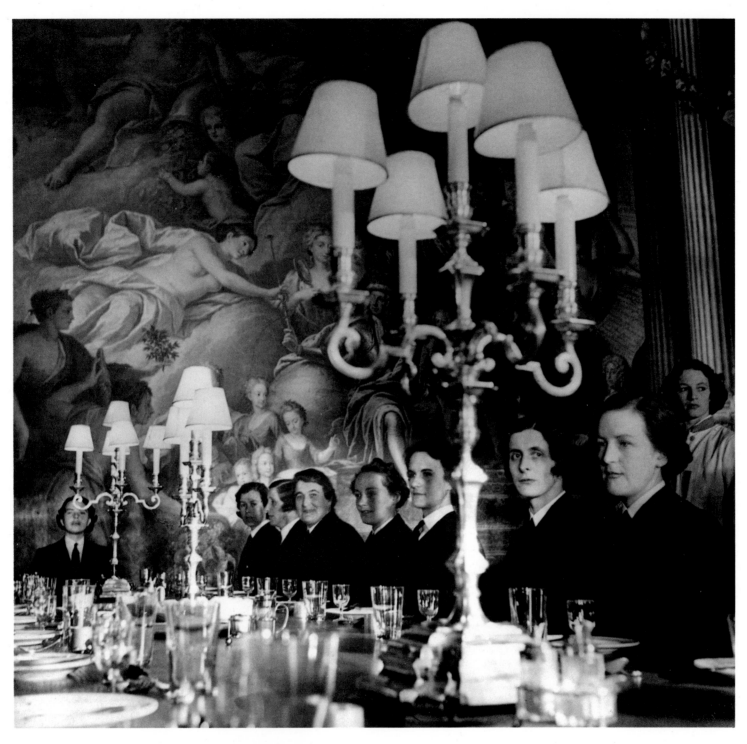

WRNS officer in a model ship on the lawns of Portsmouth Command, 1940 (*opposite*); WRNS officers dining in the Painted Hall, Greenwich, 1941 (*above*); the Duchess of Kent, head of navy women, 1942 (*left*)

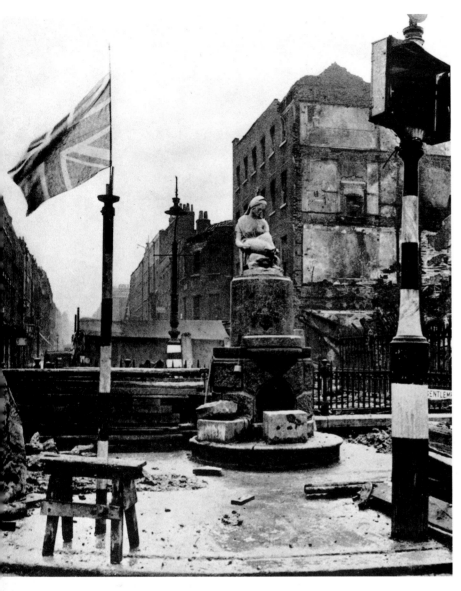

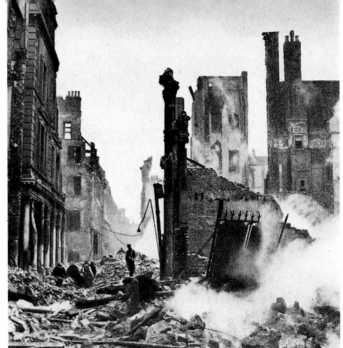

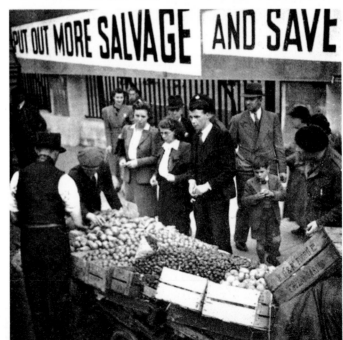

On the Home Front. A Union Jack flies amid the rubble of Bloomsbury Square, 1941 (*above*); 'Paternoster Row is lost to us', 1941 (*top right*); collecting newspapers, 1944 (*centre right*); queuing for fruit, 1944, (*bottom right*)

Bombed houses in south-west London, 1945 (*opposite*)

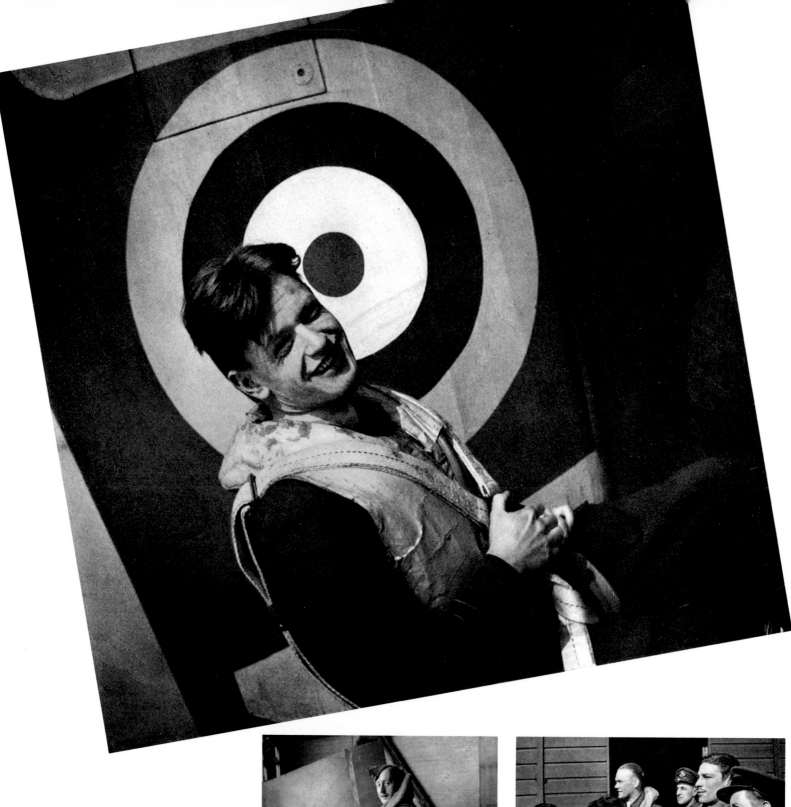

Winged Squadrons. A Flight-Lieutenant puts on his parachute before take-off, 1941 (*above*); 'On all air stations much time is spent waiting', 1942 (*right*); American airmen of one of the RAF's Eagle Squadrons, 1942 (*far right*)

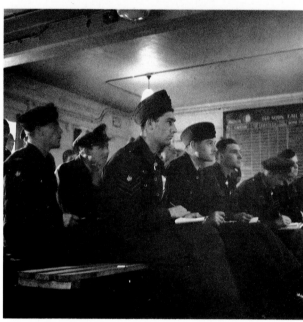

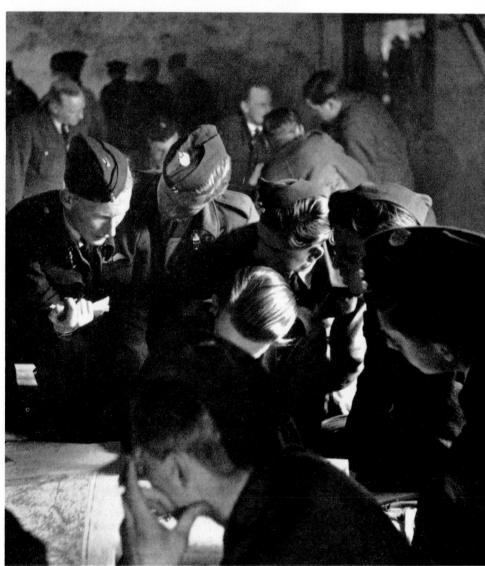

On an RAF Station, 1943. An armourer bombs up (*top*); an observer makes his calculations (*top right*); the captains of the aircrews are briefed (*above*); the interrogation when the crews return (*right*)

In the Aircraft Recognition Room, 'its walls decorated with every type of war-plane, friendly and hostile', 1941

Winston Churchill at 10 Downing Street, 1941

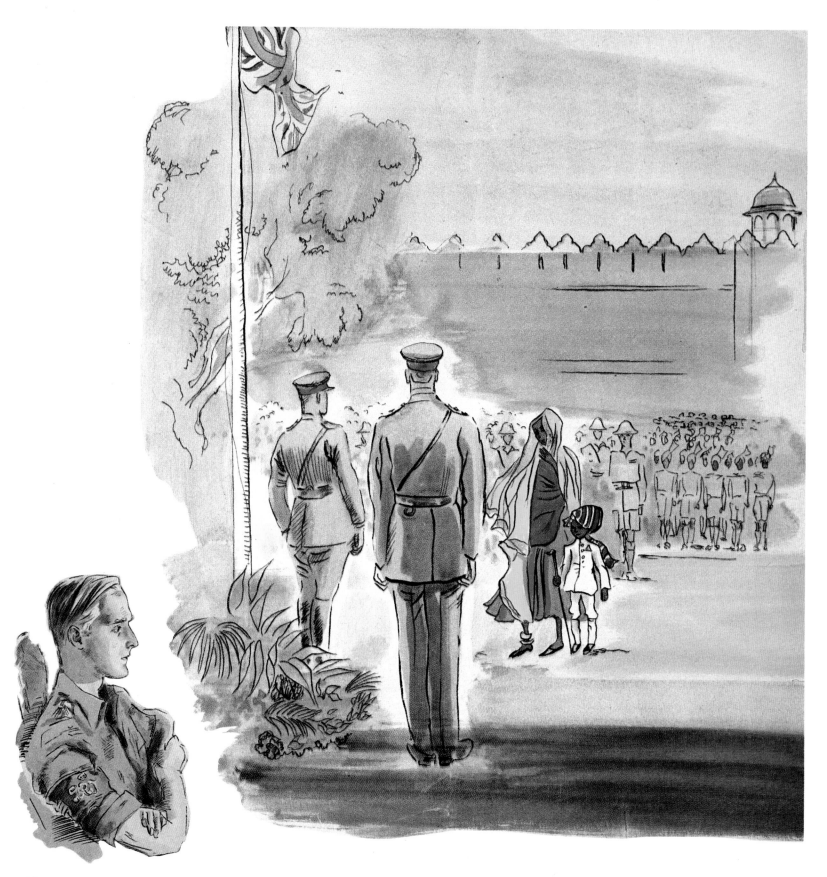

Eastern Assignments, 1944. At the Delhi Fort, the widow of
Havildar Chhelv Ram receives the Victoria Cross from the
Viceroy, Lord Wavell. In the foreground is General Sir Claude
Auchinleck. *Inset*: The Earl of Euston, ADC to Lord Wavell

Along the river at Kweilin, a strategic Allied point in the path of the Japanese advance in China (*below*); Mme Sun Yat-Sen, (*right*); General Li Mo-An (*centre right*); Dr H. H. Kung, Minister of Finance (*bottom right*)

Overleaf: General Charles de Gaulle, 1944; the White Ensign is hoisted over Tobruk, 1943

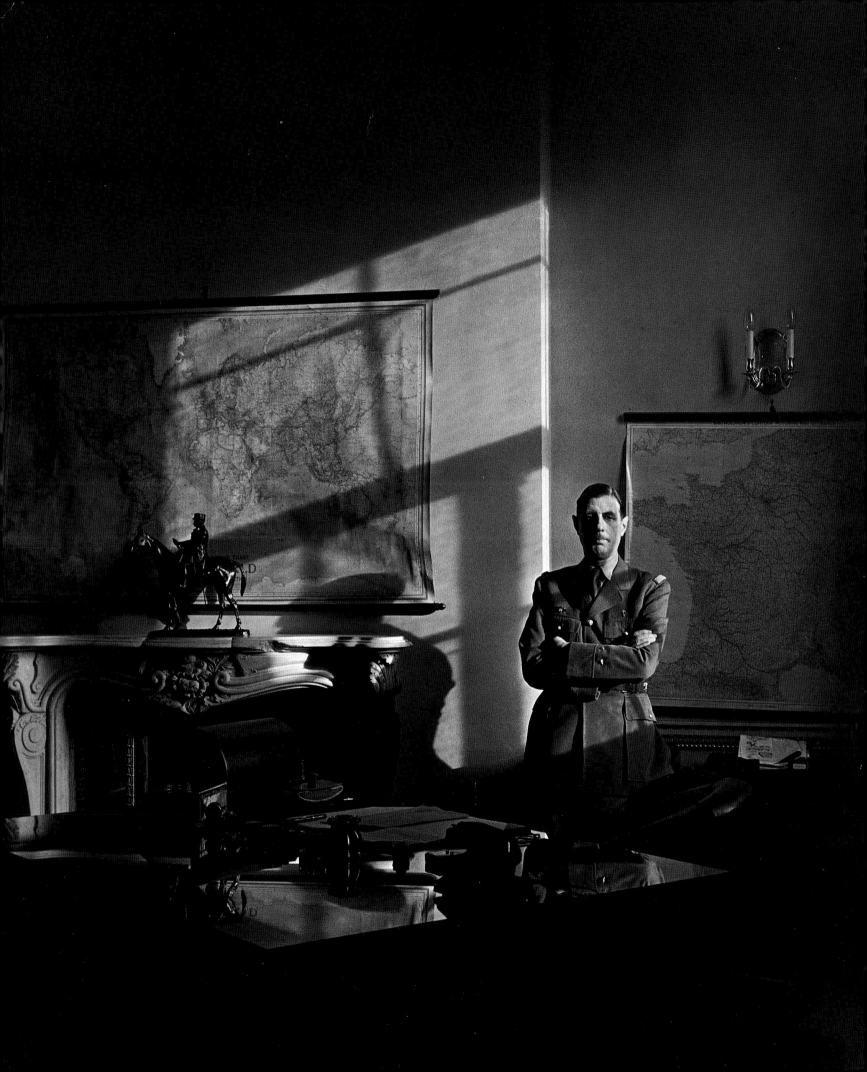

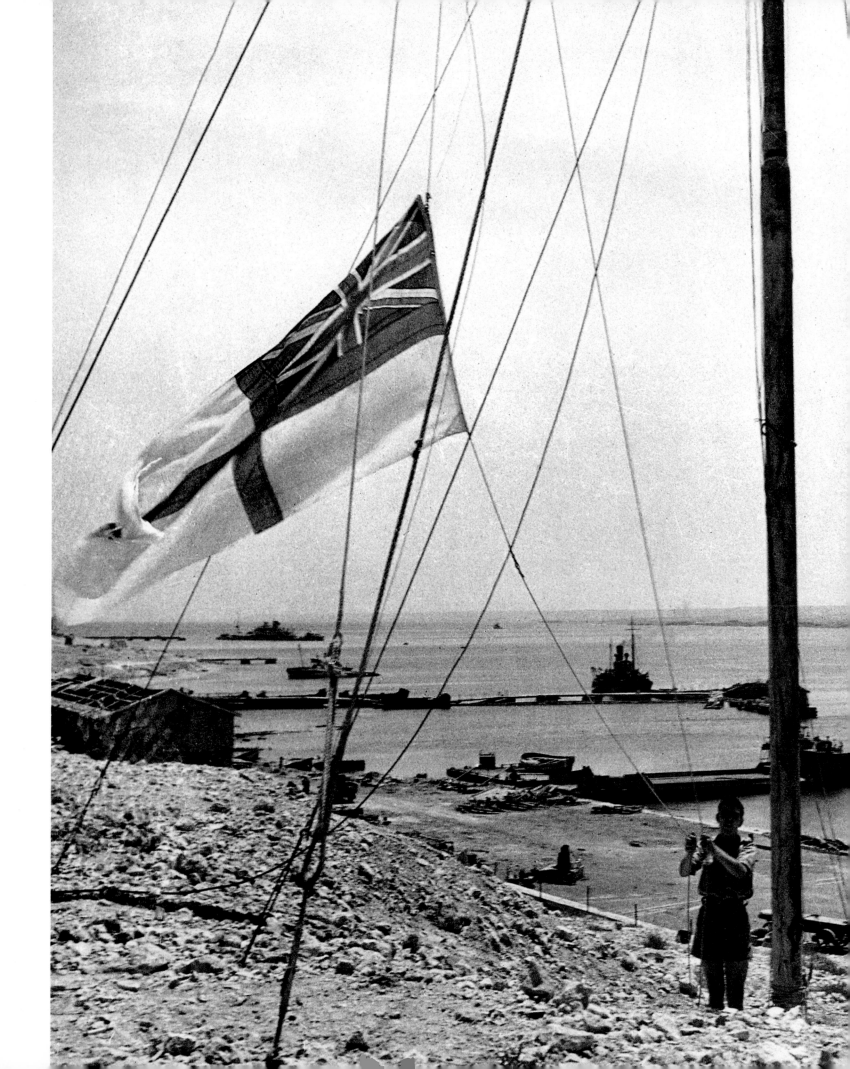

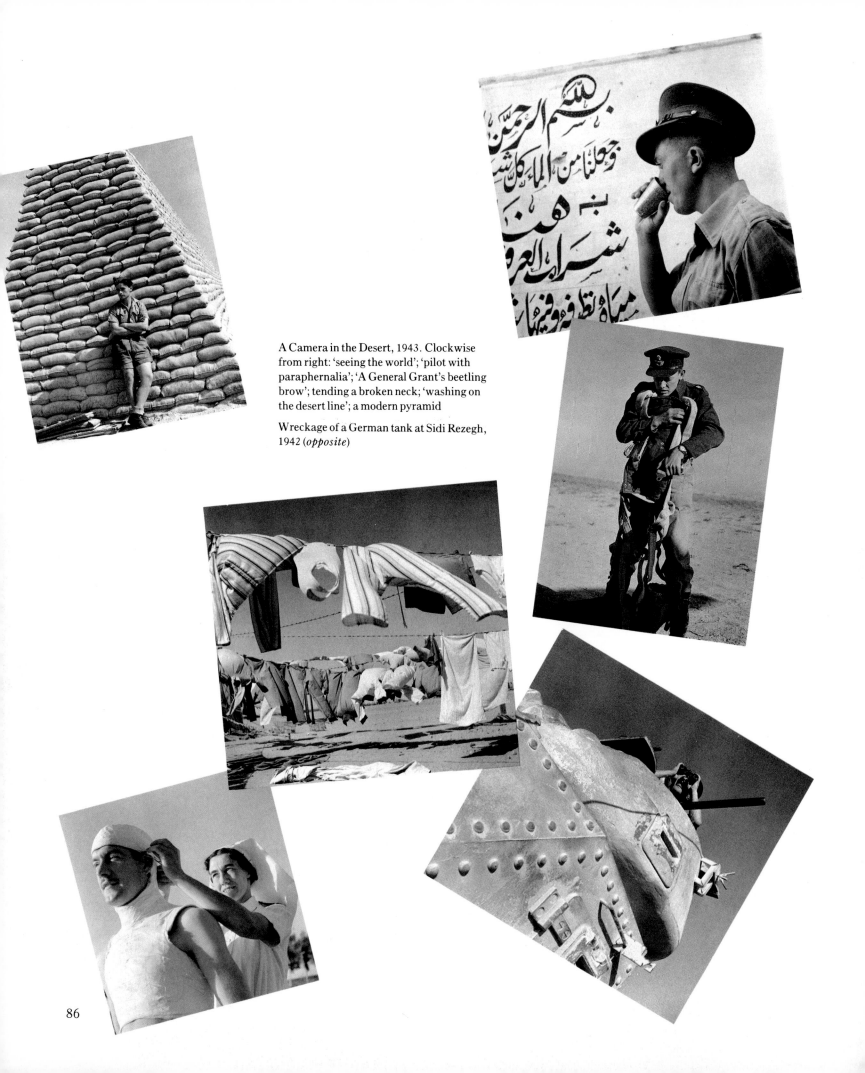

A Camera in the Desert, 1943. Clockwise from right: 'seeing the world'; 'pilot with paraphernalia'; 'A General Grant's beetling brow'; tending a broken neck; 'washing on the desert line'; a modern pyramid

Wreckage of a German tank at Sidi Rezegh, 1942 (*opposite*)

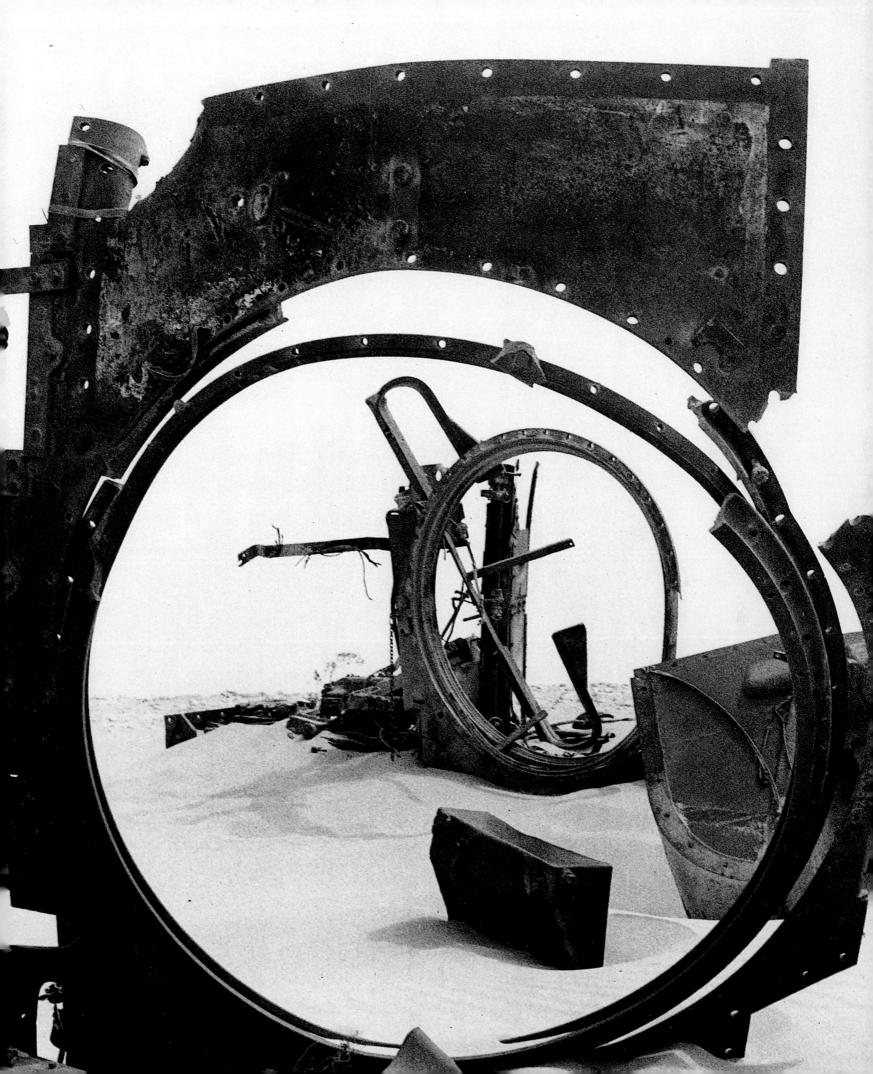

Jungle Front, 1944. Liaison officers of the 5th Division,
14th Army, Arakan, under camouflage nets (*right*);
Gurkha sniper in the Chin hills, Burma (*below*)

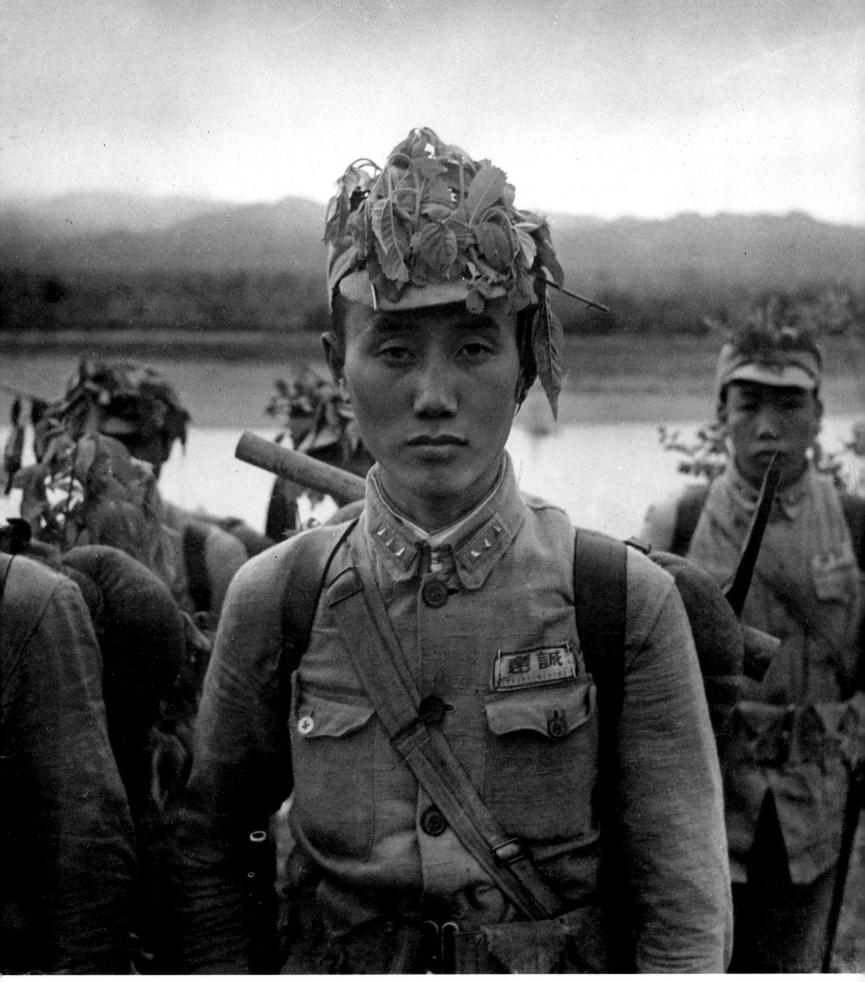

Chinese commando, 1944

The Chinese at War, 1944. After eight years of war, the Chinese people endure great hardships (*left*); China's armies march on, though short of equipment (*top*); 'the hospitals are filled to capacity' (*above*)

Overleaf: China, past and future, 1945

3 · People

The Sitwells – a Triptych, 1931

Paris Sketches (1945)

IN PARIS, individualism has always been encouraged. The names of scholars, poets and painters are not merely known to a few but are as much a source of pride to the ordinary citizen as the civic monuments. It is inspiring to arrive in a city where the individual is still able to express himself with uninhibited passion.

The venerable André Gide seems to be typical of this isolated activity. In his penthouse studio in the rue Vaneau, he continues his studies and writing, determined, as he has been throughout his life, to do only that which holds interest for him, oblivious to the opinions of the outside world. How few people realize, as he does, the simplicity of preventing a morning of interruptions and distractions by the expedient of serenely reading Plutarch while ignoring the front door and telephone bells.

Colette, too, has learnt to immolate herself [*sic*] from the stress of a disturbed and disturbing world: 'Madame is busy working and does not wish to see anyone for a fortnight.' In her apartment with its waist-high windows looking on to the Gardens of the Palais Royal, Colette, muffled up on her bed with rugs and hot water bottles, nine fountain pens and a dozen sharpened pencils by her side, crosses out, makes appendages and re-writes. She is writing her memoirs, writing, she says, like a monster without stop. 'It is such hard work – I must expurgate half my memoirs, and invent the other.' A woman with a tall hat covered with birds comes in from the French Ministry of Information. 'No, I cannot write anything for you . . . ' But, after a time, Colette has promised to produce something that may 'encourage a respect and love for France'.

Miss Gertrude Stein is a dynamo. Her prose machine is at work non-stop, now on a novel about GIs and democracy, now on a play about the Resistance called 'Yes is for a Very Young Man'. During the four years of war, living at Aix, she became friends with a neighbour, Pierre Balmain, a young Savoyard who had been, before the war, a dress designer. Then, as a friend, he made tweeds and warm clothes for Gertrude Stein and Alice B. Toklas; he made extremely good clothes, for he was a craftsman. Now, as master of his metier, he was starting on his own. Miss Stein, looking like a self-portrait by Corot, went to Balmain's Paris opening. She whispered to Miss Toklas, wearing Chinese attire, 'We are the only people here wearing Balmain's clothes, but we must not let anyone know for we are not great advertisements for the world of fashion.' But nothing could jeopardize Balmain's success, which was immediate and astounding, and he has now become, overnight, the symbol of the new generation continuing in the great tradition.

Bébé Bérard showed me enchanting and tender illustrations for Colette's and others' books, and some simple and poignant pictures of drab young girls and grave urchins. He said the last days of the Occupation were like a De Mille production of the 1848 Revolution, reminiscent of Victor Hugo, of the barricades, with the citizens rushing out with bottles filled with alcohol, to fire tanks . . .

A new school of painters has appeared that continues to work in abstract forms, but, unlike Picasso and his followers, they do not make abstractions from concrete subjects but compose pictures of pure abstractions. Though the artist's intention was only to create an intense emotion unconnected with any subject, in some instances the result appears the same, for many of these abstractions create a vision that resembles familiar scenes. Atlan is such a young painter, whose work shows extraordinary vitality and power. Picasso is painting a huge picture of a concentration camp. It seems he paints a huge picture after every war.

Boris Kochno, Diaghileff's discovery, is carrying on in his master's tradition, and has taken up the thread of his career as impresario of Ballet. He has also become the editor of a magazine, *Art and Style*. Paul Eluard, the poet, a man of great personal charm, much loved throughout France, has become editor of *Labyrinthe*, published in Switzerland, and like many other editors, is dedicating an issue in homage to England.

Everywhere is evidence of the native and natural ingenuity and taste; it is the innate gaiety and sometimes tragic frivolity that gives a distant perspective even to present-day hardships.

BÉRARD'S BUBBLING ZEST gave off sparks in every direction. Literature, painting, sculpture, architecture, period furniture, jewellery, fashion, and all the arts of living in turn absorbed him night and day. Although he wished to devote himself to the canvases drying unfinished in his studio, he could not resist undertaking the décor for one more play, film, or ballet. With his indefatigable generosity and rich fecundity, he was impossible to curb. Time must be found to illustrate a new book, design more materials, or give his individual arabesques to decoration on glass or in magazines. His roughest drawings, so free in line, so full of suggestion in their elimination, were the results of gallons of midnight oil. Roused from only a couple of hours of a drugged sleep, he was at once, with a word or an idea, giving inspiration to others; no matter how driven, he could never refuse to help fellow artists, or to give advice to a friend opening a flower shop.

Bérard's ubiquitous activities prevented many people from seeing him as the person he really was, a devout and dedicated painter. If he had devoted less of his time to theatre and fashion, there would doubtless be more canvases; even so the number that has been bequeathed to us is a considerable achievement when one considers that Bérard died a comparatively young man.

His father, an architect himself, gave his son an architectural training that stood him in good stead throughout his career, but painting was his life-blood. He became a pupil of Vuillard. From the start Bérard seemed to have complete mastery of colour. His palette was of an extraordinary subtlety and originality. In his work of the twenties, the spectrum consisted of foggy greys, squashed strawberries and imitation-grass green. Later the tonality lightened as an opalescent sun seemed to shine. Likewise, he always seemed (though he groaned with pain at the difficulties) to be able to make paint do his bidding. Either with Ripolin or layer on layer of thinly applied wash, by using an almost dry brush, or his thumb, he could wield his particular authority over pigment with an apparent facility that disguised Herculean endeavour.

Although he passed through many stages, taking his inspiration from countless different worlds, Bérard's pictures were in complete contradiction to his fashion work.

Beaton on Bérard (1960)

Never did he paint a woman of society in the mode of the day; rather were his subjects of the tragic world of the poor. Like the painter, LeNain, whom he so much admired, he depicted peasants, urchins and downtrodden women, in melancholy monochrome or in greys and restrained greens. He painted enigmatic Arabs, or gymnasts, and a whole series of personages (who were often self-portraits in classical draperies) sitting sphinx-like on deserted *plages* against a calm grey sea. In their isolation these groups present a dreamlike reality, but they are painted as if mystery was an every-day matter of fact. It is as if a posse of poltergeists had sat to Degas.

In his neo-romantic vein the circus held him in thrall, but like the clowns and acrobats of Picasso's blue and rose period, Bérard concentrated on the dusty side of the sequin; he painted these poignant performers in the sombre dark reds and blacks of the funeral parlours (from which, incidentally, his mother inherited a considerable fortune).

Bérard's enthusiasm for the theatre and fashion made him a key personage in the Paris scene, where even today, over ten years after his death, his influence still motivates so much of the artistic activity. His murals and large decorative screens remain in themselves a challenge for him to be considered the Pontormo of his time. Yet it is his easel paintings which are Bérard's real legacy to the world, and by them alone he will eventually be revered.

Golden Picasso (1965)

'IT IS TWENTY YEARS since I last saw you!' A golden Picasso threw open his arms. 'After so long we must embrace!' I kissed two soft, apricot-coloured, cleanly shaven cheeks, and we made much fun about the passage of years. Yes, he remembered my photographing him like Whistler's mother! And being so interested in the 'toys' on his mantelpiece. No regrets about dead or past: 'We must go on – even if it is madness.'

While I scrutinized him, he no doubt was also noting the change in my appearance. He appeared to be less of a bull-like man – more energetic perhaps, but slightly shrunken. Perhaps his eyes are less brilliant: there can now be something sad about them and they are softer, but the range of expression is more varied. Whereas before the pupils were intense black, they now seemed to be a topaz brown. Altogether he created a symphony in sepia, beige, and mushroom: his complexion a pale cigar leaf; his hands, with heavy pointed fingers, were a darker shade; his teeth like old ivory; the whites of the eyes, parchment. He wore three woollen jerseys of oatmeal, chocolate, and *café au lait*, and his patterned velvet trousers were of cinnamon and snuff. There was a gash of green paint on one arm, and one sleeve was worn to shreds; there was a hole also in the black stockings worn with neat white leather shoes.

We went into a sunburst of a room, brilliant with whiteness and colour. The sun poured through the slats of the shutters onto a marvellous litter of papers, drawings, posters, early photographs, sheets of lithograph proofs, illustrated books, joke toys, metal sculptures, and every sort of unaccountable bric-a-brac. 'Come and see everything!' said Picasso. 'Oh, the number of paintings! Sometimes seven a day! Almost as many as you must have photographs!'

We left this crowded sitting-room for another, equally crowded and untidy: floor, desk, and tables littered with tied-up bundles of letters, newspapers, pottery, profiles cut out of metal, and stacked canvases. Such a mass that it was impossible to take in more than an occasional detail. Past a dark dining-room with the long refectory table

covered with parcels, more books and sculptures and pottery, with the walls lined with unframed pictures back to back.

A huge, bare hall was full of stacked, unused canvases and packing cases (pale honey-colour effect). Down to the vaulted hall – when Benjamin Guinness owned the house, the hall was decorated with armour, tapestries, and Italian Renaissance effects – now a cemetery of statues, over-life-size bronze figures, steel abstractions, constructions of wire, painted tin, and metal. The amount of work is truly staggering, but there is always more to be done. 'Come – you must see everything – this, nothing.'

We then circled a white staircase and came upstairs into one huge painting room after another – each filled with pictures, some still in execution. A smell of Ripolin paint permeated a corner; there were stacks of tins of paint. Through two more rooms filled with new paintings, then out on to a glassed-in terrace with a superb view of the distant purple mountains: the tiled floor littered with canvases, some still wet from last night's work, others – recently discovered – dating back to 1905.

Picasso wandered about turning on extra lights with a semi-queasy, semi-amused expression on his face, until in front of the camera he fell into his habitual poses – square on with wildly staring eyes.

At last, replete and somewhat exhausted, we had made the tour, to return to the crowded sitting-room from which we started. The scene represented the attraction of conversation. Picasso was tremendously happy and amused just to sit and talk, without the necessity for drinking. As he sat, he did an imitation of his mother in her rocking chair with her feet dangling, since they could not touch the ground. He preferred the aesthetic effect of the Provençal chair over there, but demonstrated the advantages of his modern swivel chair by almost swirling himself into space.

All Picasso's actions are quick ones: his arms are raised in a jerk, his body, accustomed to moving heavy sculpture, is too nervous and strong to be graceful, and he jumps from place to place like a boy skipping. Generally, when he turns his head, his whole body turns too.

Picasso talked of the advantage of working at night: it is then so quiet, and no one can disturb him. Sometimes it is three in the morning before he stops painting – so he gets up late in the morning: he does not need much sleep but enjoys resting and reading. When someone complained to him about not being able to sleep, he said: 'So much the better for you – sleep is a waste.'

Picasso seldom goes out from his eagle's nest – not even to the bullfights anymore – he has learned to cut his own hair – for Picasso only likes work; and this house on the mountain top is his entire world. He has already built three new studios, and he now wants to fill a fourth with painting. This, at eighty-four, is not bad.

After four hours it was time to go. Pablo admitted: 'I have to paint. Come back again in twenty years, and come back sooner as well.'

CHARM IS NOT a word that is used very much today, but charm is still a power of fascination and David Hockney has it. Although he appears unlike other people, he seems completely at home in the world. He is a natural.

Eye to Eye:
David Hockney (1969)

It was in New York in 1961 that he first dyed his hair with 'champagne ice', bought himself spectacles as large as bicycle wheels, and generally created for himself an astounding appearance. But you soon get over the shock of the pale canary silk hair,

the pistachio suits, the retina-irritant 'Day-Glo' colour of his ties, scarves and handkerchiefs.

To see him, as he does a drawing, looking so intensely up and down at you through his super-Harold Lloyds, is to be reminded of the monkey house; but he will not mind this for he is far cleverer than the entire monkey house put together. He is extremely sensitive and a genuinely kind person. He feels strongly about the way the world should not be going, is going and should be going; he challenges a great many of the problems of today. He is, in fact an optimist and speaks in euphoric tones of what the golden future is going to bring, when everyone has leisure and everyone is an artist.

David is all the while experimenting. He is quite an engineer, practical, and at home with the mechanics of today. He knows and approves of new techniques and time-saving devices. He is a meticulous worker, and seems to proceed in a leisurely fashion, always with time to spare. All life is a wonderland: like Alice he is delighted by most of the things that he discovers, be it a Lalique light, a 1920 sofa, or a shell. Most of the time David is wreathed in smiles, but he is by no means simple; in fact, his scorn can be devastating. He has the sophistication of the pure in heart: he could never say anything he does not mean. His carefully chosen words strike the ear as unexpected. He describes someone as 'not immune to the oddity of the situation'. He does not know what pretentiousness means.

A Woman of Quality: Lady Diana Cooper (1969)

SHE HAS always been a character, but never so great as now. Perhaps phenomenon is a more apt way of describing the contemporary Diana Cooper. Even as a pampered child, or later as the most adulated beauty of her generation, her fair head has never been in the clouds; there has always been something basic about her attitude to life.

But today she has developed such force of personality that she blows everything superficial, tawdry or false before her like a typhoon. She is tireless, indomitable, and courageous; frailer creatures fall by the way, but she has never lost the radiance and poise of someone who has always been greatly admired and loved.

Her mother, a gifted artist, a member of 'the Souls', and a woman of remarkable originality of taste, brought up her youngest daughter not only to have a great appreciation for music, literature and the arts, but also to participate in a practical way in almost every aspect of life. She was never allowed to be idle. She learnt how to make her own dresses, and indeed cut out her own wedding dress. In the First World War she became a trained nurse attending operations. Each year she teaches herself some new activity. During the last war, single-handed, she ran her own farm, learnt how to make butter and cheese, and scrounged the neighbourhood for fodder for her animals. The dignity of the hall porter at the local hotel was always offended by her arrival, her jeans often splashed with cow dung, as she came through the lobby to collect the pig swill.

She is self-confessedly a natural law-breaker. Rules and regulations have never been for her since, as a child travelling in a railway compartment with her mother, at the approach of the ticket collector and the command of 'Down!' she would scurry under the seat to be hidden under a travelling rug, only to be allowed up when danger was past. Today, the basket she always carries with her contains not only her books, addresses, spectacles and bulb catalogues, but, sheathed in a silk scarf, her chihuahua Doggie, who travels ticketless and treads where 'Dogs are not allowed'.

As a child Diana suffered from paralysis. Her mother dressed her in black velvet and lace or in cream-coloured pinafores – the reflected light was so becoming to the child's pallor. But a miracle doctor cured the illness by the use of exercises. Later, at the height of her beauty, while watching a firework display, she fell, as she tells us in her autobiography, like Alice, from a skylight roof to the bottom of a staircase well. Heaven knows how many bones were broken: one leg became shorter than the other; but no one would notice, although lately her right leg gives her considerable pain. She does not complain but in fact sometimes uses it to advantage. When recently visiting Stourhead on a crowded Sunday afternoon, parking was a problem. 'Turn in here!' she commanded, in spite of an aghast policeman. 'Tell him the lady can't walk.' The policeman relented. In London, when she knows she is committing a parking offence, she leaves a notice on the windscreen: 'Dear Warden: Forgive and don't fine me, but hoick me out of Mr Beaton's at no. 8.' Sometimes it works, and she has come back to find the word 'Forgiven.'

Lady Diana Cooper, 'the most adulated beauty of her generation', 1928

She is still bee-busy. If there is a quiet moment she produces her sewing and induces a companion to read aloud. She sets herself the task of entertaining a friend as if a game were being played. Some who know her only by appearance consider her affected, brusque or even rude: she is none of these things. She is slightly near-sighted – in fact, sees poorly without glasses. Instead of going to an oculist, she picks a pair of spectacles from a tray at Selfridges and goes off with those through which she imagines she can most easily read. This is only one of her many economies: she never travels first class; she invents simple but highly-flavoured dishes in which fish roes and onion are inexpensive ingredients. But she is generous in her support of others, has many dependents, and makes the welfare of lepers her particular charity. She is kindly disposed to all mankind, and is always willing to help.

She is a day-dream dresser. In matters of self-adornment she has always been an individualist and has never followed fashion. Instead of wearing the pink and white of a debutante, she dressed in stone colours; wheat sheaves instead of roses decorated her hats. She has always preferred to hide her hair, and for this reason she likes to wear a baby's cap at night and wrap her head, wimple-fashion, under a garden hat by day. A favourite combination of hers consisted of velvet slacks, three rows of pearls, a large, but short, fox fur cape, and a yachting cap. When I took her to a neighbour to inspect his apple tunnel, she wore dark glasses, high cork sandals, trousers and a wimple under a cowboy's hat. When I introduced her as Lady Diana Cooper, the neighbour, a wit, remarked, 'Heavily disguised, I see.'

Recently she made a surprising debut on radio. She was said to be extremely nervous, and her intimate friends, accustomed to a rather rough and ready mode of speech, could scarcely recognize the quavering voice with the exaggeratedly aristocratic, turn-of-the-century pronunciation of certain vowels ('u' for 'o'), and the peppering of perfectly pronounced French words. But the general response to this great character, even among those who had never seen or heard of her, was immediate; even the technicians in the studio were struck by the essential authenticity and impeccable honesty of this unique individual.

The first time I ever met her was at a Chelsea Arts Ball. The revival of Victorian fashion had not yet been introduced, so her appearance as a Du Maurier croquet player, with fringed hair and chignon and grey muslin bustle, was startlingly original. I could not believe my good fortune when I was placed next to her at supper in the box.

At every meeting since then her appearance has struck me anew with her eyes like bluebell woods, the incandescent, alabaster skin, and the dazzling fairness of hair. A while later, when I started to take photographs, we became friends. If one could imagine her as a gipsy brunette instead of the lily-like blonde, it is easier to understand her character. Perhaps the old-fashioned word Bohemian fits her as well as any other. Her qualities of endurance and adventure are most apparent as a travelling companion. Arriving in a strange city, she enquires for the cheapest hotel. 'What we want is charm, not revolving doors.' She always prefers a picnic to a five-starred restaurant. Perhaps it is her Edwardian upbringing that makes her so stoic, spartan, and forbids her ever to give in. But what has struck me even more now, with the volume of years rolling by, is the ever-growing knowledge of her sterling values.

Not only is she what in the Restoration was termed 'a woman of quality', but she herself is composed of the highest possible quality ore. Many young of today are her intimate friends, and she is as ubiquitous as ever. 'I've always been a martyr to excitement', she admits, as she goes off to see Jodrell Bank or the elephant house at the Zoo. She insists that in art and decoration she has not got further than the early Cézanne, but, in fact, she is as au courant as any: she is an avid reader of newspapers and a great television fan.

She does not easily say the things we know that she feels profoundly; she cannot bring herself to go to funerals; she seldom writes a bread-and-butter letter. There is nothing facile or glib about her, no hypocrisy, and she is the first to laugh at herself. Hearing about an old lady in black rags, and brimmed hat covering a painted, mask-like face, whom the locals refer to as 'La Folle de South Kensington', Diana says, 'Yes, that's me.' There is nothing of the folle about Diana, but she is fast becoming an eccentric in the great English tradition.

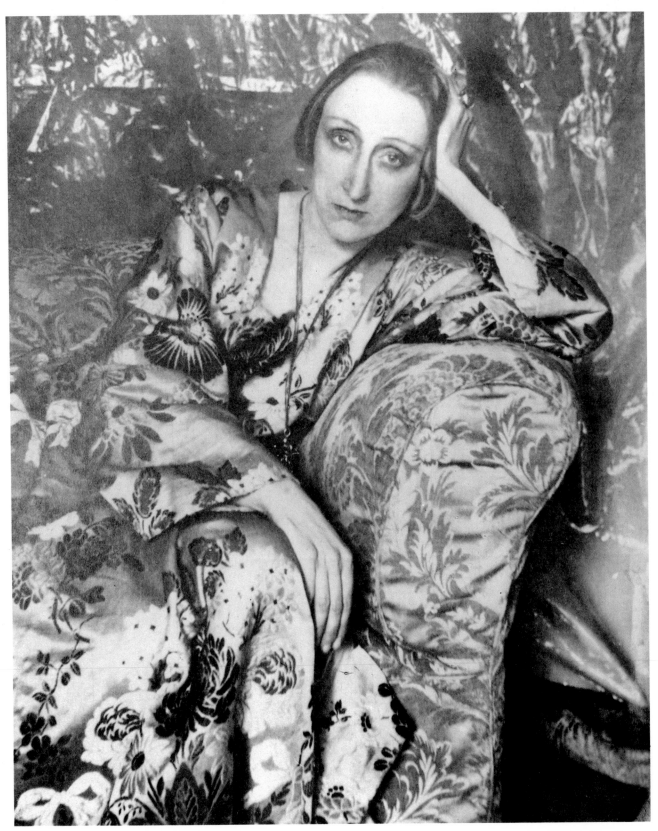

Edith Sitwell, 1928

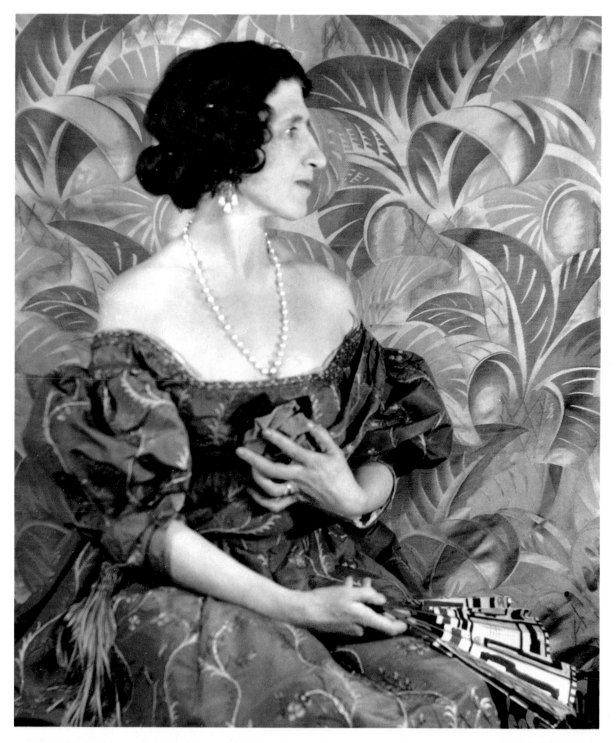

Lady Ottoline Morrell, Bloomsbury hostess, 1928 (*left*); 'Intelligent Young Persons' (*below, left to right as printed*): Mr Sacheverell Sitwell, The Hon. Stephen Tennant, Miss Rosamund Lehmann, Mr Osbert Sitwell, Mrs Sacheverell Sitwell, Miss Elinor Wylie, Mr Cecil Beaton, Mr Edward Sackville-West, Miss Zita Jungman

Margot Asquith, Countess of Oxford and Asquith, 'one of the most brilliant and picturesque people of our time', 1931 (*right*)

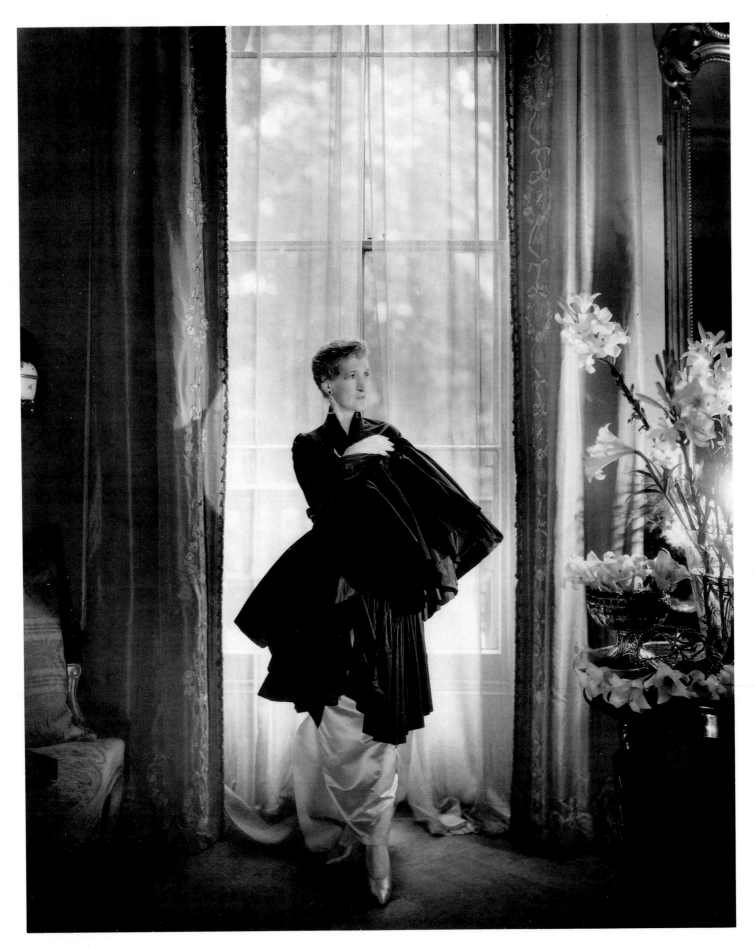

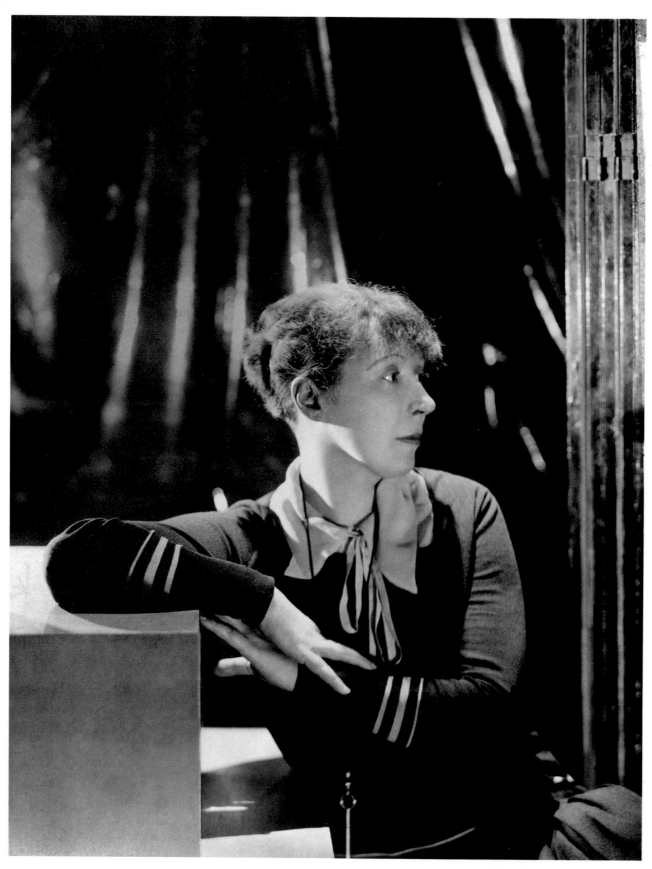

Marie Laurencin, painter, 1929

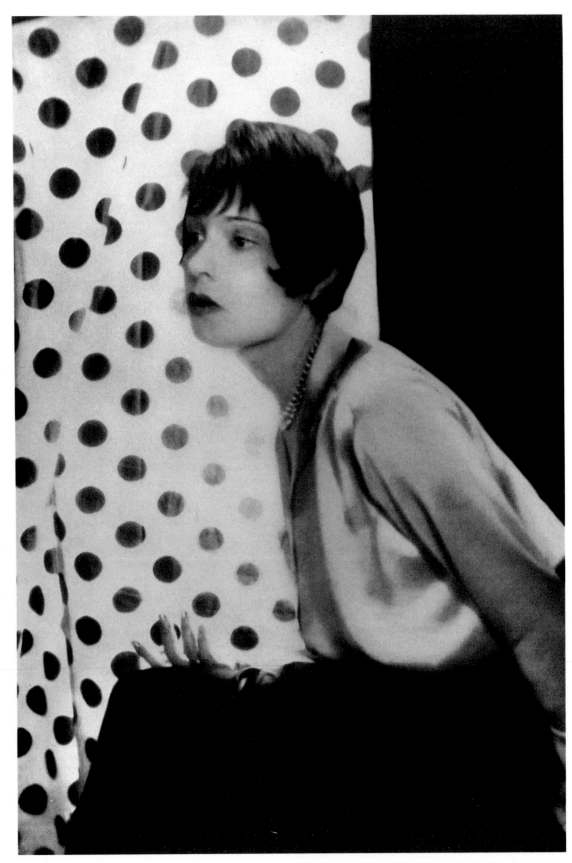

Anita Loos, author of *Gentlemen Prefer Blondes* and, for
Beaton, 'the essentially 1929 Venus', 1929

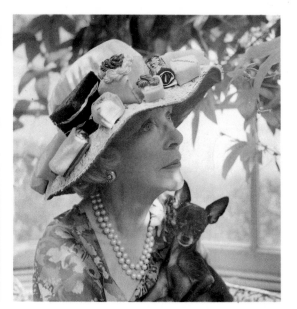
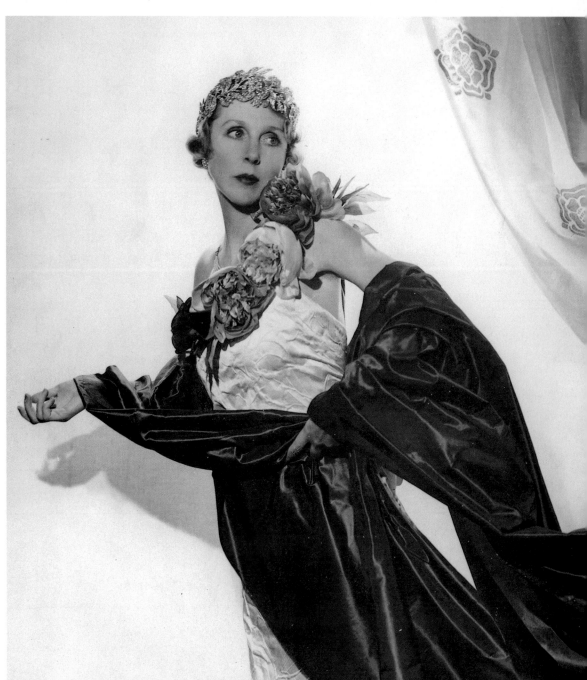

A Woman of Quality. Lady Diana Cooper, 1937 (*left*); as Minerva, 1937 (*right*). 'She has never lost the radiance and poise of someone who has always been greatly admired and loved': *above, left to right*: in 'barbaric hat', 1930; at work on her home farm, 1941; in birthday hat, with Doglet, 1973

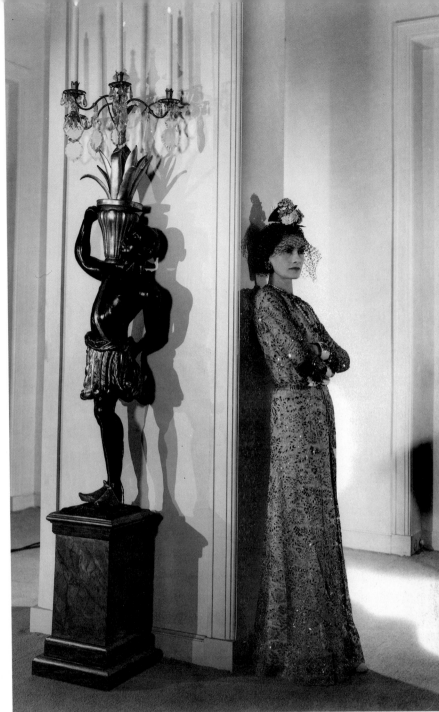

Coco Chanel on her famous mirrored staircase, 1971 (*left*); previewing
a new evening gown from her autumn collection, 1937 (*above*)

Aneurin Bevan, Minister of Health, 1945

General Dwight D. Eisenhower, 1952

111

Rebecca West, 1942 (*right*); André Gide, 1945 (*below*); Cecil Day-Lewis, 1942 (*below right*)

E.M. Forster at King's College, Cambridge, 1965 (*opposite*)

Augustus John, 1941

Graham Sutherland at work on his painting of
W. Somerset Maugham, 1949

Overleaf: The poet **Marianne Moore** and her mother,
1946; Gertrude Stein, **with Pépé**, 1946

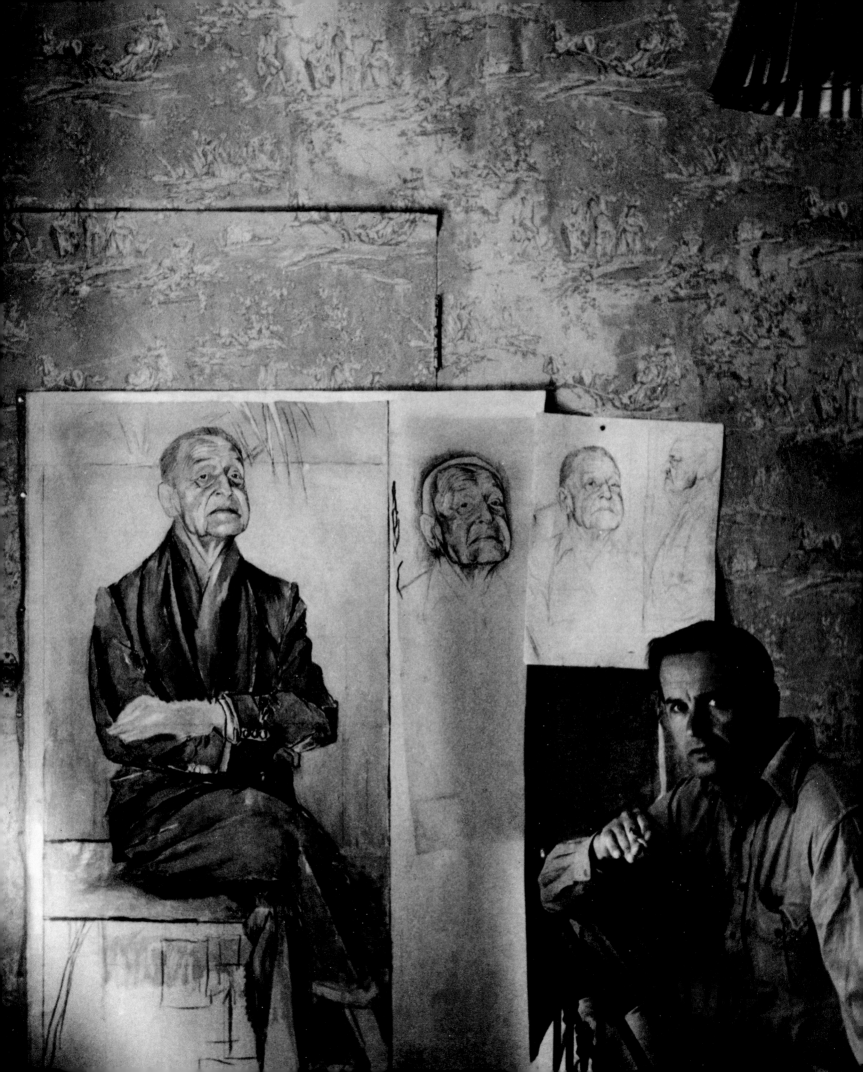

Shades of Proust. His friends Princess Marthe Bibesco, 1971, and
Jacques Porel (with portrait of his mother, the actress Réjane), 1971

Overleaf: Pablo Picasso, aged eighty-four, in his
studio at Mougins in the South of France, 1965

David Hockney, 1969. 'His scorn can be devastating. He has the sophistication of the pure in heart'

Mick Jagger, 1970. 'Onstage, the spell of Mick is physical. While he grinds and bumps in his poor-boy black sweater, his buttocks flat in his black pants, a long red satin scarf swinging, he faces kids who have a sweet, bemused absorption as though they didn't know how roused they were'

Overleaf: Dominguín, 1952

4 · A Windsor Album

Queen Elizabeth II at her
Coronation, 1953

Mrs Simpson (1937) THERE IS A LOT to draw in Mrs Simpson's face, no short cuts to getting a likeness. No feature is less important than another. As important as the design of her face are the contours. Noble brow and high cheek-bones are as salient features as the rugged mouth and excessively bright, humorous eyes.

She is difficult to draw. It is not easy to concentrate on the pencil, for it is almost impossible not to talk too much. The afternoon was so amusing. She has the capacity for making afternoons amusing.

The room in which I drew her in late November in London looks over Regent's Park. I see it still – a charming feminine setting, with walls, carpets, curtains and upholstery the colour of bleached olives. The flowers and exotic leaves are a bleached olive colour. On the mantelpiece is trailing ivy, intertwined with green orchids. On the piano, there are swords of some exotic iris. The only colours in the room are the mauve orchids and crimson roses on an occasional table, and the pink in Mrs Simpson's cheeks. The air is sweet from the miniature bonfire of perfume, which is secretly burning somewhere in the hall.

The lighting is becoming, and my sitter is at her best in a nondescript black dress that she makes smart by wearing. She reminds me of the neatest, newest luggage, and is as compact as a Vuitton travelling-case.

Hers is the figure that is admired now. Lady Louis Mountbatten led the school of proffered hipbones. Mrs Simpson's stance is different. The elongated curves are a slender variation on the Edwardian figure, and her posterior subtly invites a bustle. Her appearance is made up of paradoxes that make a striking entity. The wide jaw, the smoothly parted hair, the strong, enamel-less hands give her the appearance of an early Flemish master, but her eyes, incredibly bright, could only be painted to-day. In repose, her expression is wistful, but the grave effect is shattered by the sudden explosion of her broad firework laughter. Her eyes seem amazed at the sudden change. Her gaiety is contagious. Around her, there are incessant squibs of laughter. She herself laughs a square or downward laugh and, doing so, makes a grimace with pained eyebrows. Her eyes denote the real amusement.

Just as she makes, rather than mars, her daytime appearance by capping her essentially hard, strict clothes with a baby's bonnet or becomingly brimmed hat, so in contrast to her trim messenger-boys' suits is her almost dowdily ladylike, but well-controlled, bun of hair.

Of late, her general appearance has become infinitely more distinguished. Not only is she thinner, but her features have acquired a refined fineness. She is unspoiled. She is like an ugly child who wakes up one day to find that it has become a beauty, but she

herself has created this beauty by instinctively doing the right things. She is not able to pose in the flamboyant gestures of the professional beauty without shyness, but her gestures are simple and compact. She occupies a small amount of cubic space in the room, standing on one foot, her arms folded, or she folds herself up on the floor.

Her taste in clothes shows always a preference for bold simplicity, and her jewellery, especially for day, is extremely modern, though again the bracelet of little crosses is a surprise. She is the antithesis of pernicketiness, but she is tidy, neat, immaculate. Her hair, like a Japanese lady's hair, is brushed so that a fly would slip off it. She is conscious of the corners of her mouth and frequently reassures herself that they are there. She has a little brush in her bag for her carefully shaped eyebrows. She has a mole at the right side of her mouth, which, typically, she converts into a beauty-spot.

My sketch is nearly finished: the beige-coloured Cairn wakes up. A variety of fastidiously presented hors-d'oeuvres, grapes stuffed with cream cheese, diminutive *chippolatos*, and such, appears and disappears as quickly as the banquet in *Scheherezade*. On a low table is an array of bottles. The pineapple-juice bottle came from Budapest, others from antique shops in Scotland, others from any old antique shop.

The floor is strewn with unsuccessful sketches. There is so much that should be suggested in the painting, so much of her 'personal touch', neatness, practicality, and logic. The artist would be in despair, were it not that one of Mrs Simpson's greatest gifts is her capability of creating a carefree gaiety.

Wedding of the Duke and Duchess of Windsor (1937)

IN THE GROUNDS of the Château de Candé, a swan, blindingly white in the sunlight, glides like clockwork over the glassy lake. Many Cairn terriers bask in the sun, a Borzoi appears only for a minute, and the greyhound can hardly bother to saunter along the dappled lawns. But inside, the activity is strangely in contrast. The preparations for the wedding are reaching their final stage. In the office, five secretaries are dealing with the ever-increasing torrent of letters and telegrams. On a large tray, a pile of five hundred letters addressed to the Duke, bearing his profile on the stamps, is this morning's crop. A wad of pale green folded papers is the latest batch of telegrams – mostly from America for the bride-to-be.

The presents, from all over the world, stand in stacks and range from gramophone records to a portrait of King George V made of over thirteen thousand stamps. Luggage has to be labelled with tags of different colours, signifying various destinations, and Mr Dudley Forwood, the Duke's Equerry, is aghast that some one has run riot with the red paint-brush. The butler, assisted by footmen in their shirt-sleeves, is presiding over the setting of the elongated dining table for the festivities. The conservatory floor is a mountain of imported flowers; little boys are picking the leaves from long stems; women in large picture hats, white piqué overalls, and surgical-looking rubber gloves, are trailing bundles of Madonna lilies, syringa, and laurel into the main salon.

The parson is here – a genial man with a broad smile – and gives his suggestions for the placement and ornamentation of the altar. It is in the lime-coloured music-room – quite a small, but sunny room, with sun-coloured curtains; a portrait of Madame Bedaux hangs on the walls beside eighteenth-century French engravings. The Duke, with the enthusiasm of a schoolboy home for the holidays, gives instructions on a

thousand different issues and, himself, attends to the positions of the squashed strawberry chairs for the thirty-two guests, and to the candlesticks and the draping of the curtains.

The guests are arriving by car, train, and air. Every one gives a helping hand. Mrs Merryman is doing her bit by supplying missing addresses of some of the Baltimore telegrams that have to be answered. Mr Allen, the solicitor, hauls in some wrought-iron candlesticks. Mr Rogers, with a handful of typewritten papers, is harassed by overwork and the press. Bells ring continuously, the telephone bells and the house telephones. 'Where's the best man?'

Meanwhile, the towering vases of flowers become greater monuments to Mrs Spry's genius. The air is heavy with the scent of lilies-of-the-valley and white peonies.

Upstairs, in readiness, hangs the grey-blue wedding dress and slip that Mainbocher made to give the bride-to-be the fluted lines of a Chinese statue of an early century. The bonnet of pale blue feathers and tulle is on a stand by the open thirteenth-century window. Downstairs, the bride-to-be, trim and smiling in yellow, with raised finger-tips, is giving last-minute instructions and the first greetings to the organist. A large white carnation arrives for the Duke's buttonhole, and the final touches have been given to the preparations for the marriage that has involved so much. The sun shines with such startling brilliance that it seems to bring with it the blessings of the millions of well-wishers whose thoughts are with this historic couple this day.

Royal Album (1953)

WHEN I ENTERED the gates of Buckingham Palace for the first time, on my way to photograph the Queen (now Queen Elizabeth the Queen Mother), I was determined that my photographs should give some hint of the incandescent complexion, the brilliant thrush-like eyes and radiant smile, which are such important contributions to the dazzling effect she creates in life. I wanted so much that these should be different from the formal, somewhat anonymous-looking photographs, or the rather hazardous candid camera shots that had, till then, been taken of the Royal Family.

To help me in my task I found I had every facility that the Palace could offer: the various state apartments, with their groups of marble columns, ornate ceilings with garlands of fruit and flowers, rows of crystal chandeliers illuminating the acres of Savonnerie carpet below, gave me wonderful opportunities for 'conversation piece' backgrounds. Or, if I wished, my camera could utilize the felicitous glimpses of the long corridors with their tall windows hung with crimson silk, through which could be heard the click of bayonets and rasping voices during the changing of the guard. The gods were with me that day. Everything went well. There were no unforeseen difficulties. The sun even came out and poured down through the tall windows, giving an extra sparkle to the gilded carving and the glitter of diamonds. Wherever we went in the Palace, Blue Drawing Room, Yellow Drawing Room, Circular Music Room, Throne Room, the scene was dominated by the enchanting almost fairy-story figure in her sparkles and spangles.

Afterwards, the Queen changed into a lacy day dress and picture hat. We walked across the lawns down to the lake, and talked of the dread of war hanging over us. The light began to fade, and the Queen, with all the wistful symbolism of a Chekhov character, said, 'You watch, Mr Beaton: in a little while the sky will become rose colour. I often feel that Piccadilly is on fire at night.' Her words, alas, were oddly

'A halo hangs over Buckingham Palace', 1932

prophetic. Before the pictures that were taken that afternoon could be released for publication the skies of London were red with the fires of war.

Since that initial sitting, I have been fortunate enough to be asked to take pictures both at Buckingham Palace and at Windsor Castle on many historic occasions.

I have been honoured to photograph the present Queen at many stages of her adolescence. The first occasion was as a girl of sixteen, who wore a Kate Greenaway party dress of pink taffeta, and I tried to take the pictures 'in the manner of Gainsborough'. During the war I photographed her many times wearing schoolgirl blouses and skirts, Scottish tartan suits, or with the insignia of the Grenadier Guards in her cap: once, at a time when the Royal Family, like everyone else, had to conform to clothes rationing, in one of her mother's evening dresses altered to fit her.

During the bombing of London, we photographed in the ground-floor living rooms, when many of the possessions had been taken into hiding. After the war, pictures were taken with her sister on the ornate 'Ministers'' staircase of the Palace and against a snow scene painted by the late Rex Whistler. I was always impressed by, and grateful for, the exceptionally charming manners that the young Princesses had in relation to the job of being photographed. Unlike other children, Royal and otherwise, by whom I have been victimized, they never showed signs of restlessness. Sometimes, while I was photographing her sister, Princess Margaret would stand on tiptoe to peer into the ground glass of the camera, and I think sometimes she pressed the trigger release for me.

Though I am not a child photographer, I was to take the first photographs of Prince Charles and, two years later, of his new-born sister. On this second occasion, after a number of pictures had been taken, Prince Charles, who had been watching the proceedings with great interest, kissed the baby on the cheek, and thus was achieved the best picture of the afternoon, an infant version of the Sleeping Beauty.

My most recent pictures of Princess Margaret were taken when she came of age. That day, we utilized the Chinese Drawing Room for our backgrounds, also a pretty, rose-coloured room whose walls were hung with Boucher tapestries representing the life of Don Quixote. She looked extremely small as she sat for my camera, while through the lens I could see her wonderful complexion, the ice-cream pink cheeks and the intensely blue cat-like eyes. She was wearing an evening dress by Dior of which she was very proud. The embroidery on this skirt intrigued her for she said it contained pieces of potato peel. It was not easy for her to get French dresses, as she must of course encourage British dressmakers, but this was a rare exception.

It is not always entertaining to sit still and pose by the hour while inarticulate people run around one in circles, but long after the novelty has worn off and saturation point

has been reached the Royal Family are patient and obliging. Sometimes three or four changes of dress or uniform are made during the session and each change may mean a walk of a quarter of a mile down endless Palace corridors to a bedroom and back.

The late Duke of Kent was my first royal patron. A most sensitive and delightful subject for pictures, he brought a lightness and charm to every photographic session, even to those difficult occasions when it is necessary to stand stiffly to attention in some resplendent uniform. I was fortunate also in taking many sittings with his beautiful wife and children in their house in the country, including those tragic snapshots which were taken a few days before he was killed.

The Duchess of Kent has provided me with many of my most pleasant photographic memories, imbuing them with her mysterious beauty and dignity together with all sorts of ravishing dresses, Queen Alexandra hats, Greek national costumes and parures of romantic jewellery.

Many members of the Royal Family are extremely interested in the technique of photography, and, taking their own private snapshots, know a good deal about the various small cameras in use. Like all of us, they are often curious or even impatient to see the results of these long sessions. When the proofs of the pictures have been submitted, I am sometimes summoned to discuss the results. There are perhaps thirty or forty prints laid out on the floor so that the housemaids have a shock in the mornings when they come to do the rooms. I have never suffered heart-break that my favourites were not among those chosen, for, in general, the royal choice has coincided with mine.

In the old days, the Court photographer brought in to document a family event, a christening, a wedding, a coronation, was allowed ten or fifteen minutes to peer under his black velvet cloth at the figures as they stood stiffly in a group upside down in the ground glass of his camera. Today members of the Royal Family realize that, the demands from the public and the Press becoming ever more voracious, being photographed is one of the serious obligations to which they must submit at increasingly frequent intervals and for sittings that can take a whole afternoon, or a whole day.

Like all people who are good at their jobs, whatever their walk of life, members of our Royal Family are thoroughly professional in their attitude to the procedure of being photographed. The photographer is asked about the locations and clothes which will be most photogenic, anything within reason that he requires will be supplied with grace, and he is given every opportunity to do his best work.

Kings and Queens are not in the habit of visiting a photographer in his studio, and so he has to set up his paraphernalia and lights in one of the rooms in the Palace. The sitting usually involves a number of people – the Palace electrician, my own electricians and assistants, the superintendent who produces a screen and some red velvet curtains, the gardener who manages to provide some carnations or gladioli splayed out in a cut glass vase. I bring a number of extra props in case they are needed, but I try to avoid delays and to make the sitting as informal and relaxing as possible.

An equerry or lady-in-waiting appears to check that all is well, retires and soon the page announces the imminent arrival of the sitter. At the far end of a long corridor a very small figure, possibly wearing a crinoline, is approaching. As the swish of her dress material becomes louder, I go towards the advancing figure and make my bow. My assistants are presented. Bows left and right, smiles, some remarks about the background I have set up or the chair chosen to play an important part in the sitting. Then the feverish exciting work begins.

THE HANGMAN'S CALL . . . The Peeresses' hair set at dawn by the hairdresser . . . At six o'clock the stream of arriving guests: dignitaries in cockaded hats, black velvet tam o'shanters, grey top hats, the windscreens of their motor cars proudly boasting their destination . . . Guests from every world, and from every part of it . . . Pink silk turbans, African feathers, apricot striped jellabas, magenta, orange, yellow waist-bands . . . From Burma, maybe, someone in emerald green velvet . . .

The Mistress of the Robes, Mary, Duchess of Devonshire, 1953

The massed Peeresses, an inconceivably wonderful sight . . . Their foam-white ermine and dark red velvet looking like a parterre of auricula-eyed Sweet William . . . They sway, nod and fidget graciously so that their diamonds are never at rest . . . Their décolletage the palest pampered pink . . . Nothing in the world could be more elegant . . . Among them, undoubtedly the most beautiful is the young Duchess of Devonshire, wearing the original eighteenth-century coronation robes belonging to Georgiana, Gainsborough's Duchess, completely different in their cut and line, her hair dressed wide. . . .

The Dowager Duchess of Northumberland, particularly pink and white with her blonde hair . . . She is a martinet, so her albino-haired page is all the time setting her embroidered train to rights . . . The simple beauty of the Duke of Edinburgh's mother in her nun's grey drapery . . . Even the young ladies in the choir orchestra playing the harp and the oboe wearing tiaras and white veils . . . An elderly peeress hobbling on a rubber-ended stick . . . The white satin bows on the shoulders of the crimson cloaks.

This wonderful ceremony takes the mind back through a thousand years, yet it is fresh and inspiring . . . The movements, the gestures, the weaving in and out of the robed figures, using first one portion of the Abbey and then moving, for contrast, to another . . . The supreme nobility of the words of the service has the double impact of surprise and familiarity that greets the mark of real inspiration . . .

Always one's eye is beguiled by the unexpected effect . . . A page wearing a turquoise uniform comes forward to receive a coronet . . . A mote of light catches a gold sequin fallen on the floor or a jewel in a Bishop's ring . . . The sun comes down and lights up the massed treasure of gold plate on the High Altar . . .

This is history, but it is of today, living and new. There is nothing ponderous or heavy; it is almost gay, the service following its course with the easy flow of the River Thames . . . There is no pretence or make-believe about this great display. These people have been born to perform these offices – to present a glove, an orb or a sword to the Queen. They have been rehearsing their roles since birth. Perhaps in other countries such men as these might seem to be in fancy dress, but here they wear their gold thread embroideries with the insouciance of total conviction . . .

So English in its flavour and tradition . . . The aged Heralds with spindly legs and white hair; one young Herald with the pale dun-coloured face of a love-lorn poet, and something haunting about his composure as he holds the two wands in his ivory hands . . .

Sir Winston Churchill – a stolid figure lurching forward in the aura of arabesques of white ribbons on his Garter cloak and fronds of his plumed hat . . .

The Pages, an integral part of the ceremony, always surprising with their miracle quality of youth, touching the heart with their good behaviour, their bows, their obeisance, or their casualness, their fidgeting and yawning, with their spruce white silk stockings, the elusive lock of flaxen hair. One page has a black eye with a patch

Sir Winston Churchill, 1953

The Duke of Edinburgh, 1953

Pages, 1953

over it . . . They are extraordinary contrasts to the venerable old men they serve, and their uniforms of surprising colours, grey, dark blue, orange, white, green . . .

Black Rod, Sir Brian Horrocks, like a Tintoretto, with lean face and sinister uniform, the lace cuff encircling the black glove that holds the rod with the ebony hand, the thin, black-stockinged legs . . .

The young ladies, the train-bearers, all slender and tall with the pallor of winter flowers in their satin dresses spangled with gold, which compete successfully with the uniforms of the high officers of state . . .

The ubiquitous, ministering presence of the Mistress of the Robes . . .

Princess Margaret's poise when receiving her train from her bearer . . .

The Duke of Edinburgh, his head cocked with intense interest as he follows every detail in the ritual . . .

The Queen has the suggestion of a smile which lightens the mouth. She looks at everyone with the recognition of compassion, a dedicated look, an expression of enlightenment, with the radiance of people who are much praised and loved . . . The erect stance and rigid little head with the hair so well curled around her Crown . . . The blush-rose complexion . . . Her touching beauty at the Anointing, without her crown, like a child in a simple white dress . . . Then, her Byzantine magnificence in the stiff bell-shaped brocade that has come straight from the Ravenna mosaics . . . The Imperial Crown, containing the Black Prince's ruby and the four drop-shaped pearls said to have been the earrings of Queen Elizabeth I . . . The cool hands, precise and simple in the symbolic gesture of returning the Spiritual Sword to the Altar . . . The poignant, youthful voice giving a Sovereign's responses with an absolute and natural authority . . .

Queen Elizabeth, 1948

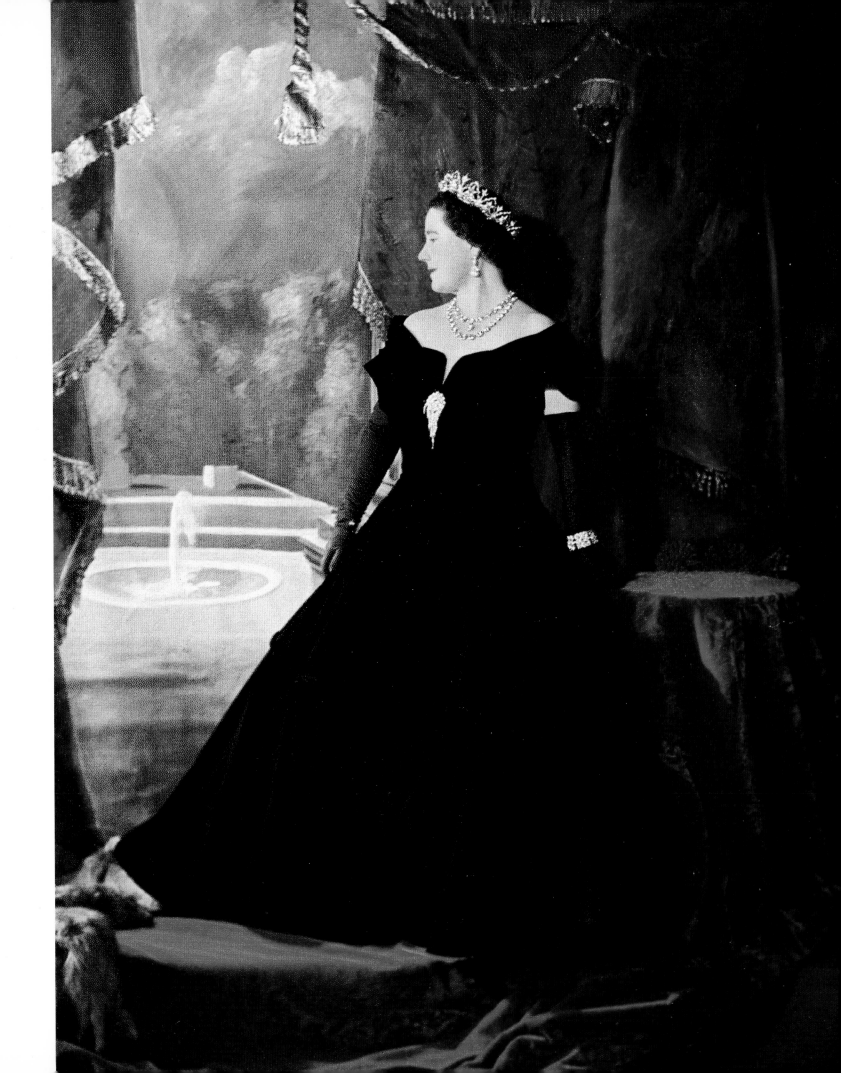

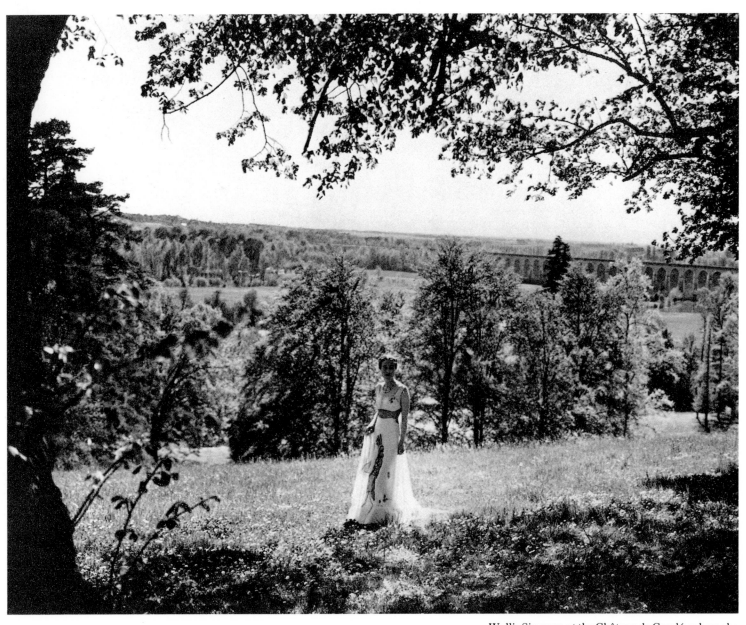

Wallis Simpson at the Château de Candé, where she
married the former King Edward VIII, 1937

The future Duchess of Windsor,
Mrs Wallis Simpson, sketched in
London, 1937

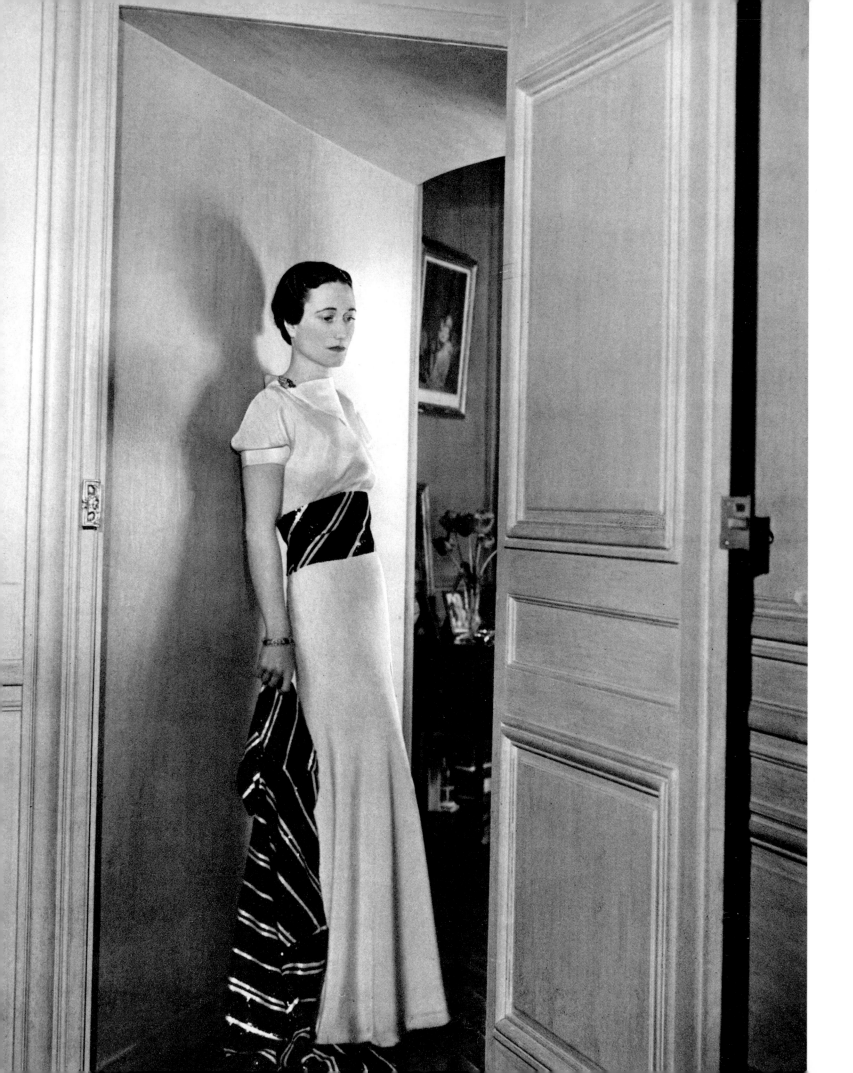

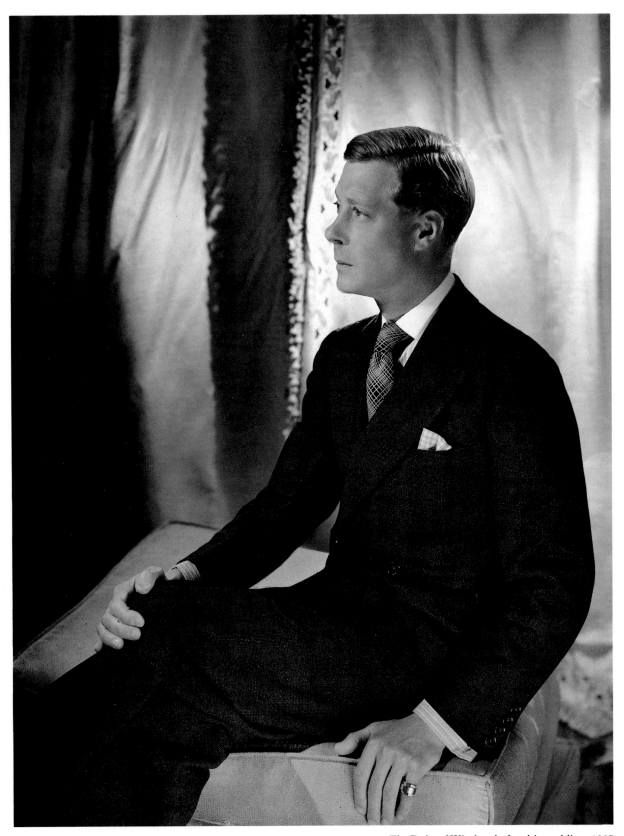

The Duke of Windsor before his wedding, 1937

Mrs Simpson at the
Château de Candé, 1937

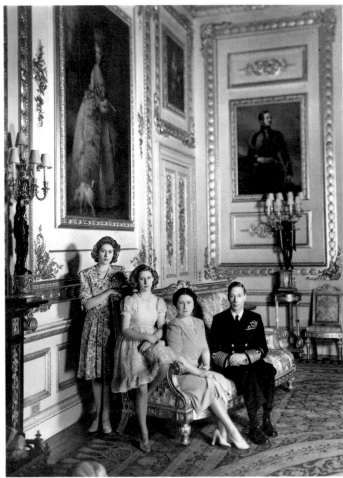

The Royal Family. King George VI and Queen Elizabeth
reviewing the bomb damage at Buckingham Palace, 1945
(*above*); with their daughters Princess Elizabeth and Princess
Margaret at Windsor, 1943 (*above right*)

Queen Elizabeth at a charity exhibition of antique lace, 1942
(right); at Buckingham Palace, 1939 (*opposite*)

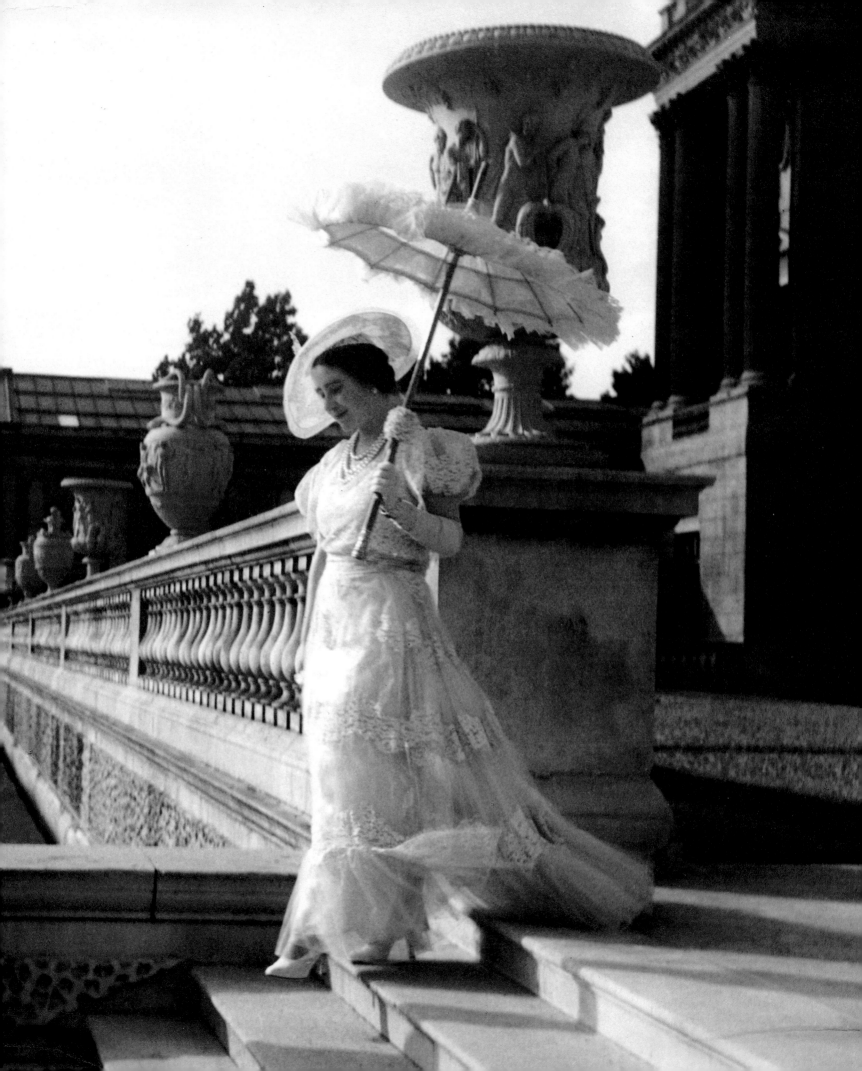

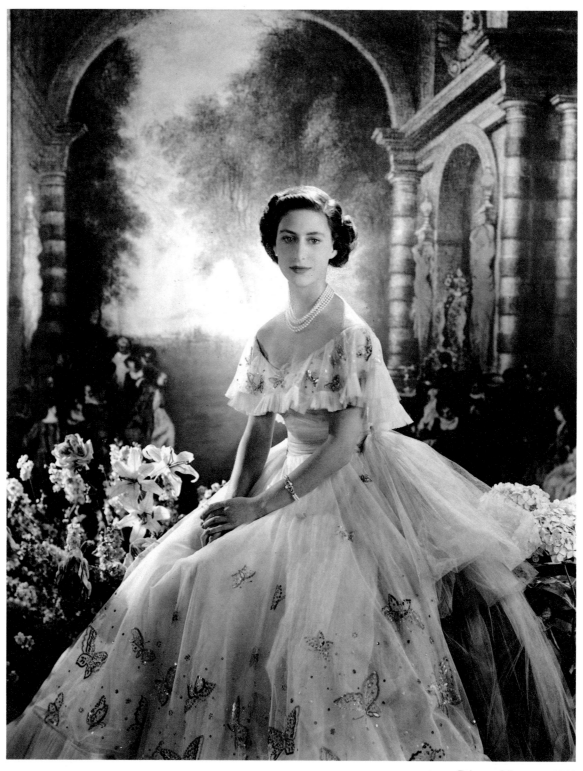

Princess Margaret, 1949

Princess Elizabeth on her sixteenth birthday,
not yet in uniform but wearing the insignia
of the Grenadier Guards in her hat, 1942

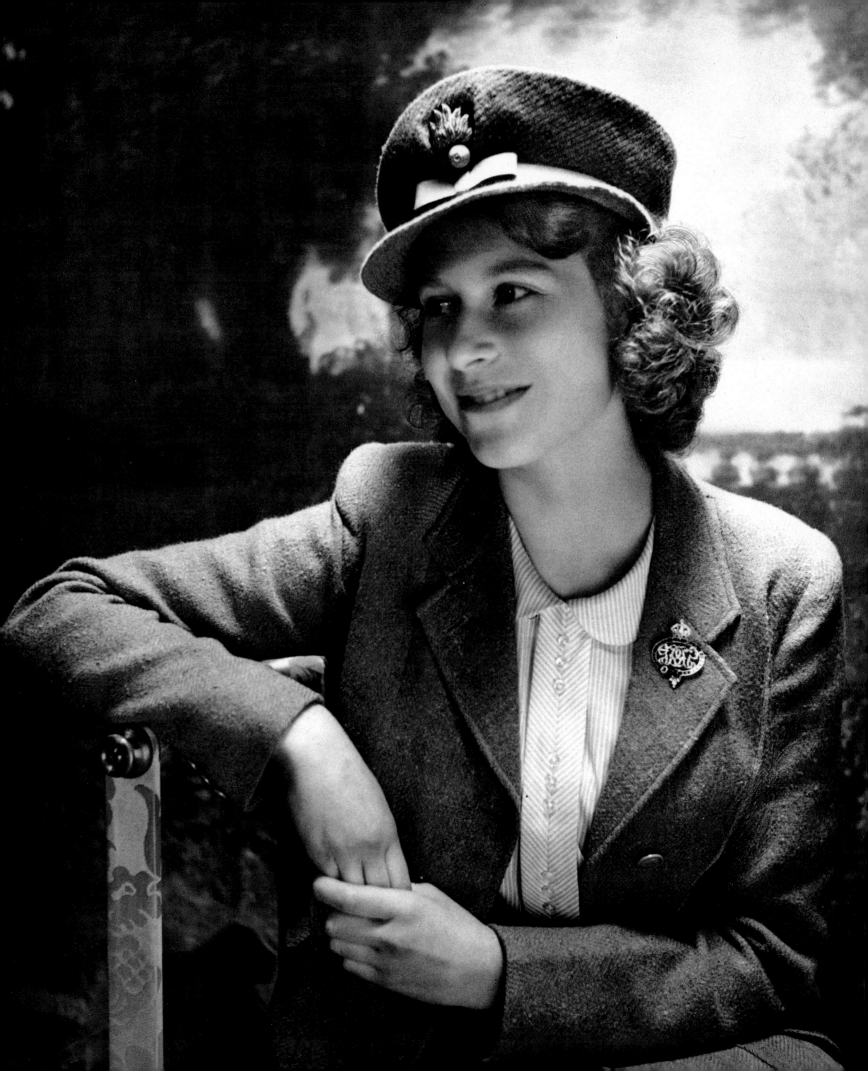

Lady Alice Montagu-Douglas-Scott, soon to be Duchess of Gloucester, at the time of her engagement, 1935 (*left*); Beaton sketching the future Royal Duchess (*above*); the Duchess's sons, Prince Richard (*above right*) and Prince William (*right*), 1949

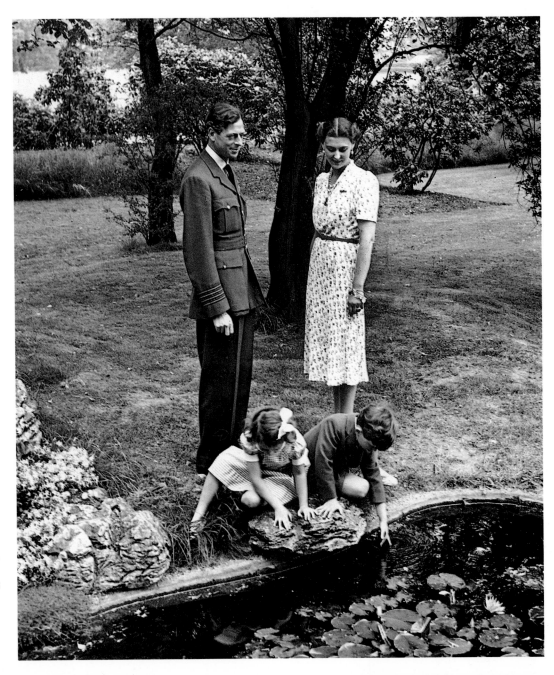

The Duchess of Kent, formerly Princess Marina of Greece, 1949 (*left*); with the Duke of Kent and their elder children, Prince Edward and Princess Alexandra, 1941 (*right*); watching aircraft, 1941 (*below left*); the present Duke of Kent photographing his mother, 1952 (*below centre*); Prince Michael of Kent, 1953 (*below right*)

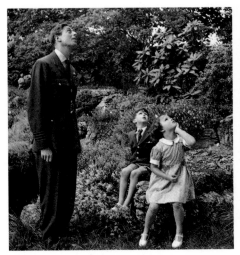

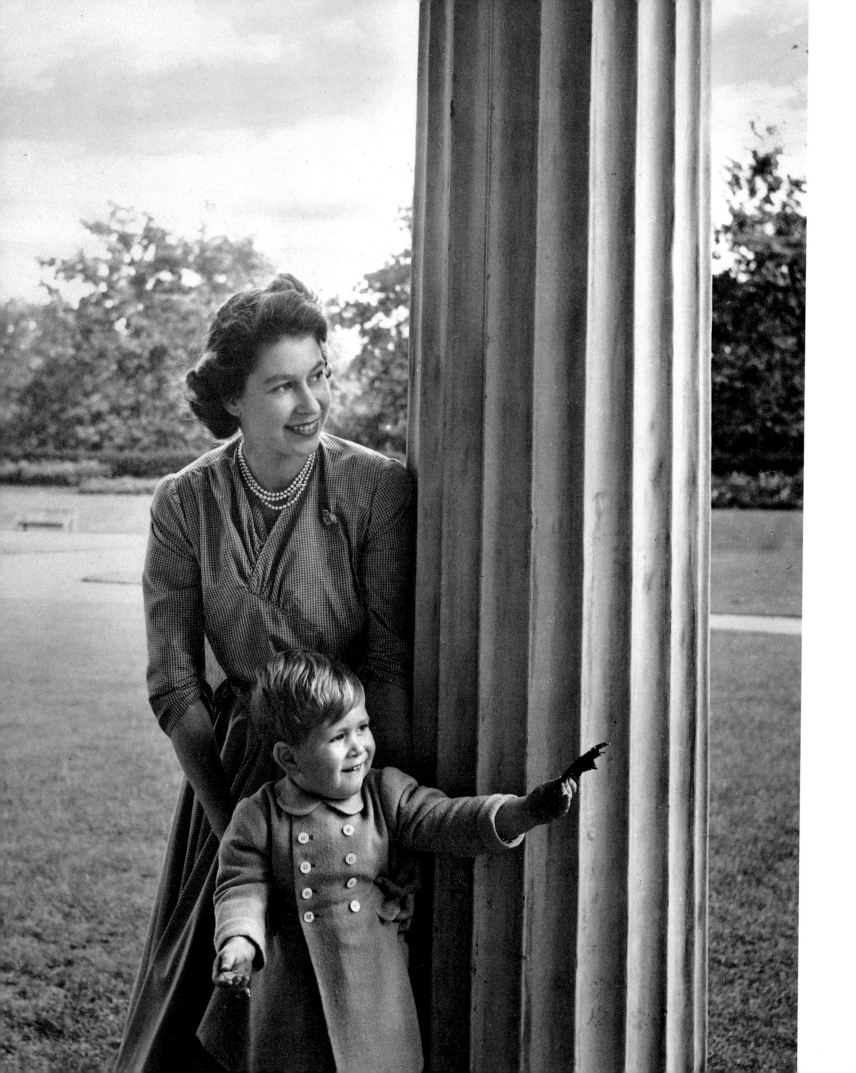

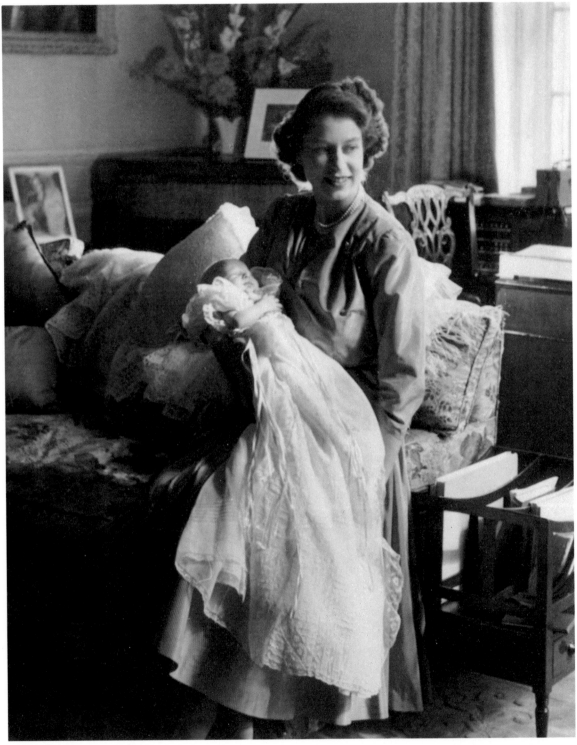

Princess Elizabeth at Clarence House with Princess Anne, 1950

Princess Elizabeth at Clarence House
with Prince Charles, 1950

Overleaf: The Coronation, 1953. The
moment of Homage in Westminster Abbey
(*left*); Queen Elizabeth II with Regalia (*right*)

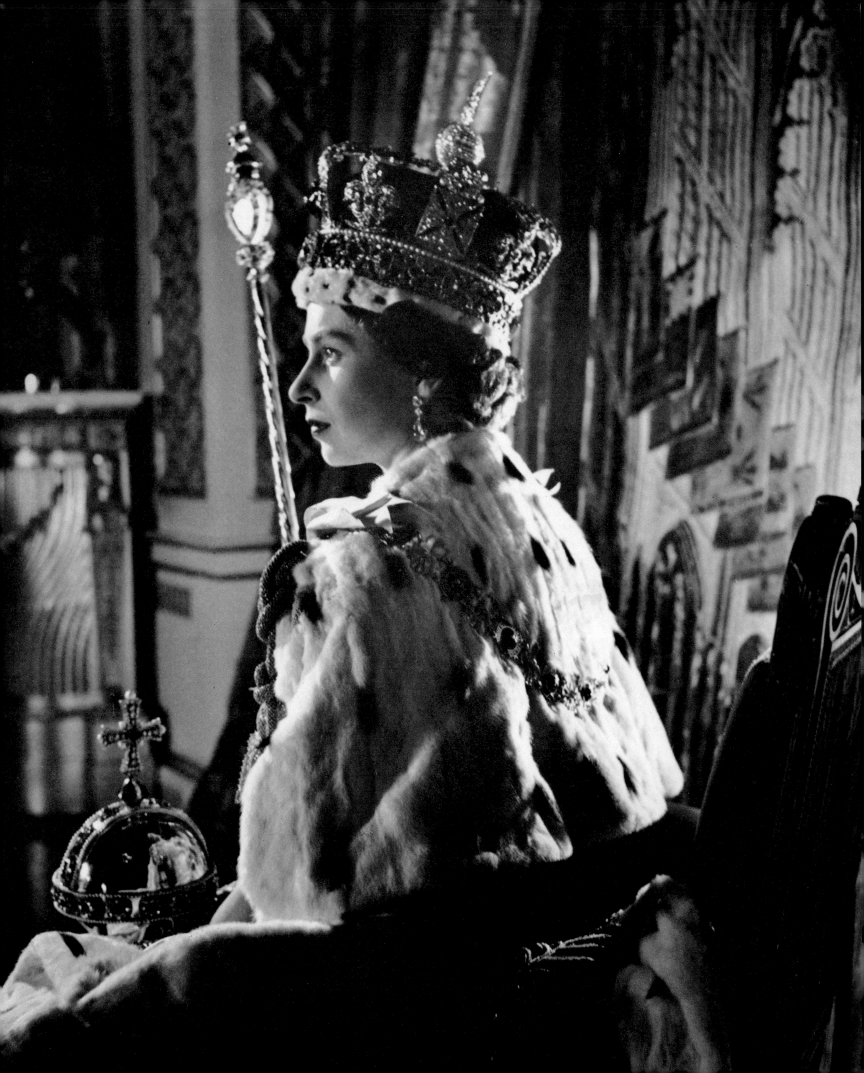

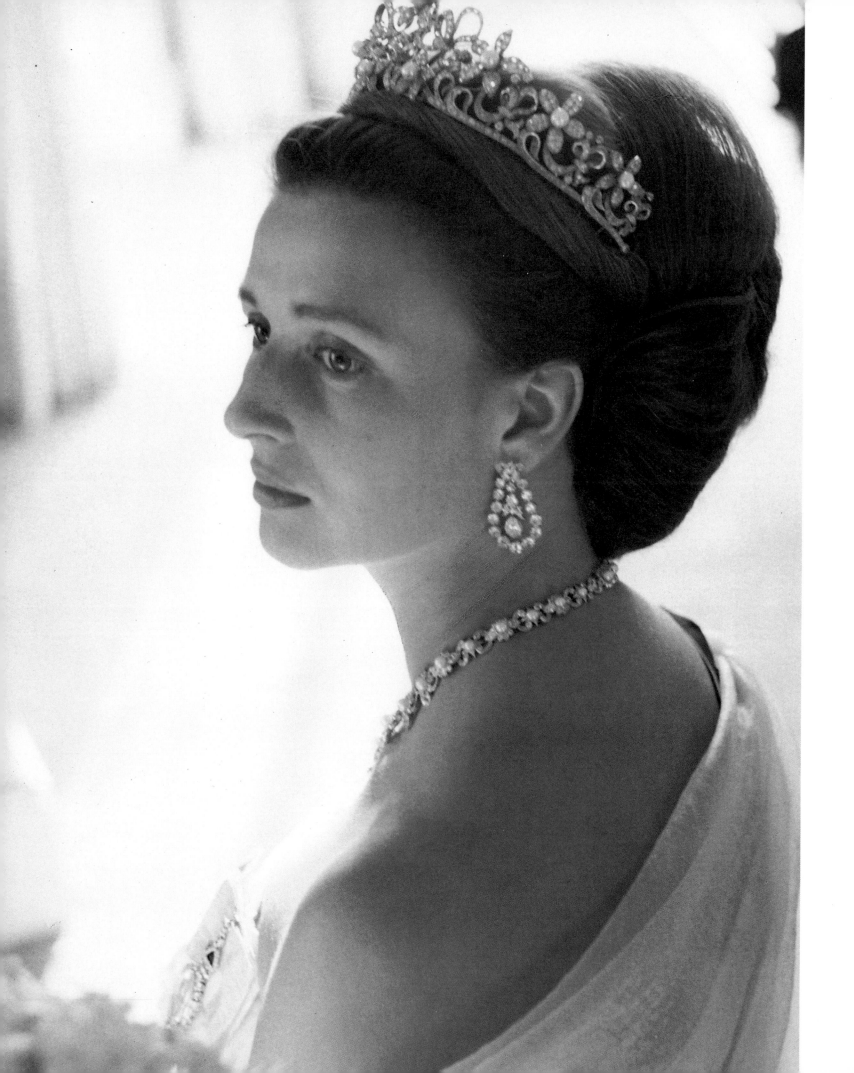

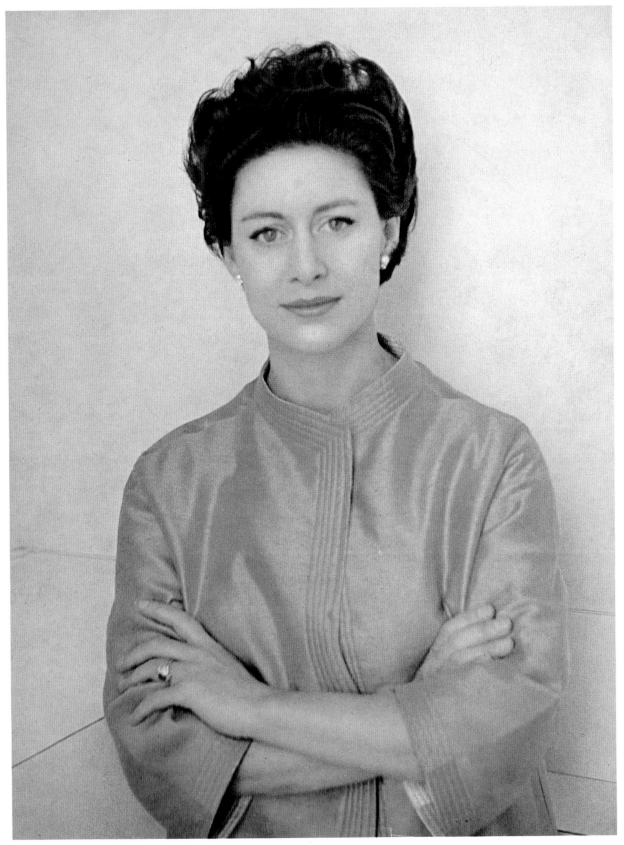

Princess Margaret, 1965

Princess Alexandra, 1967

Overleaf: Queen Elizabeth II, 1968

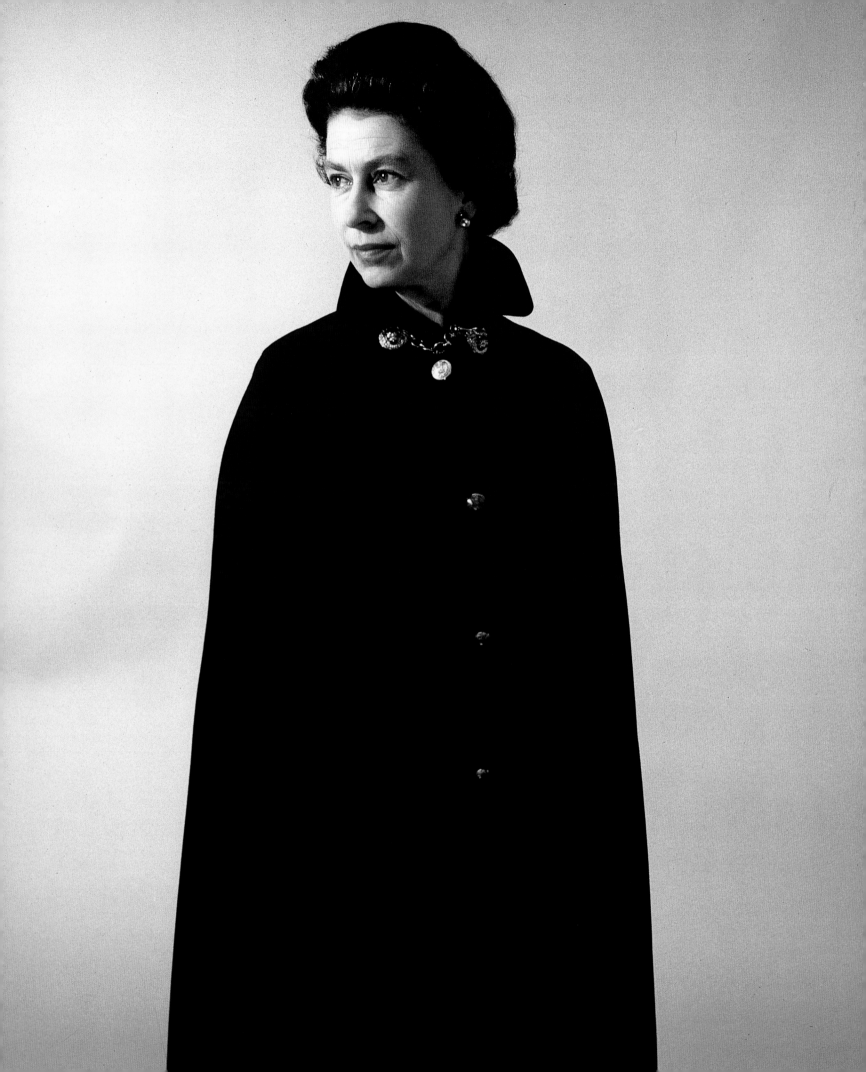

5 · Fashion

'What you don't see at Hattie Carnegie's', 1932

Modern Chic (1928)

EVEN OVER the magic of beauty is fashion triumphant. What was considered beautiful yesterday is dowdy today. The great height of Helen inspired paeans of praise in Troy, but in London today she would be considered 'too handsome to be attractive'. We may admit that Lulu [Louise Brooks] is lovelier than even the original Gibson Girl, but we have no use for copies, however good. Lulu has arrived upon the scene too late. A new kind of Venus is acclaimed.

Our standards are so completely changed from the old that comparison or argument is impossible. We can only say, 'But we like no chins! Du Maurier chins are as stodgy as porridge; we prefer high foreheads to low ones, we prefer flat noses and chests and schoolboy figures to bosoms and hips like water-melons in season. We like heavy eyelids; they are considered amusing and smart. We adore make-up and the gilded lily, and why not? Small dimpled hands make us feel quite sick; we like to see the forms of bones and gristle. We flatten our hair on purpose to make it sleek and silky and to show the shape of our skulls, and it is our supreme object to have a head looking like a wet football on a neck as thin as a governess's hatpin.'

In offering a humble platter of advice to aspiring beauties I would ask them to study well the 'top layer' of the beauties of today, to analyse, to try to get to the bottom of the success of the loveliest, the most chic and attractive, to realize the method of 'producing' themselves employed by the modern Venus, for by appreciating others a personal sense of right and wrong is developed.

It is absolutely necessary for the modern Venus to behave in a modern way. The fashionable methods of speaking, sitting, crossing the legs, smoking a cigarette, and holding a cocktail glass change as much as clothes and figures. For an example of completely modern behaviour, I would advise the pupil to study Lady Louis Mount-batten, not because of her features, which are not classically 'good' (her effect is too cold and harshly 'smart' to be luscious), but for her chic, her taut toes and superarched insteps, for her sagging stance, for her restrained self-consciousness, and for her consciousness of her elbows – for these we give her a lofty pedestal. She is the almost perfect pattern for the novice.

Copy her weighty elbows dug tightly into her hips, try to achieve her 'glamour', which effect I attribute to her meticulous grooming (one's head bursts with visions of dairy cream, waterlily cream, ice, cucumber lotions, massages and shampoos). And for those without the opportunity of studying this paragon, I prescribe a daily and careful perusal of the work of Carl Erickson (who signs himself Eric) in *Vogue*.

His brilliant drawings show, for instance, that this is the day of thumbs, for even when fashionable hands are clenched the thumb must protrude like a cold chicken leg. The drawings show us the crisp bony hands seen today, holding glasses as they should be held; they show how feet are placed and used, and they answer victoriously our

'The Modern Venus', 1928

'The crisp bony hands seen today', 1928 (*left*)

challenge of the supremacy of make-up. They show how ladies behave while waiting for the arrival of the last dinner-guest; they show how cigarettes are lit with patent-lighters; how much and what jewellery is worn; and all the other more subtle whimsies of fashion.

London Tea-gowns (*1931*)

WHAT IS IT that can not enter a ballroom, that is produced most successfully in England, that has but few fastenings, and may possibly flaunt sleeves? The answer is a tea-gown – that garment worn by ladies in languid mood during a quiet evening at home, that delights men because of its femininity, that enchants women because of its comfort and ease. Though essentially smacking of the boudoir, steaming bath water, and perfumes rather than of the grandeur of chandeliers and curtain tassels, this robe possesses the glamour of the evening dress and of that sudden radiance assumed when 'changed for dinner', yet, in it, complete relaxation is possible.

Who can lie back, full length, in an evening dress, with dignity? But tea-gowns are seen at their best advantage with their draperies flowing over sofas and cushions, and, in them, reading and lolling are considered suitable behaviour. More than any other garment worn to-day, they are redolent of feminine caprices and wifeliness. More than any other, they can be readily appreciated by men, for what fox-hunter, even, can not but feel the spell of an Ouida atmosphere of frills and furbelows, a rose that hides a fastening, and furs that soften a neck-line?

This garment is only a pretence at an evening gown, and freer reign is allowed in the planning of it. Pieces of old Persian embroidery, Russian altarcloths, and Moroccan braid can be put to all sorts of unexpected uses, and, perhaps, that is why the English, with their 'Sunday' or 'rainy afternoon' talents, excel in this particular designing game.

The tea-gown in England is as much of an institution as *Punch* magazine, and the pyjama has never replaced it. With minor exceptions, it is apart from the mode; its function is to spell quiet evenings at home – evenings when, although the cook is out, the candles are lit and a four-course dinner is still served by the enigmatic butler. Berets may come from the Basque country, astrakhan and embroidered blouses from Russia, tartans and tweeds from Scotland, and Vionnet from Paris, but tea-gowns come from England and are her contribution to dressmaking.

Putting On Local Colour
(1932)

THERE IS A GREAT excitement in returning home from abroad and unpacking the booty and spoils gained upon your journeys. Now this international passion for souvenir-collecting has veered into a purely sartorial channel. Trunks open upon motley garments collected from various parts of the earth, upon bits of peasant costume, silly hats bought in village stores. Women who dress cleverly with chic individuality and who wish to evolve something new and original for their sports clothes have turned back to native costumes for their inspiration.

Along the quay at St Tropez are the little shops that originally catered to Basque fisherfolk but have now proved to influence the world of fashion; for from here originated the little shepherdess hats trimmed with impertinent bows and bouquets of oddly assorted flowers. Made of paper, they are the jauntiest things, and Madame Schiaparelli has undoubtedly been inspired by the woollen suits in one of these little stores. Even the best of friends fight in their endeavour to be the first to make their choice of the infinite variety of grotesque hats, some enormous and like a Chinese mandarin's, others nothing but berets or knitted caps as small as the Pope's birettas, and ten thousand brands of sailor suits. The sailor clothes and the sweaters are almost indistinguishable from stage sailor costumes, and there are wiry flannel pants for any man who may wish to turn himself into a pirate for an evening.

'Handkerchiefed like a fishwoman', 1932

The Austrian Tyrol provides opportunities for the hunter; here the clothes have infinite variety and charm and are fashioned in much the same tendency as the current mode, for they have broad padded shoulders and lapels, bright brass buttons and jaunty billy-cock hats. In Salzburg visitors are rabid to 'go Tyrolean', for the little jackets such as the red and blue ones with old horn buttons, in the sketch, are terribly smart. Mr Lanz supplies a variety of coats and capes, jauntily cut out of coarse materials in white, pale blue and olive green. Mr Jahn's speciality is making short leather jackets to any design in any colour at the minimum notice. It is said that a smart American has bought one hundred pairs of short white leather or linen pants which she will wear at Palm Beach, and she cannot resist (how could any lady?) an outfit that Robin Hood might have worn in the forest of Sherwood.

And so it goes the world over. In Scotland all the visitors buy tweeds and tartans. In America's 'West', blue canvas dungarees, leather jerkins, large sombreros and windbreakers, made of leather or imitation leather, patterned in checks of various sizes and colours, with elastic belts, are piled to the ceiling in the local store and can be had for small coin. In Havana, white canvas boots, soled and decorated in geometrical patterns in black rubber, black laces, looking like an acrobat's or tightrope walker's footwear, and infinitely suitable for the tennis court. In Mexico, belts with silver studs, and, if you are the kind who like barbaric jewellery, here is your big opportunity.

In Tyrolean jerkin, 1932

But, beware. You must be wise and discriminating in the junk you pick up right and left, just as you must be with the rest of your wardrobe. Because Princess Obolensky wears a Tyrolean peasant's jacket with complete success while drinking her chocolate at the Café Bazaar, little Miss Anybody must not be under the impression that she can stroll out upon the golf links sporting a pair of sailor pants. The rules of suitability and practicality apply, and there are many pitfalls, for every detail must be right. Nothing can be overdone. The right shoes have to be worn and also the necessary swank. You must not wear an African necklace unless you wear it with an air; you must be cocksure in your Saint Tropez shepherdess hat. You must not blush when your lederhosen are remarked upon.

FASHION, RATHER than clothes, makes the woman, for fashion brings about physical changes in the feminine frame – adds inches here, lops off there, reduces or adds weight by many pounds, and even alters the colour schemes of human nature.

In one decade fashionable women look quite different from those of the next. Fashion moulds not only the silhouette, but also the face and figure. After the last war we admired flat-chested women, with slightly hunched shoulders and cropped messenger-boy hair. Before that the beauties had an admirable en bon point, with dimples and well-covered wrists. For ten years now we have admired high cheek-bones, pouting mouths and bony hands, so that, perhaps instinctively, a large number of women who in other decades would have acquired another cast of form, have now acquired the most envied attributes of fashion.

Perhaps the swing of the pendulum is now pointing to a complete change. If ever any of us enjoy peace and plenty again, the great beauties will be like Renoirs and Rubens, and the beauty of the neck will be once more admired, and we will look back with distaste at the hollow cheeks, the salt-cellars and scraggy necks of the beauties of the Forties.

Comparing photographs of the fashions of today and of our grandmothers' time, one is inclined to wonder whether the twentieth-century ladies are as enhanced by their dressmakers as were their predecessors: whether the woman of today stands a chance against the more statuesque grandeur of the past. Comparisons are always unsatisfactory: the stance, bearing and manners that went with skirts containing yards of heavy brocade would be unsuitable with the scant tweed suits and little black dresses of today. The spirit and attitude of mind of each epoch must be complete in itself, with its own independence, its own indivisible personality.

EVEN THE MOST exceptional beauty can add to her effect by means of adornment. Decorative needs vary from woman to woman, depending on age, aura and bodily structure. Some women, to balance oddly shaped heads or uneven features, or to complement some outstanding feature, may resort to a bird, feathers, or simply a rose. Since the days of Rubens, the value of a brim has been greatly appreciated.

There is beauty and beauty. Nature, capricious to the extreme when it comes to doling out virtues, makes one woman flat-breasted, another full; hips, height, features and complexion vary according to the laws of an unpredictable universe. If nature loves the unique, why should we not allow these variations latitude?

Thus the wise woman accentuates her individuality. Cleopatra's nose did not prevent her from becoming the quintessence of allure. The woman with black hair and eyes should dress herself as for a funeral; the woman with blue eyes should put cornflowers in her hair. The woman with the big mouth should never paint her lips to look small. Neither do I approve of pale powder or anti-kink lotion for Negroes.

Each woman must discover her own tricks in these matters. Each must assert her own personality. Each nationality must abide by its own laws. The English tourist in Tyrolean dirndl and edelweiss is as unsuitable as the Japanese lady in sweater and jeans. The Frenchwoman, though she often tries, never looks her best in tartan and tweeds. The American woman should wear a little pill-box hat on top of her head, as most of them do. The Englishwoman is at her best in garden hat, the Indian in her sari, and the Chinese in her slit chemise. After all, there is a relationship between form and

content (which is why I personally disapprove of plastic surgery). We are what we look. Artifice can be a dangerous thing; when misapplied, the results are vulgar and tawdry. Its correct use depends upon instinct. But when properly invoked, it is not merely an illusion: rather, it makes the observer see what he should see.

The Changing Face of the Fashion Model (1967)

The 'heart-breaking, helpless appeal' of Lily Elsie, 1928

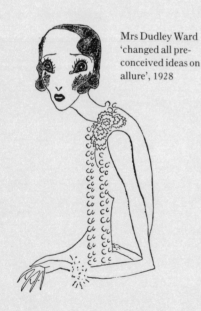

Mrs Dudley Ward 'changed all pre-conceived ideas on allure', 1928

LOOKING BACK at the serried ranks of model girls who, ever since I started out with my Folding Pocket Kodak, have moistened their lips and looked at the 'birdie', the greatest surprise comes with the realization of how short the butterfly span has been of these exquisite creatures. Of all careers, that of a star model has the shortest span.

By her very nature, being the possessor of a photogenic face (one without shadows or undertones, one that never reveals too much character), she is merely pretty; and, like the primrose and breath itself, she is gone tomorrow. And how quickly our views on beauty fluctuate. Even in two years the ideal can undergo a complete change.

Lily Elsie had London at her feet with her heart-breaking, helpless appeal, but her type today would seem too gracious, gentle and lacking in vitality. When Mrs Vernon Castle, an American, bobbed her own hair and protruded her hips in a backward stance, a more boyish appeal was admired. This was further developed by Mrs Dudley Ward who had the bones of an ortolan and, flat-chested in her Chanel suits, changed all pre-conceived ideas on allure. It is a curious phenomenon that the demand for a certain new type of beauty is always supplied. Anita Loos, Adele Astaire and a million others were of the same spindly, 'messenger-boy' mode. Suddenly any young lady with a large bust was considered extremely unfortunate.

A little later Baba d'Erlanger appeared like an Arab's monkey with a pillbox on her shingled head, since when this look has become almost universal and is apotheosed today in Schiaparelli's granddaughter, the appealing marmoset Marisa Berenson. Paula Gellibrand, a corn-coloured English girl and foil to Baba d'Erlanger, was the first living Modigliani I ever saw.

It was not until Miss Marian Moorehouse was discovered by Steichen that photographic models became so well known that they exerted an influence on the public. The aim of models at this time was to be grand ladies, and Marian Moorehouse, with her particularly personal ways of twisting her neck, her fingers and feet, was at home in the grandest circumstances. Like a highly trained racehorse she responded to all nuances of direction, and being a woman of the greatest sensibility was able to give distinction to every tea-gown, riding habit or buckled shoe that she wore. Miss Moorehouse, with her sleek head and attenuated limbs, was the epitome of elegance and of everything that dear old Aunt Edna Chase (with Condé Nast, the creator of *Vogue*) would have held up in comparison to the abominations perpetrated in fashion pages today. Miss Moorehouse (now the widow of the poet e e cummings) was the first famous model with whom I had worked, and suddenly I was breathing pure oxygen.

At this time another American, Lee Miller, cut short her pale hair and looked like a sunkissed goat-boy from the Appian Way. Only sculpture could approximate the beauty of her curling lips, long, languid, pale eyes and column neck. But Miss Lee was not happy in Hattie Carnegie's frills and flounces and discovered Europe where Jean Cocteau, making films, discovered her and covered her with plaster.

Dovima, a beautiful giraffe from the suburbs of New York, with almond-shaped face, raven hair and turquoise eyes, painted her face so white that her teeth appeared

black. She posed with often outrageous exoticism in the salons of Fifth Avenue, Avenue Montaigne and the Sahara until the warning bell, and with her bags laden with golden dollars, she returned to her happy husband, suburban villa and obscurity.

By far the best model with whom I have ever collaborated is Dorien Leigh, now the successful owner of a model agency. Never strictly beautiful in the academic sense, but with features that combined to make a marvellous aesthetic entity, she knew more about the job of posing than anyone before or since. She took ballet lessons, did physical exercises and kept to a rigid diet. She trained herself to keep still for hours on end without showing a twitch of fatigue. Dorien sensed exactly what to hide, what to project, and was an inspiration to a photographer. Many is the time I have confessed that the clothes to be photographed have found me lacking in all inspiration: each time, by inventing a new mood, she elevated the sitting above the level of tawdry commercialism.

It was only recently that English girls were among the ranks of top models. Jokes were made about heavy legs, vast feet and thick wrists, but it was no joke for the photographers trying to make something with such raw material. The nadir was reached directly after the war when, released from the WAAF and WRNS, buxom girls tried to assume in rationed clothes a sophistication that neither they, nor their costumiers, understood. The situation perked up when Miss Barbara Goalen appeared as if from Cruft's.

While working one early morning at Shepperton film studios I noticed a picture of misery sitting on a packing case. She was wearing tawdry finery supplied by 'Wardrobe' and a tired cotton camellia on her partly-dyed head. I realized this extra had something extra. This indeed proved so. In London, Paris and New York Della Oake gave a refinement and delicacy to every garment she wore until she was claimed in happy marriage by an American tycoon. My love to you, Della.

My other discovery to achieve an hour of glory was Carmen – a 'Renaissance' child with a heart-shaped face, enormous aquamarine eggs for eyes, and bad teeth, whom I saw on a bus on Fifth Avenue. Soon, wearing a brace but never smiling, Carmen blossomed into a highly paid clothes peg. But the 'Renaissance' and applied sophistication did not ride happily together.

By now England was supplying a new breed of model girls who tripped the cat-walk from all walks of life: Fiona Campbell-Walter (Baroness von Thyssen) and Sandra Paul were among my favourites. English models became indispensable everywhere; they flew to Berlin after a Paris stop-off, then ricocheted across the Atlantic. More coveted than any was Jean Shrimpton who, with her Pekinese features, could well have been tied up in ribbons, placed on a swing and told to sing 'Swing High, Swing Low' from *Véronique*. Miss Shrimpton's appeal is not so much in her baby-boy eyes, cleft underlip and cosy round cheeks but in the length of her extremities, and the underwater manner in which she wields them. But it was bright-eyed Bailey who realized that by wearing Levis and jackboots, and clothes that militate against her sweet-briar appearance, 'the Shrimp' can belong to the contemporary scene.

Most models have 'no' faces: faces without noses, without definition or any too marked characteristic. Today anonymity is further exaggerated by painted-out lips and eyes lost in black shadow. (These painted lids, started with Garbo, have become so hackneyed that they will soon appear as ridiculous as the plucked eyebrows of the twenties.)

But there are great changes afoot. In spite of the butchery of plastic surgeons and the commercialism of facial lifts the nose is now on its way back. Avedon went to Guatemala with a girl with a large nose; when his photographs appeared the shape had great impact.

But if character is emerging in the model's face it is becoming even more apparent in her figure, stance and the way she moves. We like our models to place their legs in the natural way of a gangling child – the patterns formed by the body must be personal. It is not the baby stare that makes Twiggy a success, rather is it her concave droop, as of a punctured marionette, the almost 'triumph over the spastic' appeal that sends her to the top of the class. The fact that Luna from the jungle can thrust her head forward like a champion ice-skater while turning her arms back to front, is her important individual contribution to the history of fashion modelling.

Today models do not try to emulate grand ladies. They do not want to look rich, for dressing is no longer a question of one-upmanship. Class distinction has gone from the model scene, and a moth-eaten ostrich feather boa from Granny Takes a Trip, or a policeman's cape from I Was Kitchener's Valet does as much for its present owner as a sweet-pea toque from Reville did for Queen Mary.

It is forever fascinating to see the human form undergoing its continual changes. It is no use the wholesalers trying to dictate, nor the clothes manufacturers, the cosmeticians, nor hair-stylists. The change from fat to lean, from small to tall, from strong to weak, from grand to poor, will continue unassailed in spite of all protests, and the one ineluctable, abiding fact is that these changes are mysteriously brought into being by those who have no knowledge of their forebears in fashion – but who by some instinct know how to personify the next generation.

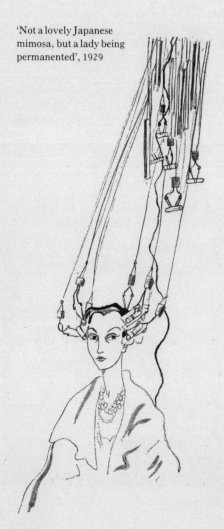

'Not a lovely Japanese mimosa, but a lady being permanented', 1929

The dressmaking workroom at Elizabeth Arden's, 1944

Dress from Bergdorf-
Goodman, in the
background a painting
by Tchelitchew, 1935

Silk paper taffeta dress,
against a Jackson
Pollock painting, 1951

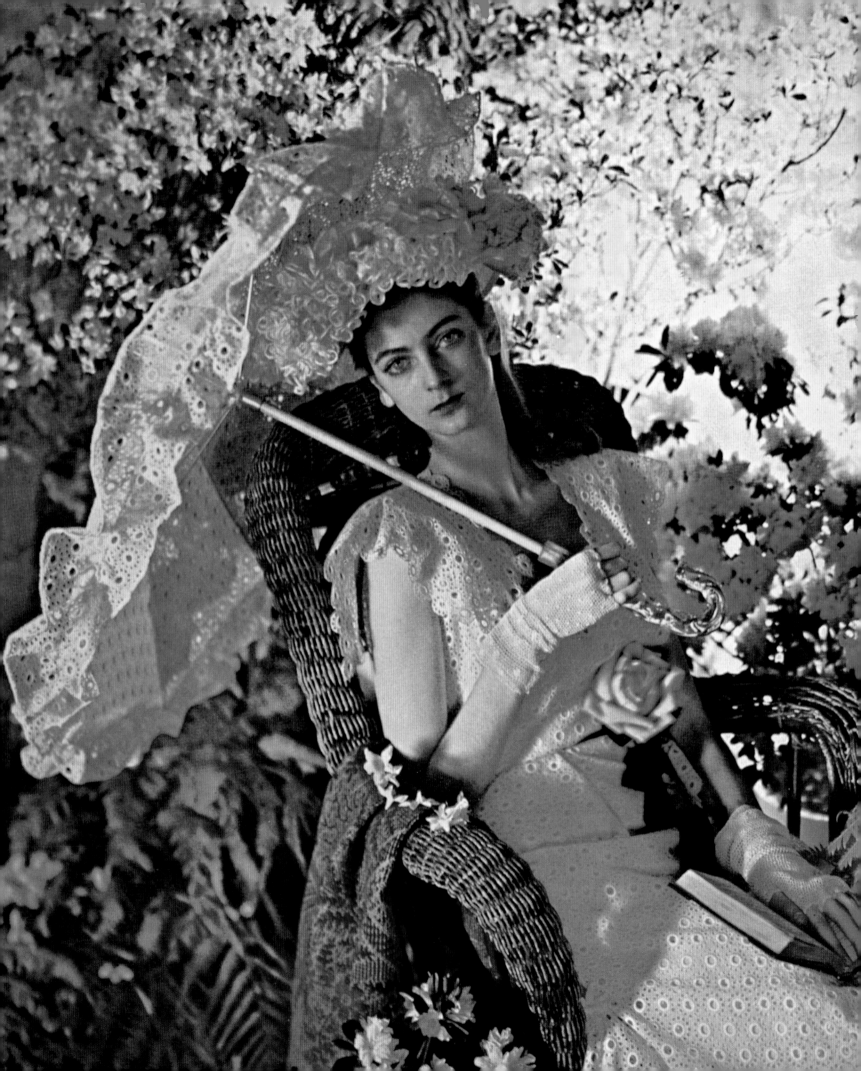

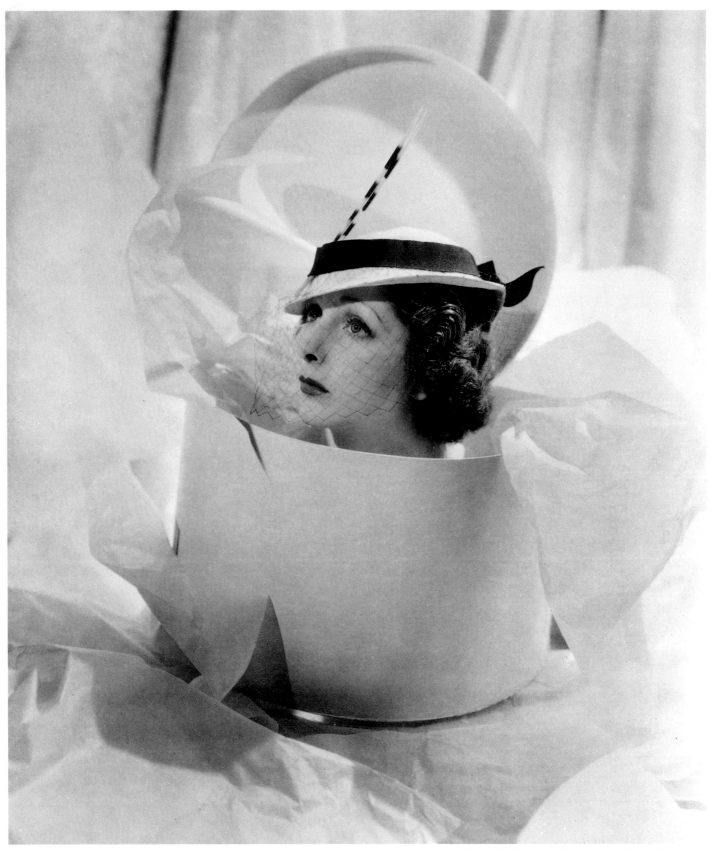

Surrealist Beaton: white panama hat by Suzy, 1934

Broderie anglaise dress and parasol, 1946.
'The blue on blue effect was tricked up in the
engraving' by eliminating parts of the black
plate

165

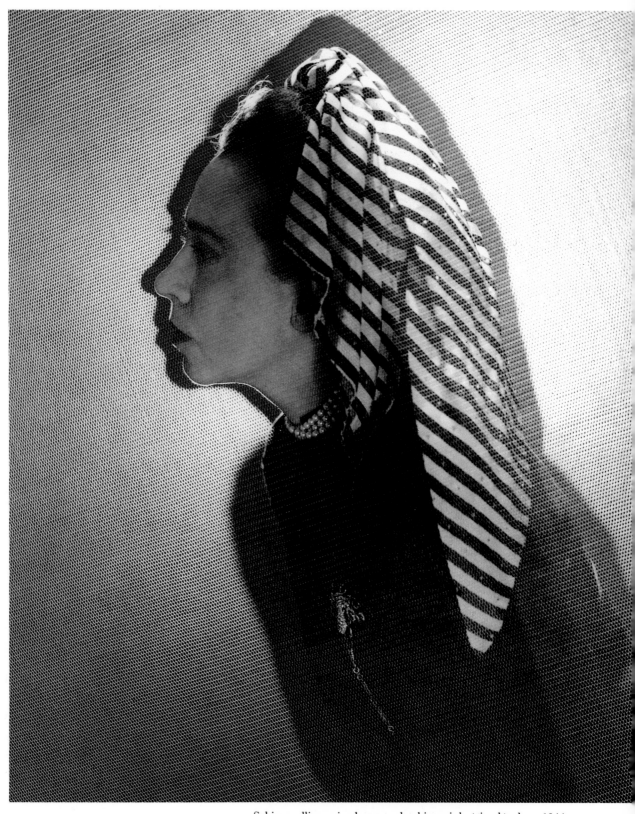

Straw hat with fish-net veil, by Lilly Daché, 1934; Napoleon hat of black felt with red-and-white cockade, by John Frederics; navy sailor hat by Molyneux, 1934

Schiaparelli wearing her new shocking-pink striped turban, 1944

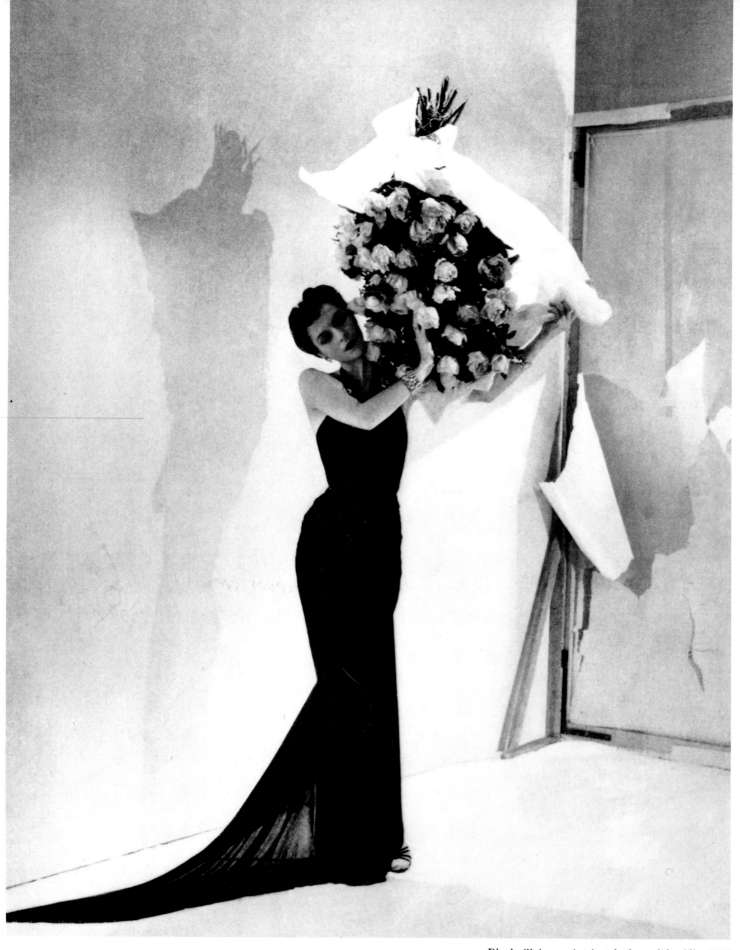

Black silk jersey, intricately draped, by Alix, 1936

Slipper-satin gown by Molyneux, 1941

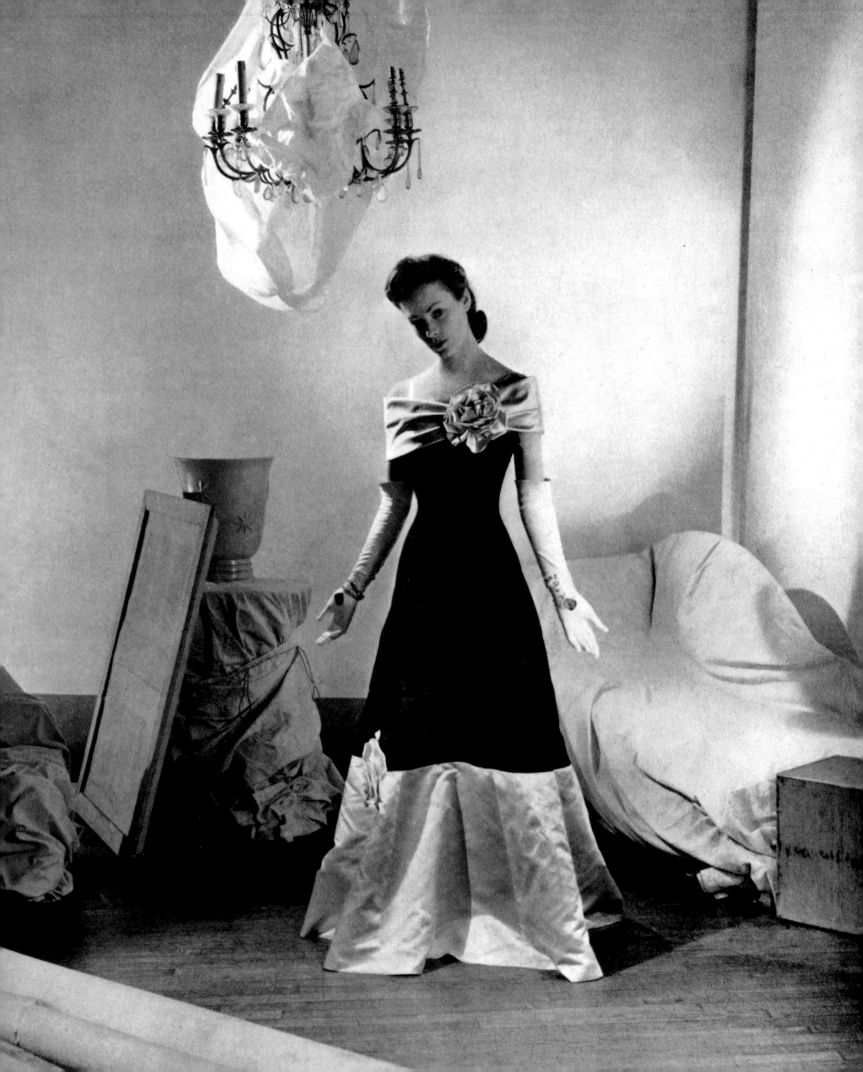

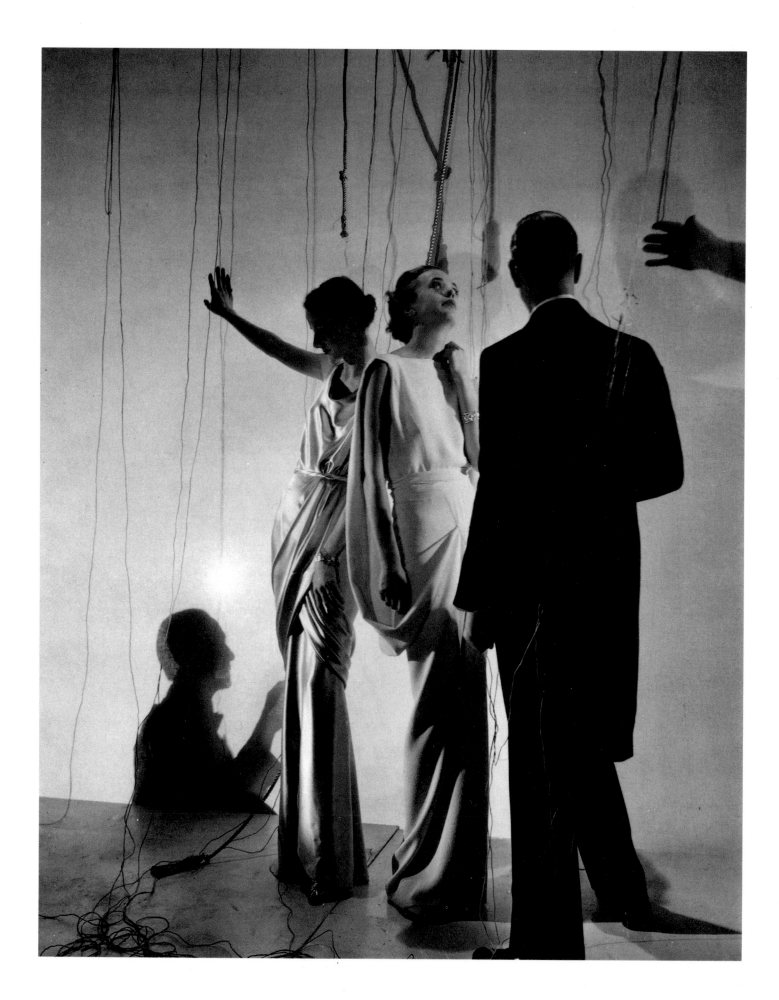

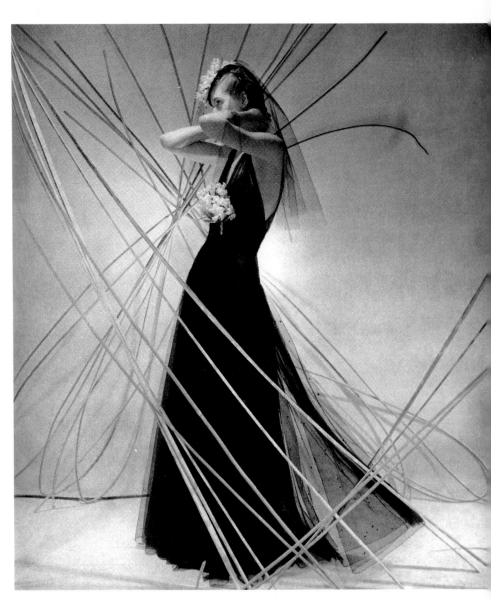

Breaking the straight lines. Piguet's hip-swathed satin gown, 1936 (*opposite*); Eva Lutyens' blue silk organdie, 1936 (*above left*); black tulle dotted with sequins, by Molyneux, 1941 (*above*); attitudinizing in black-and-white checks, 1935 (*left*)

171

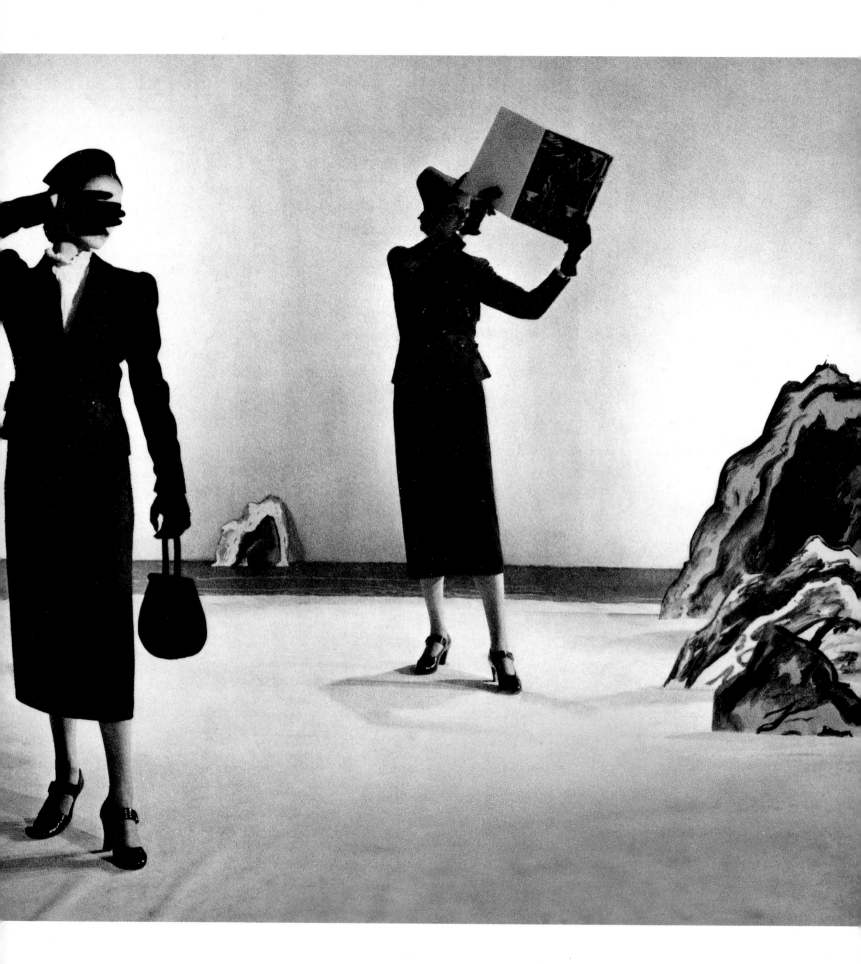

Homage to Dali: Schiaparelli's
suits with 'bureau-drawer'
pockets, 1936

Lelong's dress and jacket, in a
Bérard setting, 1936

Overleaf: 'Fashion is
Indestructible' – Digby Morton
suit, in the ruined Middle
Temple, 1941; Balmain coolie
coat and trousers, 1945. Beaton
took this photograph in an
artist's backyard in Paris, and
wrote, 'I tried for some of the
lighting of a Corot portrait. I
think it is one of the best I have
ever taken'

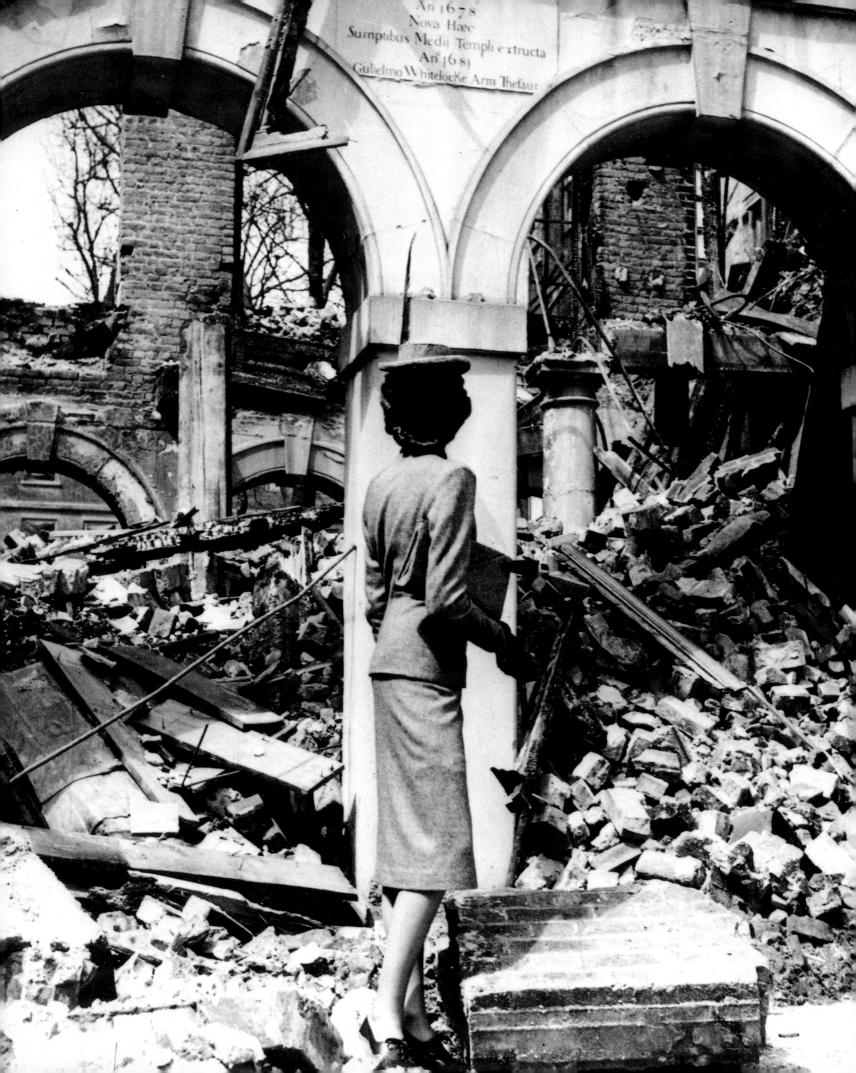

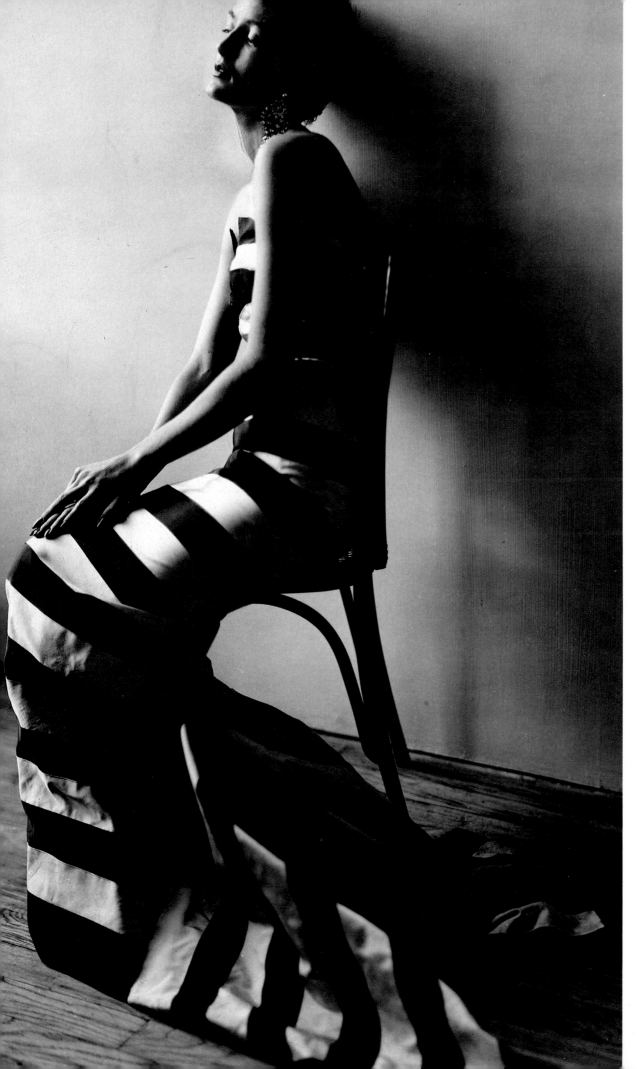

Black and white striped fishtail taffeta, by Paquin, worn by Maxime de la Falaise, 1950

'A look to echo Japan' – Jean Shrimpton, 1964 (*opposite*)

Overleaf: Twiggy, photographed 'in and around Cecil Beaton's London house', 1967; Tina Lutz, wearing a silk cheongsam from her collection, 1973

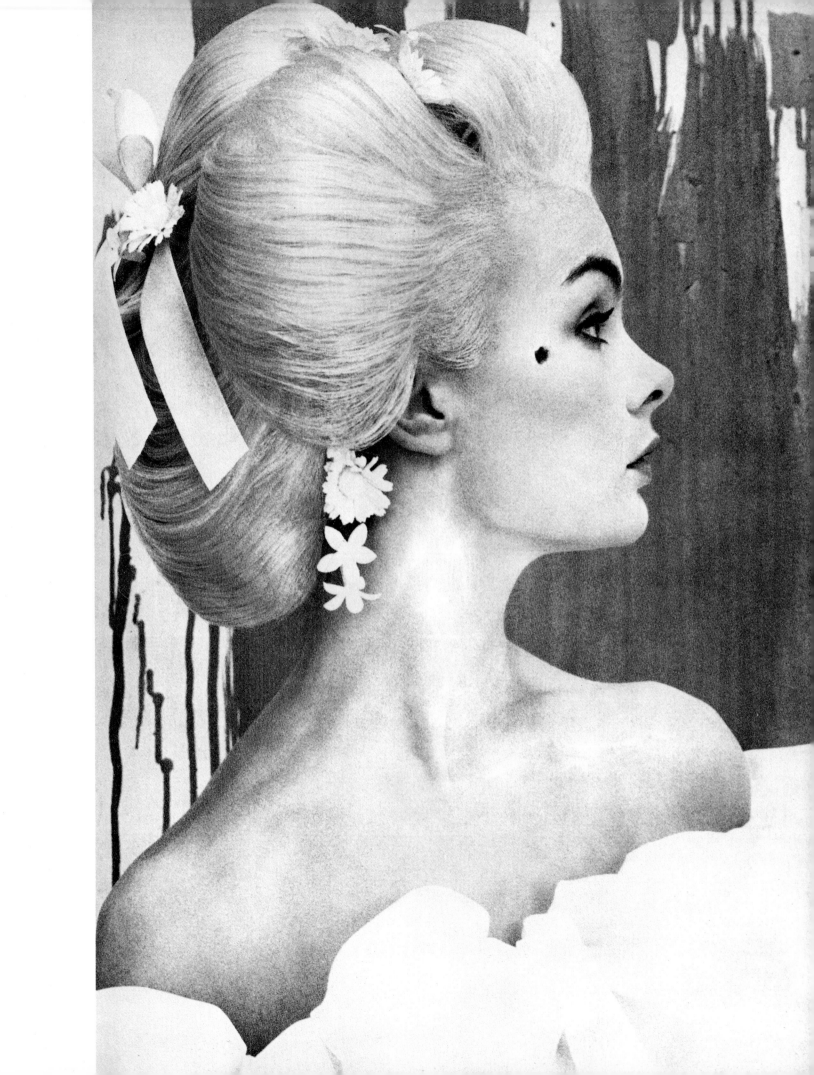

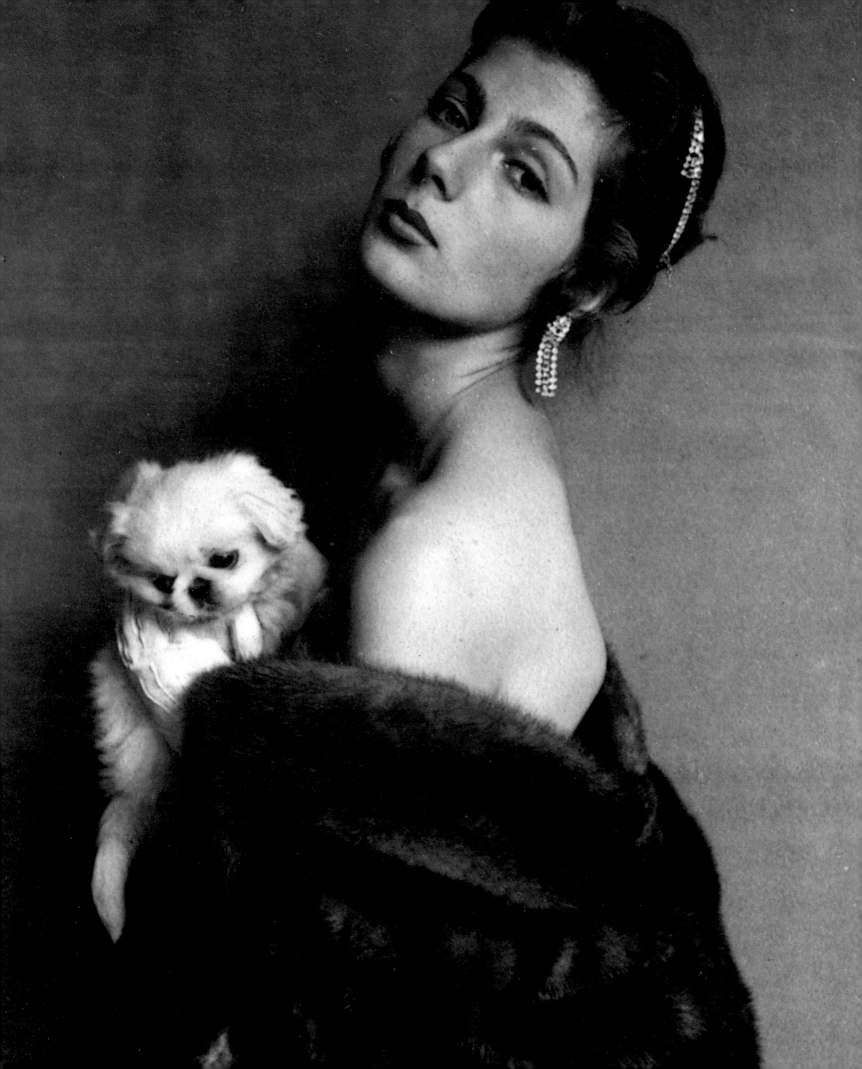

Fiona Campbell-Walter, a
favourite Beaton model, 1954

'Casual evening pants in vividly
striped metallic threaded
hopsack', 1954

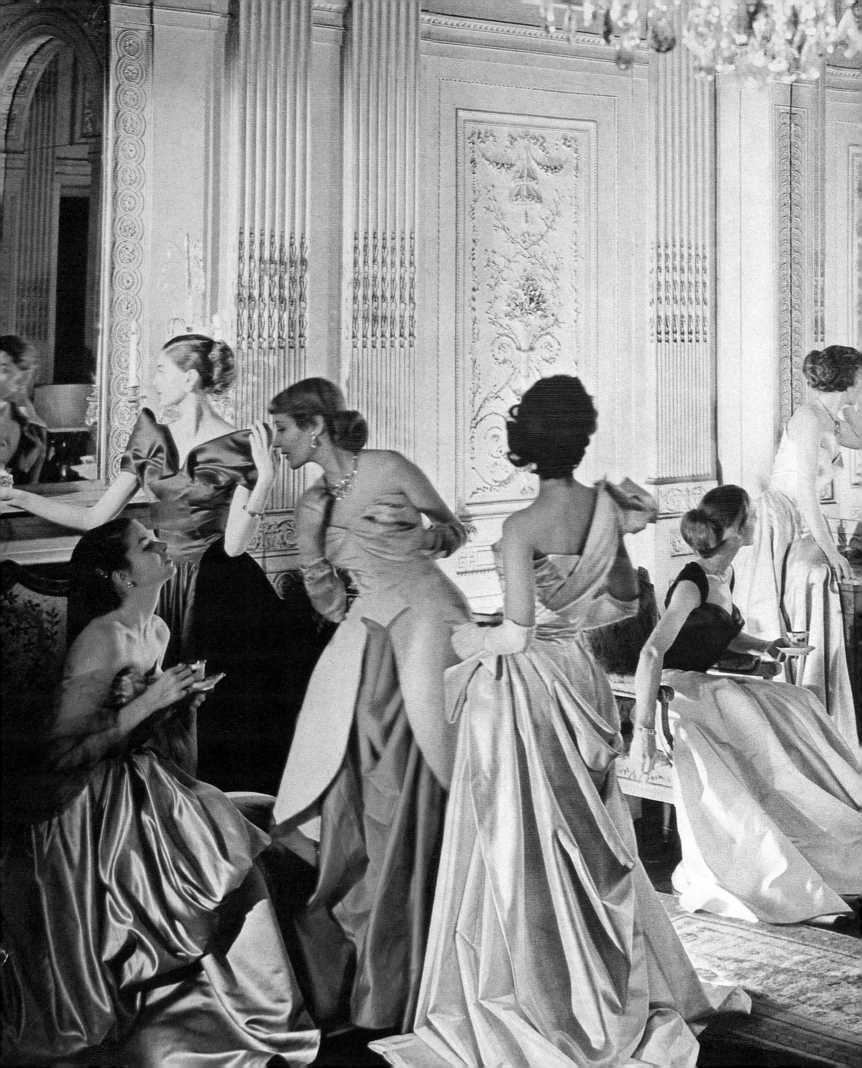

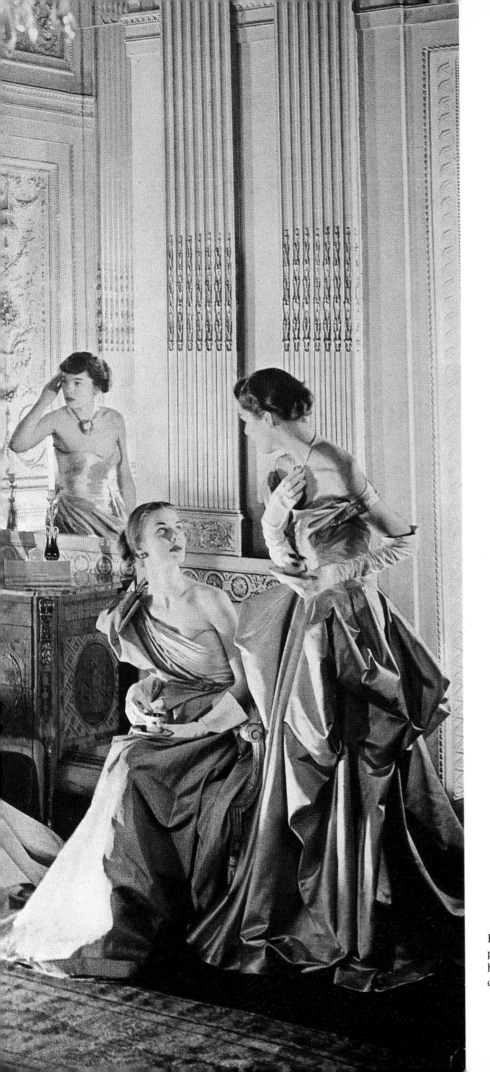

Evening dresses by Charles James, 1948. Beaton wrote: 'Any photograph involving more than one model becomes difficult; here there are eight! In such a situation one can only give loud clear directions, and insist on complete co-operation'

Lady Abdy wearing Givenchy – from Beaton's last
fashion sitting, for French *Vogue*, 1979

6 · Stage and Screen

Buster Keaton, 1930

The New Screen Stars
(1930)

Gary Cooper, 'faultlessly beautiful', 1930

CORINNE GRIFFITH photographed beautifully with drooping lips like rose petals, but they turned on the sound and her voice was like a macaw's. Jack Gilbert's was nasal and falsetto. Mary Pickford did not 'wash' either. Clara Bow is fighting a frenzied death struggle to keep her end up, and Charlie Chaplin cannot bring himself to speak. Colleen Moore, Vilma Banky and Lilian Gish have all thrown up the sponge and decided to go on to the legitimate stage, giving out the report that they are leaving the cinema 'because it has waned in popularity since the advent of the talkies'.

Greta Garbo, Norma Shearer, Marion Davies and Buster Keaton are the only old stars of the silent pantomimes who are equally successful in the new medium. Garbo has added to her glamorous lustre since we have heard her unexpected voice, and though we are now more conscious of her mouth being knife-like, and lips being perpetually moistened with her adder-like tongue, she seems even more exotic, and the fans pore more deliriously over her perfect imperfections. Oh! The pain of her beauty in *Romance*! The Metro Goldwyn Studio proudly flaunts Garbo as their trump card. She makes three films a year, and each one is a sensation. At the moment she is working on *Red Dust*, so we can look forward to some more slumberously passionate embraces.

Buster Keaton is a very highbrow comic even though he may not know it, and his expressionless face loses nothing since allied to a deep voice like the sound of breaking coke. Marlene Dietrich is Paramount's Garbo, and has Garbo's eyes, a husky voice and a long contract. But her publicity agent has had to admit that at present she is a few pounds overweight. The thinner Joan Crawford gets, the wider her smile becomes and the higher her salary.

If you want to be carried away by the charm and boyish jollity and naiveté of Maurice Chevalier, the most popular male star, you must needs go to the Carlton Theatre, for this is Paramount's most expensive star, with Gary Cooper, a resentful and long-legged cowboy of overwhelming popularity as his only formidable rival. One would imagine that any man so faultlessly beautiful as Gary Cooper would be nauseating, but he is the exception to every rule, and would have made even Valentino appear a ham, for not only is he more than fairly possessed with physical attributes, but he is a subtle and intelligent actor with a sly sense of humour, great sex appeal, and more charm than anyone. *Wings* gave him his chance, *The Virginian* made him, and his fans increased a thousandfold with *Only the Brave* and *The Texan*. 'This place is like a (blank) (dash) factory turning out talking pictures', he moans, and he is bored stiff with Hollywood and longs for a holiday to return to his ranch.

The speed with which films are turned out by Paramount is certainly astonishing, but the average level is exceedingly high. Though the humour of the comedies is often pretty low, a whiff of fresh air has been blown in with the talkies, and Hollywood is the centre of the world's drama today.

I SHALL NEVER FORGET the excitement of my first visit to the ballet. It was at the time when, at the Coliseum, one ballet was sandwiched between the usual variety turns. Joy was mixed with surprise and gratitude that, unknown to me, there existed a band of people interested in, and working together at, a synthesis of all those things which I had unconsciously been wanting. A new world of such visual loveliness was opened that, for me, in whom the visual sense had always been predominant, these colours, these costumes and scenery became an obsession.

My first ballet was *The Good-Humoured Ladies*. That I might see jewels such as this, set among red-nosed clowns and performing seals, my three-and-sixpences were impatiently saved. Under these circumstances, the futuristic colours of *Scheherazade, Thamar* and *Cleopatra* were branded on my memory, and, together with the simplicity of *Carnaval*, yielded inexhaustible subjects for my watercolours.

When the season ended, there came the unexpected discovery of the shrine of ballet in the Charing Cross Road, presided over by Mr Cyril Beaumont, whose pale complexion, thick ginger hair cut en brosse, and velveteen jacket added further thrill to this balletomane's paradise. It would have afforded me the utmost pleasure to feel that I could visit this Mr Beaumont, whose intimacy with the ballet lent him such glamour, and who just knew everything I wanted to know, and pass the time of day with him, but Mr Beaumont was there to sell books, and so I would visit him with a hardly saved seven and sixpence in my pocket, determined to get its full value. I felt that if I were buying a seven and sixpenny book, I could demand to see at least fifteen pounds' worth of other books, and be granted ten minutes of Mr Beaumont's conversation.

It was here that I heard first the legend of Nijinsky and pored over the pictures of Lopokova, Tchernecheva (whose face remains, for me, a haunting symbol of the ballet) and Massine.

When the ballet returned, it brought with it a new style. There were new French artists and composers, working together in new and unexpected ways, and, wonder of wonders, there were three ballets each night.

Picasso was the keynote of this period. In *The Three-Cornered Hat* he produced a décor which was the common denominator of the Spanish countryside, and, consequently, infinitely more telling than a representation of any part of it would have been. So true were Picasso's wiry balconies, the bird-cage tacked to the wall, the striped awning, the glaring white and hard colours, that when, later, I visited Spain, I at once recognized its characteristics.

New idols began to appear, Nemchinova, Danilova, and in particular Serge Lifar, the embodiment of charming gallantry and youth, who became the inspiration for the next group of ballets. *La Chatte* was the herald of the Cellophane, aluminium-tube furniture epoch. *Les Biches* was perverse without being irritating or pretentious. Then there was the classical simplicity and humanism of the *Apollo Musagetes*. The greys of the décor intensified the sunburnt physical perfection of Lifar, in scarlet tunic, as he slowly interwove his pattern with the Muses to the unexpected classicism of Stravinsky's swooning themes.

Four years after the tragic death of Diaghileff a miracle happened. Colonel de Basil gathered together the dismembered remains of this troupe, and, more incredibly still, made of it a financial success. Of course, just as in the later phases of Diaghileff's career, those who had known Nijinsky bemoaned the decline of ballet, so, now, many voices could talk of nothing but the good old days. And I too, prejudiced by the

Lydia Lopokova (Mrs Maynard Keynes) watching *Apollo Musagetes*, 1928

knowledge that the driving force was no longer there, unconsciously felt anything might go wrong. But gradually I realized that not only would the company not fail but that there were more dancers of technical excellence than before.

The note on which to leave the ballet is that of *Choreartium*. This is the only real experiment that has been made since the death of Diaghileff. In *Choreartium*, Massine has elaborated the ideas which he conceived in *Présages*. This ballet is a free interpretation of Brahms' Fourth Symphony. There is no story, no insistent décor. The interpretation takes the form of pure pattern in space and, particularly, in time.

Choreartium is a genuine experiment, if only as one of the many facets of Diaghileff's experiments. Possibly in our time there will never come another master like him. But the vital fact is that the ballet is a living movement and, as long as it is living, it can afford to wait for another master who will lead it to complete fullness of life.

The Lily Elsie Legend (1943)

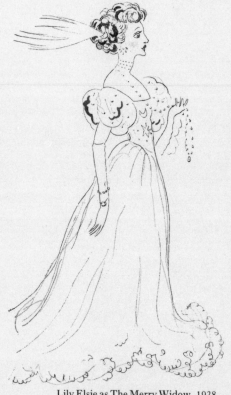

Lily Elsie as The Merry Widow, 1928

THE MEMORY of Lily Elsie that is still so alive today has survived all the years of her retirement and her natural shunning of publicity of her private life, and is built upon a career of stardom that lasted the surprisingly short space of four years.

At the beginning of this century, musical comedy was in its heyday. The Léhar and Strauss melodies haunted butcher boys for years and formed a pattern to which lesser composers still conform. The book had wit and style, the scenery was painted in trompe l'oeil by artists who benefited by a training in realistic representation that is not found today, the chorus girls, many of whom are responsible for subsequent pages of Debrett, were provided with dresses that cost forty pounds apiece. Among all these musical comedies *The Merry Widow* is supreme – and its sensational triumph was almost entirely due to its heroine.

From the newspapers, periodicals and rotating picture-postcard stands the public became familiar with the leonine eyes, bee-stung lips, the proud carriage of that head with the slight look of Greek archaism about it. But only those who saw her on the stage could fully realize the grace, the elegant coltishness, and above all, the charm of Lily Elsie.

Could she sing? Yes, with an artistry and a delightful voice. Could she dance? 'Like an angel'. She possessed a natural aristocracy of behaviour and a quality of mystery; albeit she personified that overworked word, glamour. Praise of her is so unanimous that I have yet to hear the one dissenting voice: her appeal was universal.

Although as a child I never saw Lily Elsie on the stage (it was not until a brief return from her retirement during the last war that I saw her across the footlights), she was one of the most romantic figures of my youth. Today, for me, she still possesses this magnetic quality and casts the old magic spell.

Décor Difficulties (1946)

THE STAGE DESIGNER'S LOT is seldom easy. Today, to add to the difficulties arising from the shortages of carpenters, scenic artists, workroom hands, canvas, dress materials, grease paint, false hair and timber, there is a dearth of property masters able to assimilate rare objects. Theatrical coupons are scarce, and the utility material is generally of flimsy artificial silk printed in garish modernistic flower-patterns. A shop such as Burnet in Garrick Street, which used to cater almost exclusively to the stage, is now almost threadbare, and must turn its interests to the Church.

Every film producer or theatre manager knows that no entertainment succeeds merely as spectacle. If his fare has not the elements to beguile an audience, no amount of trimming will save it. Yet a few of the more cultured managers realize that an extra cachet can be given to a production by the addition of scenery and dresses that are designed by an artist with taste.

In London today to acquire anything that does not conform to the lowest standard involves great trouble. So it is in the theatre and film studio. The brick wall against originality in any branch of film work is such that the innovator will find his efforts continuously sabotaged by the staff of 'experts'. It is essential that he is firm in standing up for his rights against others whose opinions are likely to infringe upon the success of his work, that he fight for every detail. Today, owing to labour shortage, the hairdresser and the make-up men have first to be placated, or Messrs Bérard, Furse and Messel, with all their inspiration, taste and knowledge, must take themselves off elsewhere.

The actresses whom the designer is called in to help are apt, on sight, to treat him with suspicion, or to become openly defiant; he has to compete with their various temperaments. It is strange how most actresses always insist upon wearing something as near as possible to that which they have already worn in previous productions. The designer, however, must remember that after all it is the actress who, possibly for hundreds of nights on end, must wear the clothes; so that personal idiosyncrasies must be respected.

Dr Fausting and pupil: Sir Gerald du Maurier and Grace Wilson in an Arnold Bennett play, 1928

The designer must show respect first and foremost to the play itself. He must prepare to face a thousand technical obstacles, foresee and circumvent hitches and disasters. Whatever may be said to the contrary by the producer and his associates at the preliminary discussions, I have found, both in theatre and cinema studio, that period verisimilitude is welcomed only up to a very limited degree. Concessions to period dressing are, in most instances, made only to the point of adapting modern clothes to the epoch in question, and few actresses are honest enough not to cheat with make-up and hair-styles. Although it is the uncompromising passion with which Miss Bette Davis transforms herself into any required period that gives her films their great and esteemed authenticity, few follow her example.

Gladys Cooper in *Excelsior*, 1928

Audiences could glean an idea of the energy and trouble that has gone into a production from a quick look at a rehearsal, when the cast perform in the clothes they have chosen for everyday life in the light of an unshielded bulb hanging overhead.

The question of lighting is dangerous. The designer's pictures can be ruined at the final moment by a distorting system of coloured lighting. An actress, powerless to see the effect of lighting on herself, is apt to play for safety behind a few generalizations: for example, she may become terrified of an unshielded open light, will seek solace in the shade of an amber gelatine, without realizing that amber takes most of the colour out of her face, and that it is the direction from which the light is cast that matters. Hermione Gingold has been seen at her worst for thousands of performances at the Ambassadors, a victim of harsh cross lighting coming from the sides of the stage, than which there is nothing more cruelly unflattering; while Evelyn Laye's cheeks appeared bruised by the proximity of the footlights in *The Three Waltzes*. Few managers pay attention to light, yet it is as essential as lighting a sitter for a photograph.

With all theatrical productions the element of the unknown is always present to make or mar your effects. There is no formula for success, but when all elements fuse, and an entity is created, all the heartburns seem to have been worthwhile.

Audrey Hepburn (1954)

AUDREY HEPBURN has enormous heron's eyes and dark eyebrows slanted towards the Far East. Her facial features show character rather than prettiness: her mouth is wide, with a cleft under the lower lip too deep for classical beauty, and the delicate chin appears even smaller by contrast with the exaggerated width of her jaw bones. She is like a portrait by Modigliani where the various distortions are not only interesting in themselves but make a completely satisfying composite.

Beneath this child-like head (as compact as a coconut with its cropped hair and wispy, monkey-fur fringe) is a long, incredibly slender and straight neck. A rod-like back continues the vertical line, and she would appear exaggeratedly tall were it not for her natural grace. With arms akimbo or behind her back, she habitually plants her feet wide apart – one heel dug deep with the toe pointing skywards. And it is more natural for her to squat cross-legged on the floor than to sit in a chair.

Like the natural artist that she is, Audrey Hepburn is bold and sure in her effects. There is no lack of vigour in her rejection of the softly pretty. Using a stick of grease-paint with a deft stroke, she liberally smudges both upper and lower eyelids with black. To complete the clown boldness, she enlarges her mouth even at the ends, thus making her smile expand to an enormous slice from Sambo's watermelon. The general public, in its acceptance of such an uncompromisingly stark appearance, has radically forsaken the prettily romantic or pseudo-mysterious heroines idealized only two decades ago.

It is a rare phenomenon to find a very young girl with such inherent 'star quality'. As a result of her enormous success, Audrey Hepburn has already acquired the extra, incandescent glow which comes as a result of being acclaimed, admired and loved. In fact, with the passing of every month, Audrey Hepburn increases in dramatic stature.

Making Gigi (1958)

WITH THE ASSIDUITY of a Proust, I reread not only *Gigi* but all of Colette after I agreed to design the production. By degrees I began to see with her avid eyes: the colours employed, the atmosphere created should be hers, not mine.

Sketches in hand, I flew to Paris for preparatory consultations with Vincente Minnelli, the director. We moseyed about the city, sight-seeing for typical Colette locations. 'This is where Gigi might have lived,' Minnelli said, pointing to a tall seventeenth-century house. Gaston might have inhabited the grandiose Victorian mansion that now houses the Musée Jacquemart.

Previous experience had shown me that designing for films is quite different from theatre work and that the designer must resign himself to some bitter facts. Seldom, for instance, is a costume seen full length in the motion picture. Hence, the interest of each design must hover almost entirely above the waistline. It is the same with the scenery: a room may be festooned with elaborately draped curtains, but ornamental pelmets are out of camera range. The focal point on the screen inevitably centres about eye level. Yet no detail may be left to chance. One of the ironies of film-making is that the relentless camera mischievously concentrates on the one thing it should ignore. Period dresses that would pass on stage will be exposed on film if they are coarsely executed. Zippers are not only historical anachronisms, but they have a lamentable knack of picking up light reflections, thus looking like a snake or welt. The camera, in fact, sees as much as, or more than, an entire audience of eyes.

Conscientious tests for make-up, hair styles, costumes and general colour scheme were worked out. As a result of the tests, I began to avoid certain danger colours. Experience showed that most bright reds became claret colour; greys inexplicably turned Prussian blue; chartreuse yellow wound up the colour of a Jaffa orange; turquoise predominated with such force that it had to be labelled 'for external use only'. The greater the restraint, the more pleasing was the result.

It was a brave new world of indomitable spirit that gathered in the Bois de Boulogne for the first summer morning's shooting. Producer, director, cameraman and a huge technical crew, together with a vast sea of extras, had gathered expectantly in a roped-off section of the park. There were calèches of every sort; men and women on horseback, crowds of passers-by in 1900 costume. Cameras moved by on cranes, while megaphoned instructions added to the din. By evening, the 'take' had been reshot four times.

As part of la belle époque, Maxim's was closed to the public for four days while bright lights transformed its mellow art moderne interior into a background for rich French bankers, gay ladies, Zouaves, Egyptians, Ouida guardsmen over from London, and the moral refuse to be found in the best restaurants of the world. Supper table roses wilted in the arc lights. The confusion, noise and heat in this inferno continued until all were prostrate from exhaustion. Every sequence found me busily altering costumes, decorations and hats at various tables. Afterwards when I dined at Maxim's, I still felt the urge to rush up to bona-fide clients and change their scarfs and jewels.

By the following Monday I found myself in Hollywood. My initiation into the mysteries of the MGM lot began immediately. Each unit had its own specialists, and the wardrobe department even produced a little lady whose job it was to make new clothes look old. 'How dirty do you want Miss Gingold's skirt?' she asked.

I discovered that I could cut a stuffed peacock in half and still make it stand up on a demi-mondaine's head. I trimmed thirty hats in one and a half hours. I simulated a Sem caricature; I even made suggestions for the film's title and credits. I prowled around the stage looking for 'cleavage trouble'.

Long after the last scene had been shot the director worked with the producer, the cutter, the musicians and sound-track experts. Songs and incidental music had to be synchronized, and then the whole film edited and polished to a handsome gloss.

Hats for the 1914 Ascot, 1930

GUSTAVE MOREAU would have been tempted to paint her as the Love Goddess of the Ephesians; Aubrey Beardsley might have drawn the canary-white tendrils weaving over the hourglass figure as a landlocked mermaid; but only the jewelled pen of Huysmans could have given adequate praise to this triumph of artifice. Yet, before this enigmatically smiling automaton even Huysmans would have faltered, for appearing through this spun-sugar-and-dross façade is a reality and a goodwill that breaks through the artificiality.

Mae West is a product of her own outrageous fantasy. She has not only created her own silhouette, colour scheme, and subaqueous flow of movement, but she has written the script of her life. It is a creation on a grand scale, and once having achieved this result, she can not, nor would she want to, alter it to suit changing times. In her belief

Unconquerable Mae West (1970)

in herself she is utterly sincere; it is no doubt the reason why she remains a phenomenon. She may have been through an eclipse, but she knew that time would come back into her favour, and wow – it has!

Her recently discovered old films have become a cult among a wide new public: Special 'Mae West' festivals have been remarkably successful. The young people of today (the Prince of Wales among them) may not take her seriously on her own sex terms, and possibly find her witless as a performer, but they accept wholeheartedly her one-track effort to amuse.

Mae West's Californian apartment is symbolic of her idea about herself. Everything is designed to flatter her psyche. Little or nothing is done to the rooms 'behind the scenes': ordinary skills of housewifery have no place in this palace; dust-ridden, discarded cardboard boxes and massage tables must remain where they are. But in the salon, where all effort and energy is concentrated, the low, pebble-dash ceilings are painted a pale primrose yellow to complement her hair; the off-white divans are a foil for her alabaster bosom. . . .

On the mirror-and-white-and-gilt rococo-esque coffee table are earlier photographs, framed in silver wire, of the star in her rôles. From these over-touched prints one can not detect the real Miss West. And that is obviously her intention today; she allows us only to admire the beautifully preserved muzzle with the pouting, polished lips and teeth, the froglike nostrils, and the blue-and-black intensity of her lion's eyes.

She makes every effort to prevent us from seeing behind the mask. The hair now falls so that the jaw line, neck, and shoulders are completely shrouded. The heavy armour of her negligée seems separate from her torso, and although her skirts hang to a certain length, one has the feeling that her feet, encased in sabots, are high above the white nylon carpeting. To lie down in libidinous luxury accoutred in this way would be impossible. One would like to see more of her than she presents (and those who have been privileged to do so say that it is well worthwhile), but Mae West knows best; she has made a worldwide industry of her myth.

As Mae West stands reflected in her mirrors in a bower of Forest Lawn plastic flowers, surrounded by ex-musclemen, Chinese servant, make-up expert, wardrobe mistress, coiffeur, and the like, she instinctively demands respect. She chooses her words with care and talks little; she moves scarcely at all. When she turns her head from one side to another, there are gasps of admiration from all around the room. 'Oh, Miss West, you have never looked so beautiful!' The empress responds graciously. Sensuously she strokes the yellow-white fronds of her wig with pointed fingers, makes another moue, and with a flicking of her heavy false eyelashes denotes her girlish pleasure.

It is perhaps a bit odd that this 'sex merchant' seems to demand obeisance rather than intimacy. Certainly one is on one's best behaviour in front of her. I said: 'I remember once in London at a party given by the Sacheverell Sitwells, you wore a long, white dress.'

'Oh yes, with a white scarf over my head.'

'And Lady Cunard, seeing you, said : "Oh, there's Miss West, dressed as a virgin."'

Miss West pouted and coyly lowered the eyelashes.

It is said that Mae West has few friends, but there are always people around her; they may not be her intimates, but they are dependent on her until, imperceptibly, they drift away.

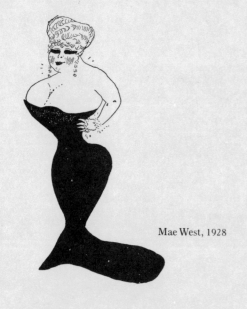

Mae West, 1928

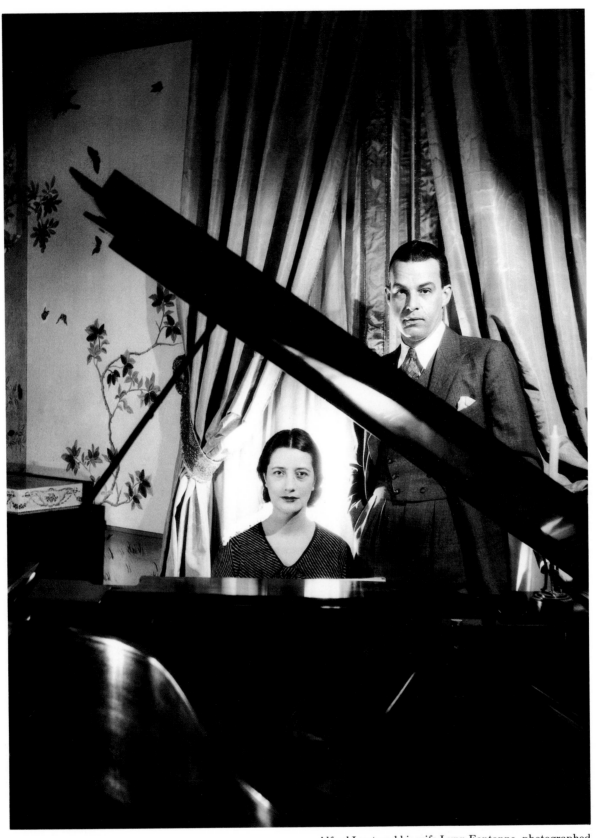

Alfred Lunt and his wife Lynn Fontanne, photographed
in Condé Nast's apartment, 1929

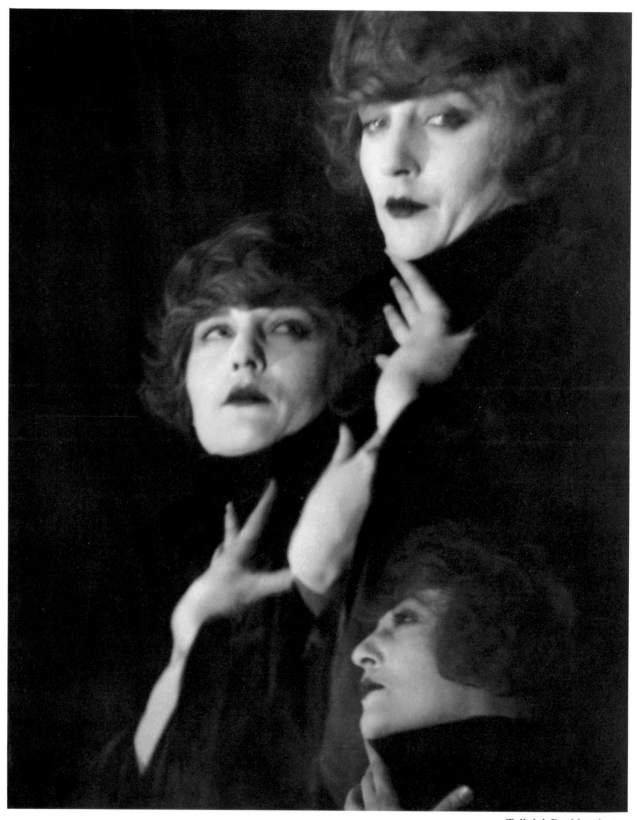

Tallulah Bankhead, 1929

Katharine Hepburn, 1935

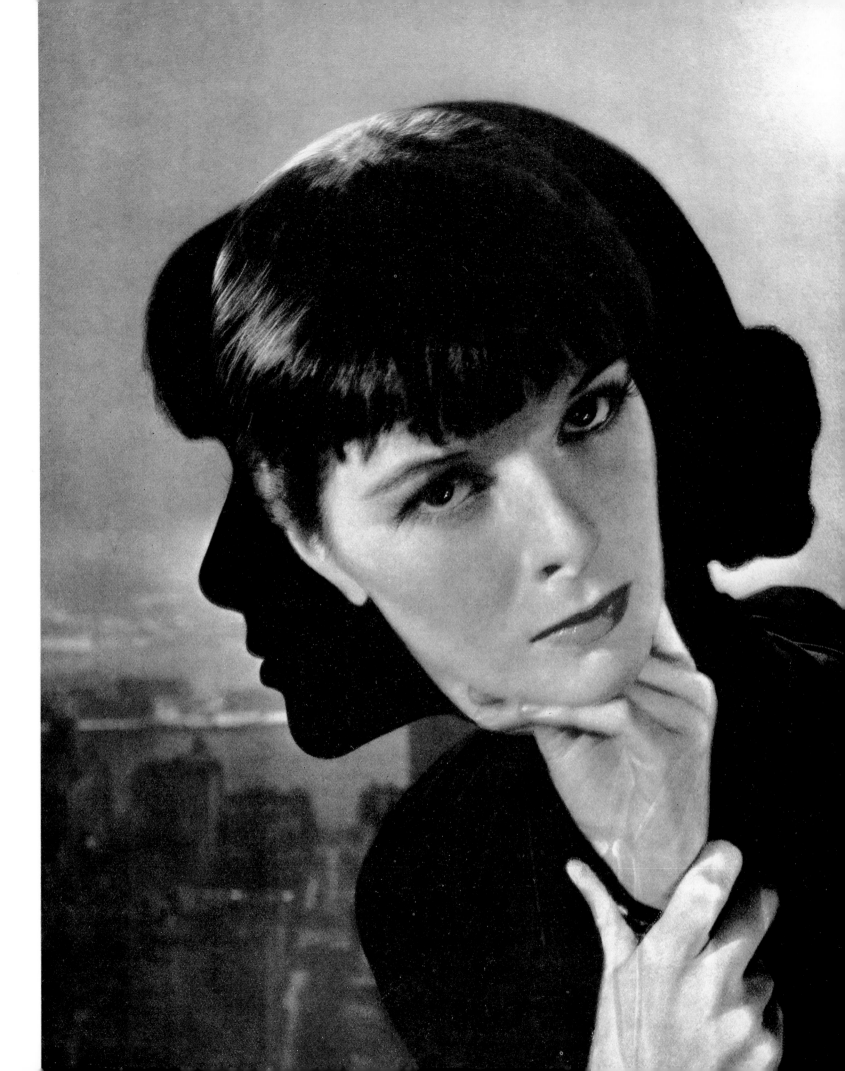

Nicholas Magallanes as the poet Rimbaud in the ballet *Les Illuminations,* for which Beaton designed the sets and costumes, 1950 (*above*); George Balanchine, 1951 (*right*)

'In years to come we shall all be old bores and grumble that the ballet is not what it was in the days when Lifar ravished us all by his dancing': Serge Lifar exercising on the sands of the Lido, Venice, 1928

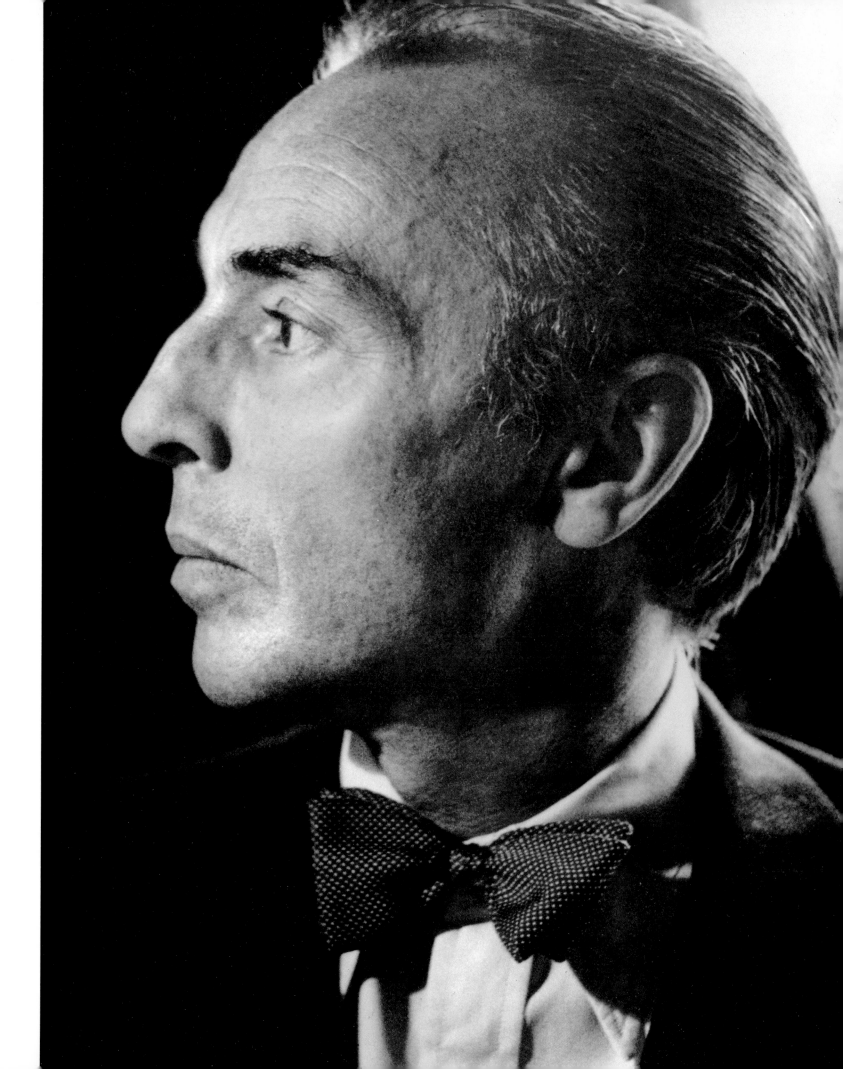

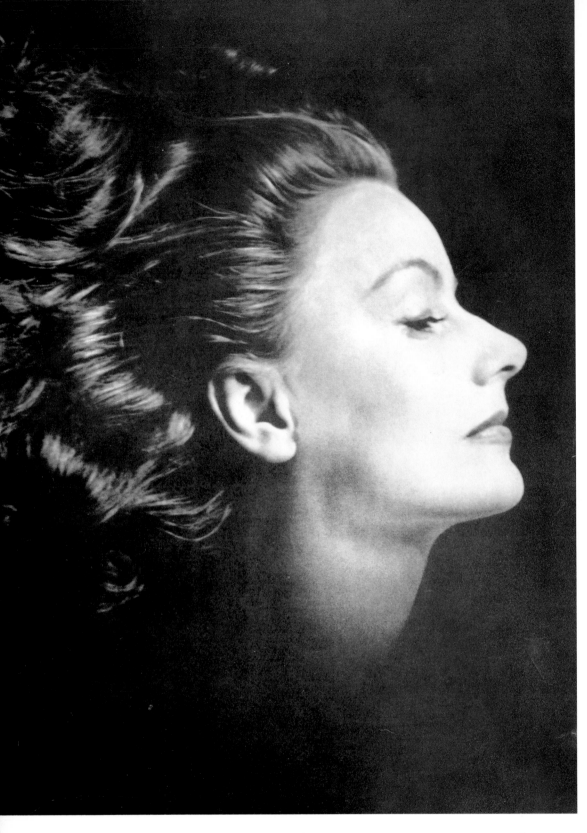

Greta Garbo, 1946. Garbo gave Beaton
permission to publish one of his photographs
of her in *Vogue*; when this two-page spread
appeared it caused a rift in their relationship

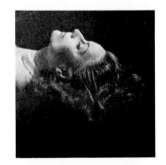

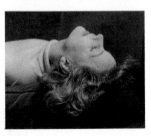

198

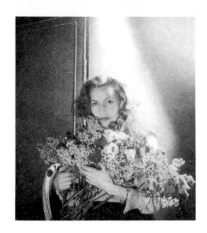
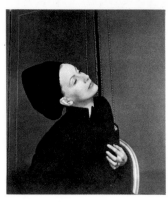
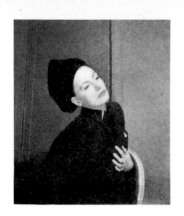
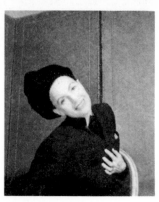

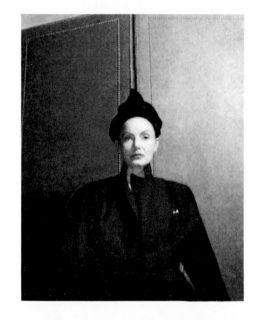
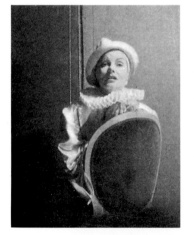
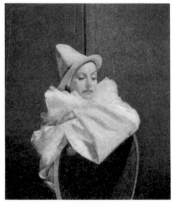
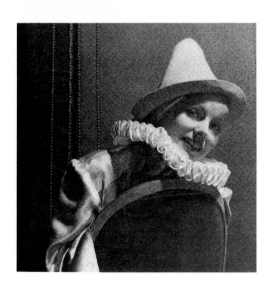
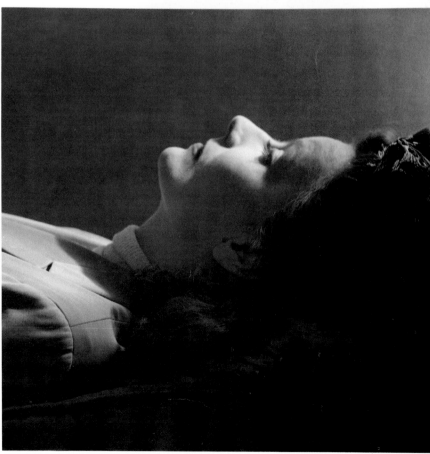

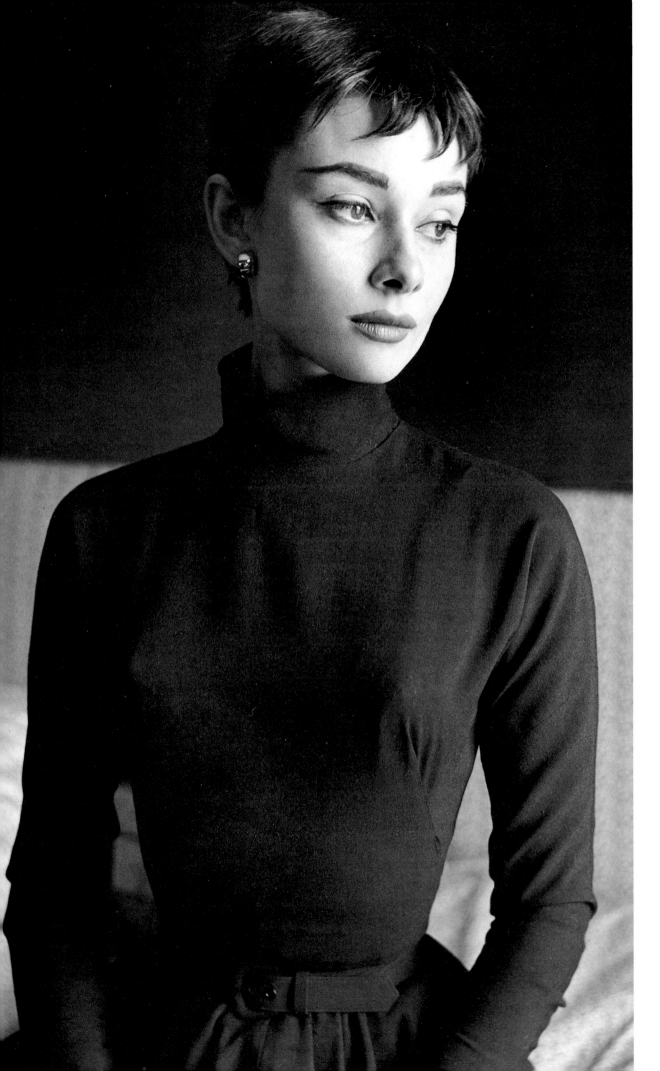

'No lack of vigour in her rejection of the softly pretty': Audrey Hepburn, 1954

Martita Hunt in *The Madwoman of Chaillot* (*La Folle de Chaillot*), by Jean Giraudoux, 1949

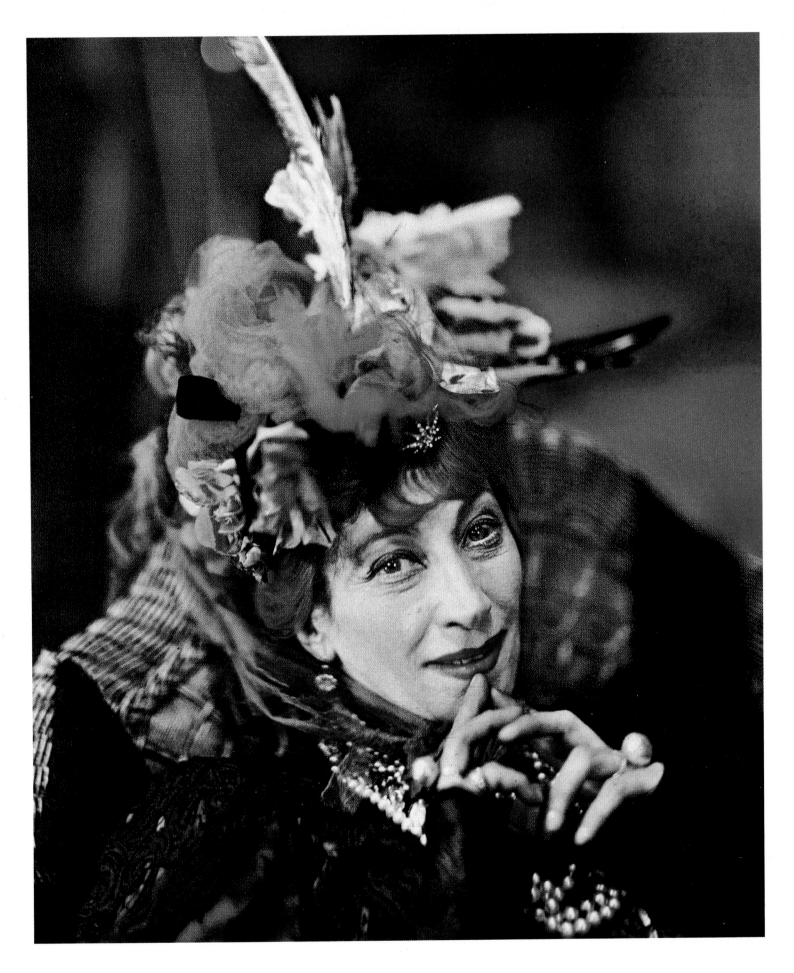

A red-lacquer drawing-room set for the Somerset
Maugham comedy, *Our Betters*, 1946

Beaton's impression of his own
costumes and decor for *Le
Pavillon*, 1936

Overleaf: One of Beaton's Oscar-winning
costume designs from the film of *My Fair Lady*,
with Audrey Hepburn as Eliza Doolittle, 1964
(*left*); Margot Fonteyn and Rudolf Nureyev in
Marguerite and Armand, 1963 (*right*)

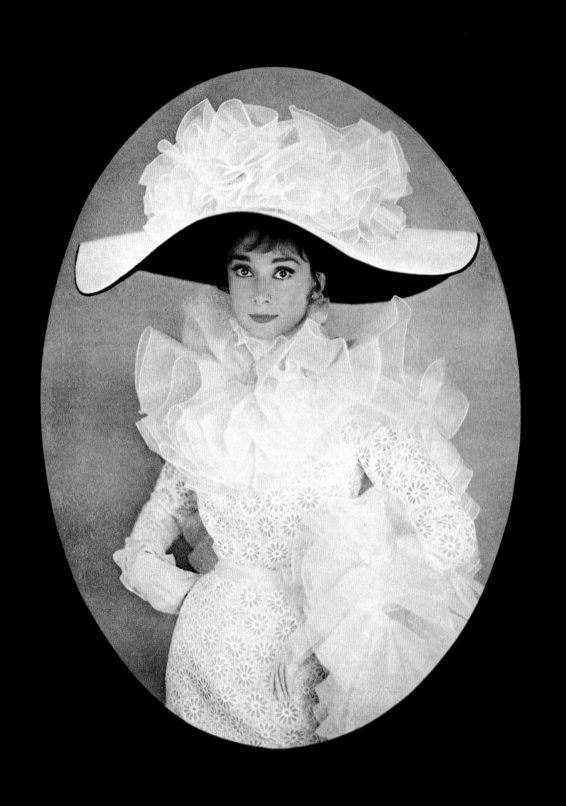

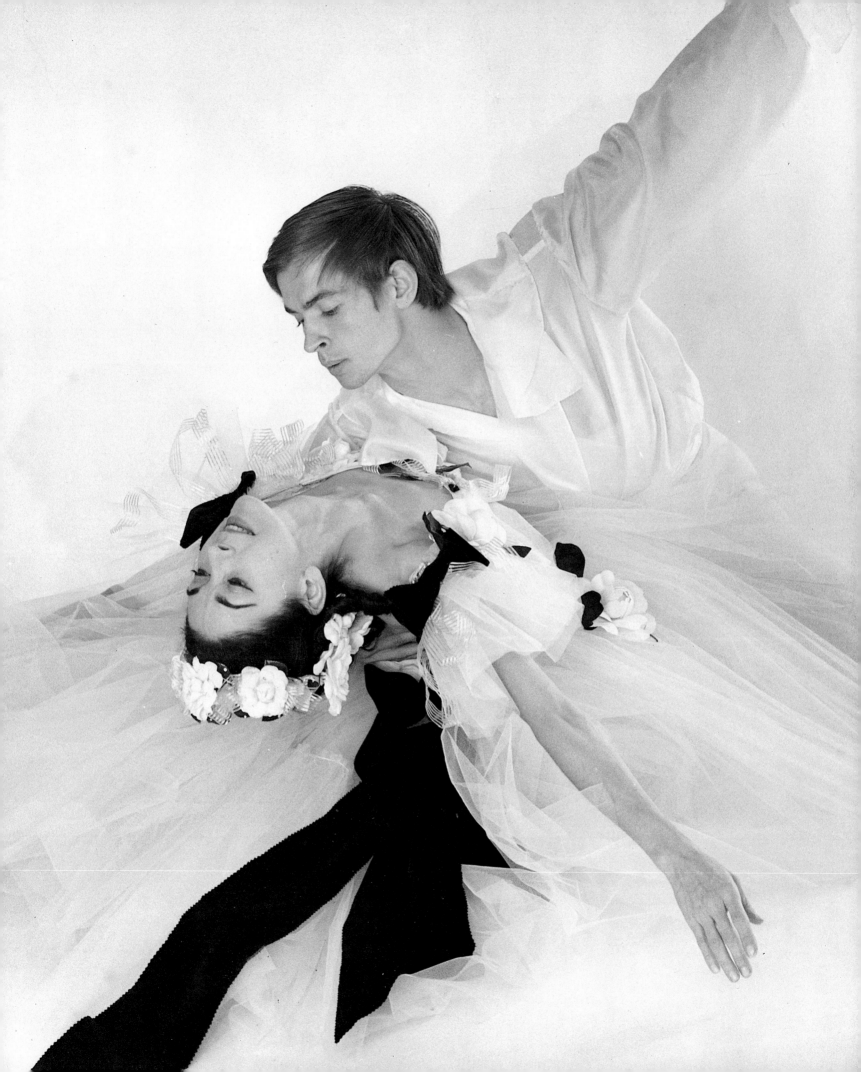

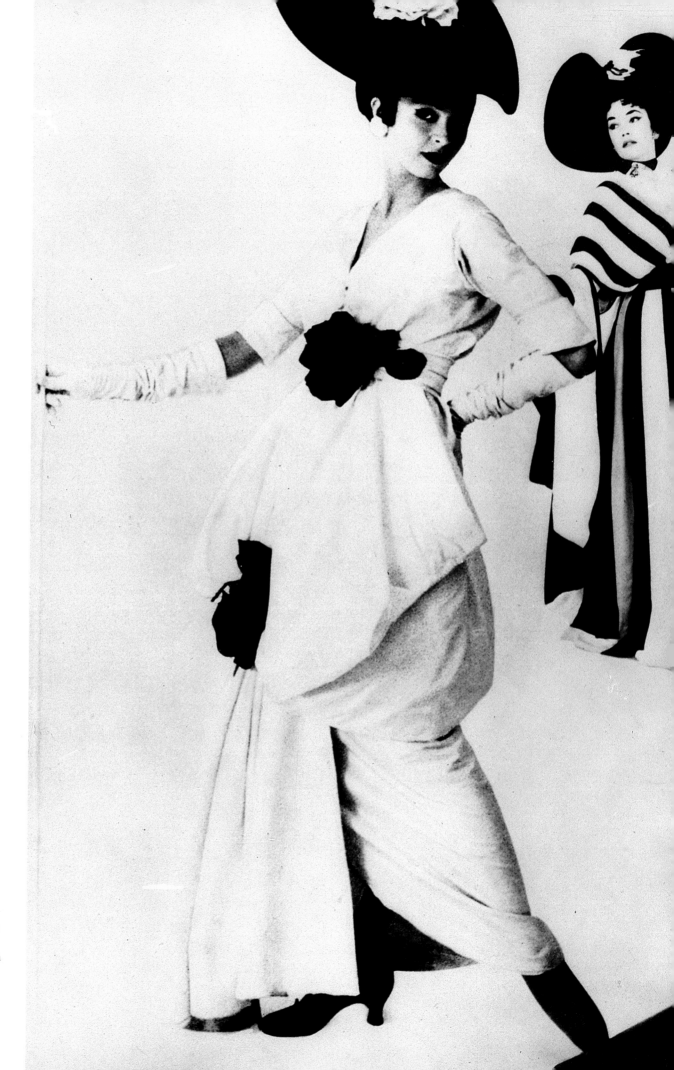

Beaton with his black
and white Ascot Gavotte
costumes, from the
original stage production
of *My Fair Lady*, 1956

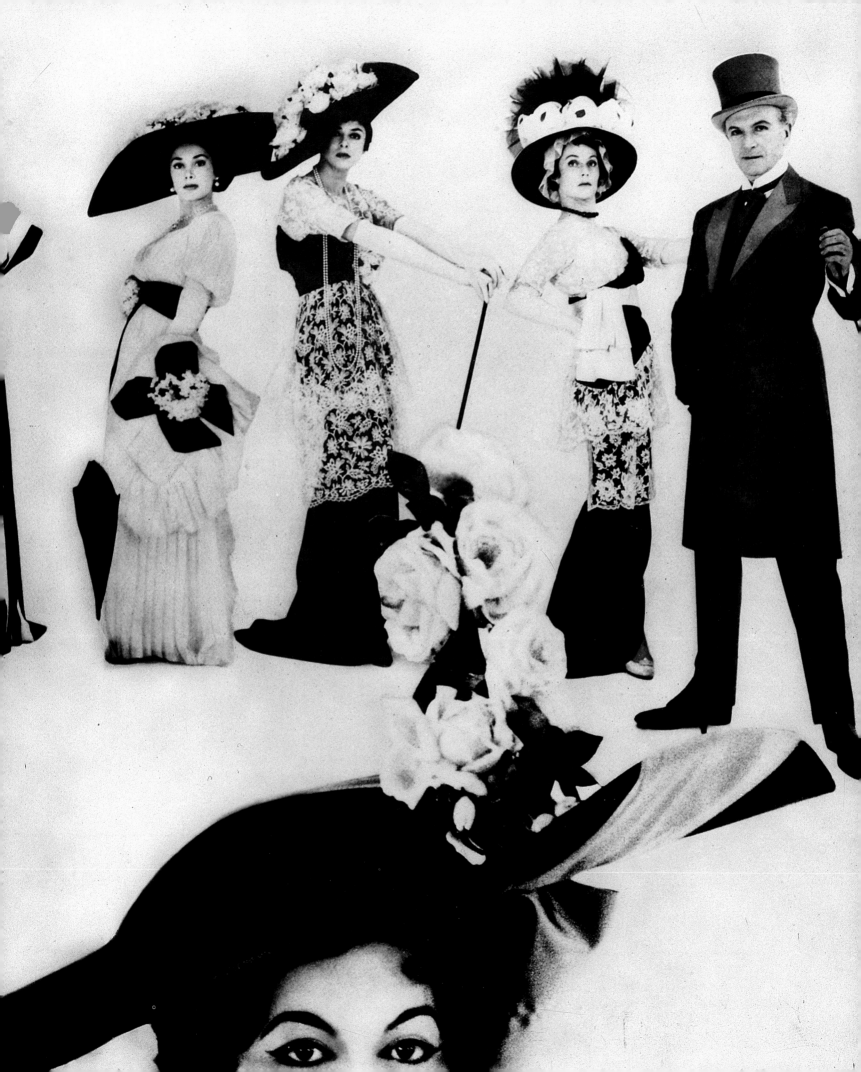

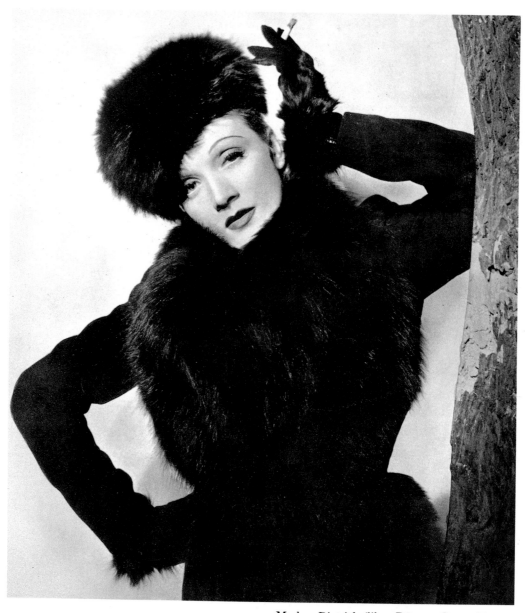

Marlene Dietrich, 'like a Dürer or Cranach', 1936

Mae West, 'reflected in her mirrors in a bower of Forest Lawn plastic flowers', 1970

Overleaf: Martha Graham, choreographer, teacher and inspiration of modern dance, 1976 (*left*); Maya Plisetskaya, of the Bolshoi Ballet, 1964 (*right*)

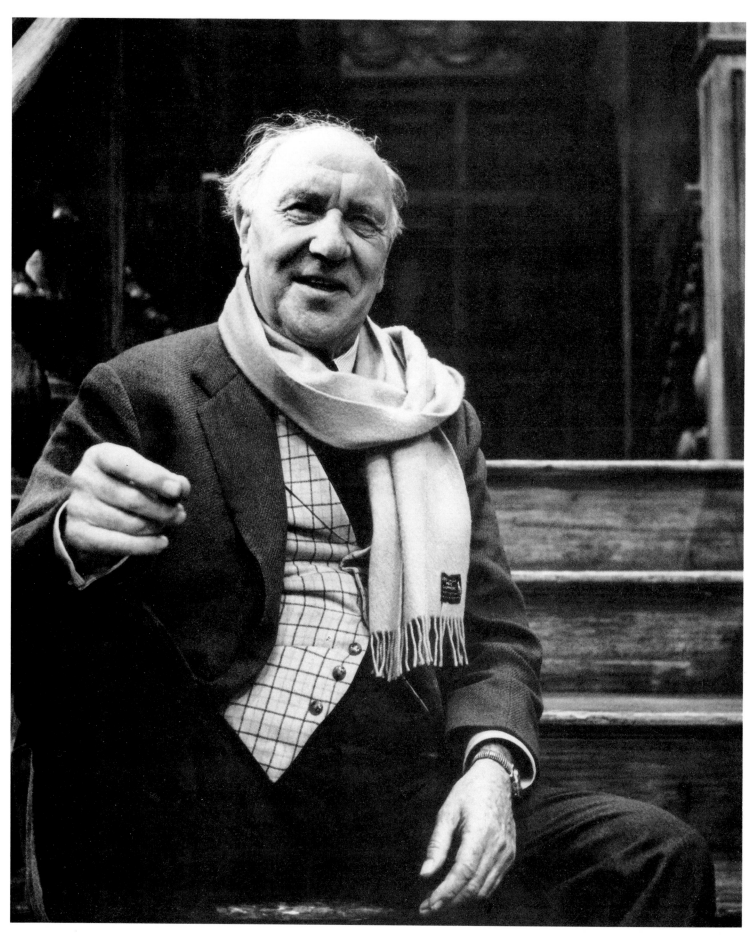

Sir Ralph Richardson, aged seventy-six, at the National Theatre,
London, 1979

7 · The Joys of Travel

After lunch, Cap Ferrat, 1929

Good-bye, New York (1929)

I HATE TO HAVE to leave – I feel like the Student Prince who is called away from Paradise, knowing that he may never return and that, even if he does return, everything may have become changed and wretched. I can't bear to think that in a fortnight's time my winter here will have become a thing of the past.

The sentimental telegram messages, the novels, the candy and the flowers only make the parting more unbearable. The dock is a seething mass of wavers and kiss-blowers. The sirens hoot, the fog-horns blow; this is the final wrench – good-bye! The friendly mound is soon out of sight. The sky-scrapers diminish. FRENCH PLAN twinkles in scarlet letters in the far distance. It is all over, and one has great difficulty in swallowing.

I shall miss so much. So many perfect persons are left behind, so many 'good times' are definitely over. Greedily I try to capture for posterity some of my memories by writing a detailed diary, but the boat rocks high and low, there are interruptions, one's fingers begin to ache with writer's cramp, and all that is left of the commendable intention is a list written on pale yellow *Ile de France* notepaper of things that never must be forgotten. Here is the list, but how insufficient it is!

The generousness, the fabulousness, the kindness, the brightness, the 'all-there-ness', the smartness.

New York bathrooms, superb, immaculate, and considered one of the most important rooms in the house.

The peppy gramophone records. (I always feel I was born for the stage every time I hear a phonograph.)

The El Grecos in the Hispanic Museum. The salads with pineapple sprayed with red pepper and little balls of cream cheese on crisp lettuce. The overpowering beauty of the sky-scrapers of New York, lighted up by night.

The sunny climate and the well-heated rooms. (Letters from London had conjured up vivid visions of the dreary frigidity, smoking fires, and gloomy fogs.)

Corn-beef hash for lunch at the Colony Restaurant, dancing to *Love Me or Leave Me* with lovely ladies at the Embassy Club.

The flowers at the Goldfarb market, which is surely the most lovely shop in the world, where the scents and colours of the piles of fresh flowers are a revelation, pansies stacked on bunches of hyacinths, magnolias, lilies-of-the-valley and every other sort of lily, orchids, and violets that out-perfume all the perfumes of Arabia.

The impermanency of New York homes. If I return next year, I shall find my address-book of little use, for most people listed there will have changed their abode at least three times.

The paradox of the Leonardo da Vincis, Goyas, and Modiglianis hanging in a Park Avenue palace completed only last week. The similarity of all the cabarets located in Harlem.

The perpetual fever, the frantic frenzied rush, the pandemonium.

The Blackbirds revue.

The photographic sittings, with jewellers guarding the exquisite jewellery with revolvers, and my inevitable instructions to the lovely sitters, 'Please lower the chin and place your feet in the dance mistress's first position.'

The busy mornings that unravelled themselves like a three-act play.

Mrs Harrison Williams, who has an immortally lovely complexion of pink and white and wet marble.

I read my list; there are so many things that ought to be put down. But it is impossible, one cannot write of all the lovelinesses. Besides, the gong booms, and as one is being honoured at the Captain's table for lunch, one must not be too late.

It is a lovely boat, very beautifully decorated in a modern and utilitarian way, and everybody is having a very good time. A blonde cinema star is on board, and Noël Coward has promised to organize the gala cabaret tonight. One day follows another with extraordinary rapidity, the tears are dried and forgotten, and the excitement and joy as the train steams into Paddington Station are simply terrific.

'Fortunes have gone pfft, have they?', 1932

THE SKIES WERE GREY; blustering winds. One quaked at the idea of a Channel crossing, and while the car was being put aboard at Folkestone it was decided to go to the nearest hotel for a solid meal. Really, the tyranny of English hotel dining-rooms is appalling! We ignored the inevitable mutton, the trifle, the prunes and the flake-dry Cheddar cheese, and chose a cutlet, for safety's sake, immersed in Worcestershire sauce. Perhaps many English do not mind what they eat?

And now I am going to tell you, in terms of food, of my recent journeys. What do I remember? Cahors, Perpignan – the foie-gras and truffle country. Oh, the delight of the foie-gras, pink and juicy, dappled with black truffles! And the truffle omelette to follow was milkily wet, yet stringy, just as an omelette should be and never is in England. The delicious purple wine that we drank out of a carafe stained the teeth, gums and tongue as though we had been eating blackberries.

The best things in Spain were the Ensaimadas, huge pastry puffs astonishingly lighter than foam, that if squashed could be packed in a thimble. Impossible, I fear, for Ashcombe, though there is no reason why Mrs Noble should not have a shot at the tumpettas, a light vegetable omelette, succulent with aubergines, peppers and many sorts of the more unusual vegetables.

The hors d'oeuvres at the Hôtel Jules César, Aix-en-Provence, were unforgettable. No sigh of a sardine, Russian salad, cold egg or anchovy. Here it seemed that heather and thyme were mixed with the persimmons and the onions were treated to taste as gingerbread smells. At Cannes the hors d'oeuvres are lush and luxurious, with leeks and a dozen different salami slices and the best corn on the cob outside California. But what is not already related of the food on the French Riviera? You know about the Colombe d'Or at St Paul, and the bouillabaisse at the Lucullus restaurant at Marseilles; but, a disappointment: the night we dined the food was coarse, the iodiney bouillabaisse lobsterless and the begging street performers were hideously obscene.

A Food Dilettante on Holiday (1932)

A duck cooked in cantaloup melon, 1932

They tell so many stories about food in Italy, about sparrow, served on a stick with the cocktail, about lasagne verdi alla Bolognese (green noodles made of spinach puree served with meat sauce). It is said that a fonduta, which is a dish of white truffles sliced and grated on melted cheese, is the supreme achievement. But in Italy I have little appetite. In Venice especially I am hungerless. The food seems almost as intolerably lacking in variety as in English inns. One eats melon and raw ham and scampi and pasta, there is no sign of a bird, and it seems odd that the hotter the sun shines the sourer the wine should be.

Having lived on Florian's sherbet and water-ices, I left for Germany, where the bread is no longer of chalk and water, soup is sweet, there are innumerable varieties of trout and little birds to make any mouth water. At Innsbruck the appetite knows no bounds. Wienerschnitzel and sauerkraut and beer are never better than at the old Golden Adler, and those cakes that look so old-fashioned that they must have been made in the eighties are delicious if you try their frothy sweetness.

No food article is complete without a visit to Munich, to the Hotel Vier Jahreszeiten. How can one tell of the delicate crayfish, surrounded by such a subtle sauce? What can one say of the roebuck, of the slice of peculiarly treated ham served on a wooden plate? How can one be believed when relating the richness of duck cooked in a cantaloup melon? I lick my lips and rub my tummy.

It is time to be returning. On the way back, I lunch off moules at Prunier's and stop at Le Touquet, where my hostess serves vast quantities of Irish stew, cooked by a very French chef, and the result was delicious. We ate crême de fromage with sugar and red currants and drank champagne with peaches mashed in it.

Next day I returned home to be confronted by glowing fires, game, honeydew melons, mushrooms and 'Laver', a delicious caviar-coloured and oyster-tasting brand of seaweed from Cornwall. It is no use clinging sentimentally to the dregs of a dead summer. Autumn is here and now is the time to enjoy the cracking of filberts and a glass of madeira.

North Africa (1934)

THE THING TO DO is to arrive at the Holy City of Kairouan as the day is ending. You will see colour that you had not imagined possible. The sky is of an unimaginable brilliance; colours that in paint lose their vividness, here are juxtaposed in acid clarity. Though they belong in the pastel category, these roses are more powerful than all the crimsons, these mauves more violent than purples, and these oranges and lemon-yellows whirl motionlessly around the relic of the day that has been; a relic of turquoise mixed with little snowflakey clouds, unimaginably bright and silvery, like a flight of celestial birds. Below, the distant mountain-peaks are as though painted in magenta by Dali, on tin-foil.

After the horizonless day, the sudden appearance of Kairouan is magical, particularly dramatic in this light when the clustered domes of mosques, minarets and marabouts, whitewashed and appearing to be made of marshmallow, are lit with the rose-coloured light of the sunset on one side and the piercing turquoise-blue of the twilight on the other.

Through the important gates of the town, in the little marketing street, there is bee-like activity; everywhere the scurry and hurly-burly of white-draped, turbaned figures, selling, buying and making more things to sell. Everywhere you look a fresh

stage-set appears; the vaulted café, with the crude crimson and blue stripes on the undersides of the arches, the tinsel and glass portraits of ex-Beys and the oleograph scenes from *Othello*, is an ideal setting for the laconic Arabs, squatting, thinking about nothing, and the crimson-fezzed soldiers, sitting drinking strong coffee, shaking dice, throwing cards, or listening to the raucous, shrill scream that is issuing from the mother-of-pearl box with the enormous gold shell horn – the gramophone.

The thing to do is to leave Kairouan before sunrise. Through the filigree leaves of the olive- and pepper-trees the crescent moon shines bright in the sky. The sun has not yet risen. Biblical groups on camels and mules hurry from the wastes. A shrouded corpse is jerkily jolted to its final destination; for at this moment they bury their dead in the holy ground of Kairouan.

You are on your way, in the boundless void. In the so-distant distance, the mountains are clear-cut, like so much drapery. Quite suddenly in this limitlessness, you come across a 'Chirico' painting to the life; for here in the remoteness is a theatrical stage-set of Roman ruins, elegant, grandiose, fantastic; a huge enlargement of a classical 'set', completely disconnected from Rome or Athens. Here, in a landscape like the surface of the moon, are the triumphant arch, colonnaded forum, and three temples of Jupiter of the ancient city of Sbeitla – boulders of African stone, with cacti sprouting from the cornices and a stray camel mincing down the colonnade. The effect is deeply stirring. Carthage itself is at hand, and El Djem – the colossal Coliseum – is more surprisingly impressive and its stone more apricot coloured than in Rome. By being pitched in this endlessness against the turquoise sky, it takes on a surrealist quality.

You are on your way again, and now you have definitely left the Mediterranean; there are tufted clumps of coarse grass, like aigrettes of ospreys, dumped in the useless wastes. When, suddenly, in the midst of these tracts, you see the domes and palm-trees of an oasis, you know that you really are in North Africa. For the first time in reality, your childhood's impressions of the desert come true . . .

You bump over craters, override pits and boulders, go down through deep ravines and climb up the other side with a roar. Turn on the headlights, and you see scurrying rats and mice; in this light, the stray camel looks flat with lantern eyes. But at last the earth-bound stars of Tozeur twinkle, and you have arrived in a torch-lit village with white arcaded streets. The Saharan honeycomb brickwork is as delicate as lace. The shops are still open, and the night is warm, and the light from the acute small flame of the lamps gives a splendour to the crude white doorways, arcades and columns.

Now you travel further south, and, as you penetrate deep into the African Sahara, the sky envelops you; there is no horizon, no colour, and you have the uncanny feeling of exploring the end of the world. Not until after you have given up hope of ever reaching your destination is there the mercy of grey-plumed palm trees in the distance. Then you arrive at the magic town of pinnacles, minarets, and bubbled roofs that you had imagined only existed in the mirage, but is nevertheless real, and docketed with a name, El-Oued.

After the riot of colour of Kairouan, this seems like a pearly city of an Arabian Night's dream. Surrounded by high sand dunes of the desert, immaculately patterned by the wind, the little town, a succession of bubbles and balloons of unwashed cement, is the same colour as the sand.

The one contrast, the one splash of vivid colour here, is to be found locked away behind the thick walls of a courtyard, in which the Ouled Naïls are confined behind

217

their curtained doors. At your approach a little dog appears and raises a yapping; automatically, as clockwork cuckoos, these birds of paradise, in their gaudy ballet skirts, flowing drapery, billowing scarfs, vivid turbans and glittering jewellery, rush into the sunlight, enticing you to their rooms with silver keys in their hennaed hands. At night, these 'Matisse' houris, with their tattooed make-up, sit in the vaulted barn that is the communal waiting-room, smoking, chewing gum, preparatory to entertaining the soldiers from the garrison. Goats stray around while the one-eyed proprietress of the establishment, in black and gold, dispenses a sweet, strong mint tea to the more important clientele.

But hold hard! How have we gotten to these environments? How come we to be speaking of Ouled Naïls?

It all started with a trip to Tunis, the details of which I will spare you. You know about Tunis: the European part of the town is not attractive, with its Monte Carlo buildings that have lost their freshness. You will want to go through the gates into the Arab town. In the souks you will spend many of your Tunisian francs on shoes in every colour, on vivid scarfs and animal rugs made in Lyons, little glass scent bottles, and every size and grade of dates. At night, the turquoise cafés, decorated with painted birds, flowers, mermaids and Middle-Western highwaymen, are crowded with crimson fezzes, and frenzied and elaborate rhythms played on the strange-shaped gourds and bagpipes induce you to see the Sicilian marionette show or the crude pantomime of silhouettes, which is still the same as has been performed since the mediaeval festivals during the Ramadan.

Adjoining the palace of the Bey, there is the Bardo Museum with Punic and Roman figures and much mosaic, and in the Palace itself there is the throne-room, a perfect setting for opéra bouffe, with the vast Aubusson carpet, the gaudiest gilt furniture, the crimson hangings, and the brocaded walls, hung thickly with over-lifesize portraits of ex-Beys, under each of which rests an ornate console supporting an elaborate ormolu clock shrouded in its dome of glass.

Nearby is the famous village of Sidi-bou-Said, where the Baroness d'Erlanger dispenses graciousness in a real Tunisian palace, with cooling streams trickling through the marble floors, the air thick with geranium scent, the largest flock of white peacocks in the world, and hanging flower-gardens that droop down to the cerulean sea.

But we must turn towards home, and disregard the eternity of the desert. We have been living in former centuries, disconnected from human activity, and we now are once again conscious of time. We must hustle out of this slow-motion unreality, ignoring the caravans of camels and conquering the desert in a fast Citroën.

Haiti (1935)

AS THE DAYLIGHT FADES, the seaplane swerves in a clean circle, splashes into the sea, is pulled to the landing-stage by men in white. You have arrived at Port-au-Prince, on the tropical West Indian island of Haiti – the magic island of which you have heard so much, because of voodoo ceremonies and mystic rites and the Emperor that ruled in grand black majesty.

When, weeks later, the packing is done, the bags closed, the charming Negroes have smiled their farewells and you are again at the landing-stage, you are so full of regrets as to be almost tearful at leaving so exotic and romantic, so highly-coloured an island. Haiti, discovered by Columbus in 1492, seems to have everything and something more.

The air is crystalline, and the vivid heat of the midday sun lulls you into full enjoyment of the afternoon siesta. And at night, when the flowers have wilted from the scorching of the sun, the rain, automatic as clockwork at seven o'clock, pours from the heavens like string. You can watch the storm approaching with precise regularity, like a stage storm manufactured each night for the performance of a play. First, the distant streaks of lightning in the purple heavens over the bay, the rolling of the thunder (like shutters of a shop being pulled down), the cracking whips of the rain-drops on the tropical trees. In the morning when you wake, the chickens, turkeys and parakeets are pecking about in the hot sunshine, the world emerald-green and dewily fresh.

Haiti is one of the most lush islands: vegetation of every description flourishes in the various altitudes and planes. Even the fence made of shorn wooden sticks will suddenly sprout green shoots and must be cut back, or it will become a feathery hedge. In this abundance, the natives lead the lives of lotus eaters, indifferent and contented (on a diet of bananas and sugar-cane) to prop themselves up against a bamboo-tree, watching the butterflies audaciously flirting; or, if feeling active, flying kites with the urchins, who wear short tunics that do not reach to the navel.

The natives are poets with no practical skill. If you should ask a Haitian to put a lock on your door, he is certain to fix it upside down, so that you must turn the key the wrong way. There is no native handicraft and little to buy save lumps of spiked coral, paper flowers in the brightest colours, or, on the stalls in the ever-absorbing market, baskets or picture hats, every sort of fish, huge, pink and silver, and spiky, like cacti. There is little need to worry, no need to wear shoes – life is easy, and the men consider that there is really no need to work, for the women are strong and energetic. It is they who are seen carrying on their heads heavy loads of groceries, hardware or livestock, with dowager poise and elegance, smoking pipes as they go.

Cock-fighting is the chief sport. There is a great hubbub, the air thick with dust and crowing of the birds: a Negro spits ginger onto his champion cock to pep it up into a frenzy before standing it into the ring; and if, during the combat, it is badly pecked, he puts the head of his bird into his mouth to assuage the damage. The clustered masses form impenetrable circles with arms and heads peering between other arms and legs, a glutinous mass of black humanity. The excitement is tremendous, and many hundreds of gourdes, the local currency, are lost and won by these rabid gamblers.

On Sunday, the horse-races are run. Here are flaunted brilliant organdies and chiffons, puce and cerise ruchings, sausage curls, nose-veils and picture hats. And that large couple, looking like a Douanier Rousseau painting – he, with a roll of fat above his collar, heavy gold watch-chain, black morning coat, and straw hat, is a local grocer; both he and his wife (in petunia satin) descending from the nobility founded by the Emperor Christophe. It is said that if the black Haitians were again to revolt against the mulatto rule, this grocer could summon countless thousands from the mountains to his support.

In Port-au-Prince, the old disused cathedral drops into decay side by side with the new pink-and-white pinnacled tabernacle. The President's palace is so white in the blinding sun that it looks as if it had been whitewashed every morning with blanco, like a pair of tennis shoes. The garden, the President's pride, is a European picture-calendar garden of trelliswork, but with climbing bougainvilleas in place of the rambling roses. If you produce your camera to take a snapshot there will be slight screams and a general scurry in the opposite direction, for Haitians are afraid that one will

develop the photographs and stick pins in their image. This, in spite of the blood-curdling stories, is the only apparent relic of voodoo to be found on the island.

Cap Haitien, like Pompeii, is a honeycomb labyrinth town, definitely showing a French influence, and from here it is but a short journey to the romantic remains of the palace of Sans Souci, ruined by an earthquake in 1842, a tragic relic of the black Emperor's raptures of pomp and gorgeousness: a palace built in 1810 in an eighteenth-century French style by his own black architect who had never visited Europe. It is a palace of grey stone and yellow stucco, complete with marble and mahogany floors, balustraded terraces, fountains, sentryboxes, circular halls (refreshed and cooled with running streams), where the rule of pomp and ceremony was carried out with childish gusto. Here, His Imperial Majesty, once a slave, ruled his self-appointed court of nobles – His Excellency the Comte de la Tasse, the Duke of Marmelade, the Duke of Limonade! The army was more elaborately uniformed than in a Ruritanian operetta, coats of arms and insignias used wherever possible. In every detail of the chased goblets, the mirrors, the chandeliers, the glitter of tinsel and sequins, this phenomenal black showed his love of riches and splendour with extraordinary imagination.

Today, this sleeping palace, lying deep in nostalgic tropical surroundings, is a magic place; were it possible to take a glimpse into the past, it would be this spot, in the beginning of the nineteenth century, in all its Negro glory, that I should prefer to see.

From here, for three hours, you mount in spirals, until eventually the world is beneath you, under a blue and green coverlet, and, occupying the entire top of the mountains, commanding the world, stands the gigantic red and purple citadel, the supreme symbol of this Emperor's power. Here, at a height of two thousand five hundred feet, in a stronghold that is mightier than the greatest ocean liner and much the same shape, is the fortress whose construction, it is said, took a toll of ten to twenty thousand lives.

Towering walls (which Christophe is said to have helped build himself, having learned bricklaying as a slave) enclose the royal apartments, state rooms, storehouses, powder magazines and room to house a garrison of ten thousand men with ten months' supply of ammunition. There are a moat and drawbridge, and some of the two hundred and sixty-five cannon are still in place, in mahogany carriages. Others, lying in confusion, are covered with fleur-de-lys and regimental crests as delicate as wrought silver. And in the brick tomb, inscribed with the French motto 'I rise again from the ashes', so high above the world that it almost touches the rolling clouds above, lie the remains of this despot.

Somewhere in this fortress, it is said that a hoard of gold lies hidden, but though explorations have been mounted no one has been successful. There are no treasures, looted from the palaces on the island, to be picked up, although an isolated discovery was made by an English governess on her way up to see the citadel, who stepped on a silver candlestick covered with moss and half embedded in the stone.

This is a smiling place, untrammelled. Like the student prince in the poignant story of Old Heidelberg, I have a sentimental dread of returning to any place where I have been completely happy. And it is for this reason alone that I dare not return to Haiti.

The Blue Mosque, Istanbul, 1965

On the Mount of Olives, Jerusalem, 1942

'Creatures, big and small, rested in the shade', in Turkey, 1965 (*left*)

Oxen at the Old Fort, Golconda, India 1944 (*above*)

The Red Fort, Old Delhi, 1944 (*above right*)

Fretted alabaster window in the Red Fort; sculpture in the Ajanta Caves; a pupil of Ram Gopal beside the Indian Ocean, 1944 (*below left to right*)

Holy Week in Seville, 1952. Porters resting beneath one of the ornamental floats (*above*); penitents in hoods and mantles (*right*)

Overleaf: In Czechoslovakia, 1968. The house in the Golden Lane of the Alchemists where Kafka may have worked on *The Trial* (*left*); Charles Bridge, over the Vltava River (*right*)

Impressions of Turkey, 1965. Ferry boats on the Bosphorus (*above*); Cecil Beaton on a carved stone fragment from the Temple of Apollo at Didyma (*far left*); head of a female deity found at Aphrodisias (*left*)

Watercolours done at David Herbert's house in Tangier; Beaton was using his left hand, after a stroke, 1975: the waterlily pond, 'surrounded by the flowering shrubs of April' (*above*); a corner of the drawing-room (*left*)

Overleaf: Watercolour of the Villa Léon l'Africain, Tangier, 1979

THE VILLAGE of Purana Ghat, of colonnaded pale yellow buildings, turquoise columns, pagodas and massive archways underneath which the bullocks, harnessed to their heavily loaded carts, shelter from the rains, leads to the even more beautiful town of Jaipur. Of all the cities of India I have seen, this is the nearest to the dazzling pictures of one's childhood imagination.

Laid out in the eighteenth century, the wide streets run parallel. With its vast open squares and pleasure gardens and every building painted the uniform terracotta pink, the city is so well planned and spacious, and its colours so harmonious, that the general effect is of an almost somnambulant leisure and serenity. Nowhere else in the world have I seen such brilliant and robust colours used to produce an effect so refined and subtle.

The universal theme created by the ruling that all the houses must be painted this coral colour is so successful that one cannot understand why it has not been emulated in other parts of India, or why we do not see pale blue or green or yellow cities. So perfect is the whole in conception that one feels it must be the work of one master.

Its façades are embellished with birds and flowers painted in white. The populace sport a particularly bright coat or turban and when these inherently pictorial people bring out, to billow and dry in the sun, the freshly dyed lengths of vivid yellow or magenta muslin, their natural gestures have a most appealing grace.

Small carriages with hoods of the eighteenth century, shaped like pagodas, disgorge Rajputana ladies and their children, wearing draperies that make one's mouth water. Above, on the balconies of carved white marble, inset with coloured glass in flower designs, attendants dressed in white with dark faces and peppermint pink turbans peep inquisitively at the visitors. Women in daffodil yellow, apricot and orange draperies are polishing the white marble columns in the inner court of the Zenana Palace. A young man wearing a pea-green turban and a lilac coat, of the same colour as we see in the early paintings, spends his morning leaning against an archway. Jaipur is a living Moghul miniature. Even the games of polo are associated in one's mind less with Meadowbrook and Hurlingham than the games painted on enamel 500 years ago.

The legacy of this wonderful city has fallen into safe hands. The Maharaja of Jaipur is a young man with a proud appreciation of the beauties of his State and a keen interest in building anew. The Rambagh Palace, with its white ivory lace work, is as near to the ideal Indian Prince's Palace as any building can be. Some of the buildings in the new town are adapted from existing buildings: the barracks, for instance, are a modernized version of our own Wellington Barracks.

The goal of all visitors must be the Palace of Amber perched in the hills that cup this lovely town. This castle is of such elongated proportions that it seems as if built on stilts, and appears as if carved of the rock from which it soars. Avignon is brought to mind and the formal water-gardens and parterres are French in character, but the corridors with thick walls, cool vaulted rooms with windows strategically placed to catch the evening zephyrs, and the terraces for moonlit suppers, all prove that the architect knew how to cater for living in this oriental climate. Some of the rooms are ornamented with mirror and plaster filigree. When the windows are shut and the candles are lit, the reflections create the effect that the room is suddenly inhabited by millions of fireflies.

The Maharaja is particularly fortunate in his Prime Minister, Sir Mirza Ismail. Over the mountains and down through the gorge, Sir Mirza has restored to beauty the

temples of Gulpha where the spring (supposedly a reappearance of the Ganges) rises, and to which pilgrims come in their thousands. The scene is a strange and lovely one, where, inside the Temple, the musicians, with painted forehead markings, sit making strange sounds on peculiar-shaped instruments by the hour. The temple assistants, dressed from head to foot in blood scarlet, hurry past with plates of steaming food, curries and soups – hang garlands of marigolds and roses round the shoulders of distinguished visitors or sit watching the acrobatic contortions of some of the worshippers paying obeisance to the glittering Goddess.

The delights of hospitable Jaipur are available to all visitors. The more sensitive and appreciative soldier could find no more refreshing and beautiful escape from the horrors of war in the Far East, than in this halcyon State.

Sicily (1954)

THERE IS ALWAYS an impromptu feeling of fancy dress about one's first day on holiday; but the fancy dress soon becomes the normal, the strange becomes the orthodox; a new rhythm of existence is accepted. You have been caught in the play. You cannot bear to miss a moment of it, and you saunter along to the Piazza to enjoy another scene of the comedy. By now you are under the spell of Taormina.

The Sicilians are friendlily disposed. They may be poor, but even the peasants have a taste for cultured things. Mythology is at their elbows. Rich and poor alike eat the same food of pasta, fish and tomatoes (the Sicilian tomatoes are like small pears, unexpected in their brilliance of colour and flavour.) Everyone enjoys a similar life of sun, bathing, picnics and music.

It is twilight in the Piazza. Now is the peak-time for shopping. The shutters that have been closed during the day are rolled away to reveal the shops, their walls lined with rolls of material for curtains, for upholstery, for suits and shirts, so inexpensive and so beautiful – striped yellow and pink cotton brocade, raw silks and Sicilian stripes of all colours and variations. Other brilliantly lit shops reveal pots, baskets, pralines as big as walnuts, tuberoses. The antique shops offer a welter of engraved glass, gilt, Renaissance, and Victorian portraits of Mount Etna. You need not pay now if you have not the exact money – none of the shopkeepers has any change.

Before the 1914 war Taormina was a winter resort, beloved by King Edward VII and a flotilla of English spinsters with fluttering veils and sketching paraphernalia. The Kaiser and hosts of German tourists also enjoyed the amenities in the months from December to May; but it is only since the last war that it has been discovered by those wishing to avoid their best friends on holiday during the summer.

Monreale (a few minutes from Palermo), with the Oriental splendour of its golden glitter, its varied richness and its strange mixture of Saracenic pointed arches and Norman architecture, is perhaps the most beautiful palace chapel in the world. Many have heard of the baroque statues of Sicily; but the works of the sculptor Giacomo Serpotta come as a revelation to most. In the Oratorio del Santo Rosario (where the altarpiece is by Van Dyck), his Virtues are represented by Louis XV court ladies posing in their corsets and plumed helmets, with the flamboyant gesticulations of Cécile Sorel and the Comédie Française.

On the outskirts of the city, the villa 'La Favorita', built for Marie-Antoinette's sister and later used by Lady Hamilton for her most extravagant parties, is a small

'The Sicilians are friendlily disposed', 1936

234

Classical ruins in Sicily, 1936

architectural jewel in the Chinese style. The pastel decorations are opaque and subtle; the walls of Lady Hamilton's bedroom, of fawn-coloured silk covered with sprigged muslin, could be copied today with great effect. Nearby, in the Royal Park, is the Villa Niscemi, frescoed throughout so that even the gilt frames of the mirrors are embedded in fresco. The neighbouring Lampedusa villa boasts a beautiful exterior staircase in horseshoe design; while the Gangi Palace possesses a Galerie des Glaces, salons with ceilings of multiple domes and, on the floor of the hall, the intricate elaborations of a panther hunt.

Of the outlying villas, Palagonia, in the district of Bagheria, is a story-book fantasy. The Prince of Palagonia in the seventeenth century married a woman of such loveliness that he was terrified lest someone should abduct her. So the Prince dotted his garden with statues of double- and triple-headed monsters, figures of every shape and size; but whether to frighten the would-be lovers away or to keep his wife in continual terror, I have not been able to decide.

You must stir yourself to see the Greek temple at Segesta, or at Agrigento, the Agrigentum of the Romans which, according to Pindar, was the most beautiful city of mortals.

As you return from sight-seeing, driving through the hot summer night, every scent gives you a welcome – eucalyptus, warm hay and cinnamon; little urchins rush to sell you sticks of jasmine heads splayed on straw sticks like a Catherine wheel with which they further perfume Taormina's evenings. The nights here are of the strongest scented magic.

Next morning, so great is your joy at returning that you wake unexpectedly early. You pull back the shutters; the sun pours in as you savour the mountain freshness to its full. In the distance the sea, combed with a pattern of different blues and greens caused by the underwater currents, looks so inviting that you know, by midday, its invitation will be accepted. Another eventful, eventless day is under way.

TURKEY IS A NATION of functioning improbabilities. Here one finds together East and West, old and new. Relics of at least thirteen independent historical civilizations are here. They are not blended indistinguishably together. Instead, all parts are suspended miraculously, all together. It is a country of richness and variety.

Istanbul is the symbol and chief repository of this variety. The hub of the city is still the Galata Bridge with the Bosphorus and the Golden Gate to left and right and the Sea of Marmara at hand. There is always a mêlée of ships, buses, motors, fishermen, scurrying pedestrians – a world of flurry and movement, of steam and smoke belching from ships' funnels, water churned in the wake of all sorts of pleasure boats and barges, and clouds parting to illuminate the ancient water tower, the minarets like exclamation marks, or the fish, fruit and sweet stalls.

The city has its Art Nouveau office buildings, chromium and marble hotels, its relics of saints, Le Touquet-ish public gardens and parks, its Ginza neon lights, strident symbols of crescents and stars. Adventure is always just around the corner . . .

The slum life is still a dreadful reminder of the results of Turkey's last incursion into war. One is witness to the dredging and activity in the coal dumps with human beings toiling like spirits possessed by devils, and so dirty that they appear as basalt figures. Yet here are the Palaces of Sultans, the retreat of the Empress Eugénie, and mansions of wealthy merchants built in Rococo French style.

A huge monument to Byzantium's first golden age under Justinian is the sixth-century Santa Sophia which, with its golden dome – of an incredible volume – gives its visitors the impression of being figures in a landscape. Through the old-gold, dusty haze the wrought iron chandeliers hang almost to the ground and look like black modern mobiles. Through the perpetual dusk one must peer about to come unexpectedly upon some unlikely detail – a mosaic head of Christ, some green, strange saints, Ali Baba pots or the simple shell-shaped capitals to a green marble column.

Eight hundred years after Santa Sophia's construction, the Palaeologue revival – after the empire had been devastated by the Fourth Crusade – produced the most beautiful of all Istanbul's religious buildings. It is the small jewel box of the Kariye which is in an astonishing excellence of preservation with fine frescoes, inlaid marble panelling, and sequin-glittering mosaic of infinite refinement. Created with the dying ecstasy of the crumbling empire, it symbolizes the very soul of Byzantium.

The Sultan Ahmed (or Blue) Mosque is a true Moslem mosque. It is a perfect contrast with early Christian churches. As one enters, the onslaught of colour is as awe-inspiring and wonderful as when, as a child, one came upon a bluebell wood. Here the large dome of infinitely delicate Nicaean tiles gives an effect of azure lacy-tracery, a turquoise honeycomb, an aquamarine filigree. It is held aloft on four vast arches with archivolts stencilled with blue paint.

Opposite the entrance on the east wall is an immense set of windows of bold, brilliant Chagall colours. The transparent blue walls, and domes like hollowed-out clouds, hover over a rich dark red floor covering of carpets, each of small scale compared with the area of the floor. Carpets are piled on each other four deep, five deep, and are overlapped and interlaced like layers of a mille-feuille. Santa Sophia, in comparison, seems dark, stone cold, with hard glittering mosaics. Its hugeness is impersonal while the hugeness of the Blue Mosque seems generously welcoming.

The Seraglio, the mansion-palace of the Moslem Ottoman Emperors, the Palace of the Sultan, once a secret town within a town, with its five thousand inhabitants, its

own mint and treasury, its hospitals, baths, athletic grounds, schools, bakeries, stables and mosques, has become a vast museum. A handful of custodians now guard this haunted and romantic world. Although the gazelles have gone, its gardens are still well-kept with tall cypresses and fountains, and in the surrounding pavilions and former kitchens an extraordinary collection of unmatched luxury, as well as entertaining nonsense, is housed: porcelain, clocks and objets de vertu. A jewel-studded ceremonial throne of thirty-six carat gold, emeralds as big as ducks' eggs, huge pink diamonds (bright violet-pink), goblets of crystal inlaid with jewels, feathers made of diamonds, a blob of emerald weighing over three kilos and the 'spoon-seller's diamond' of eighty-six carats, reputedly found by some peasant who exchanged it for an ordinary spoon. For the student of contemporary design there is infinite study: much of the collection of faience could have been designed by Matisse and the masters of the *Yellow Book*. The costumes are of such bold patterns, and of such remarkable audacity of colour combinations, that they undoubtedly inspired Bakst and the Diaghileff ballet.

The Turks pride themselves that, with the French and the Chinese, they possess the best 'kitchens' in the world. In the remotest coastal village one can find a banquet with freshly baked bread to be clawed apart in one's hands, a pile of melons from which to choose one with a pink and pale green interior; trout just caught from the sea; figs, so soft, creamy and rich, for dessert. Egg plant, yoghurt, rice, honey and pastries are the main ingredients of their dishes, many of which have picturesque names: bulbulyuvasi is a delicious 'nightingale's nest', kadinbudu are 'ladies' thighs'.

The classic cities stretch along the coast south and east of Ephesus. In Ephesus itself the excavations and reconstructions along the white marble paved main street made it seem a new city rising under original construction rather than a relic of a dead civilization. In Priene and Miletus one sees vistas of Piranesi disorder. The scattered blocks of stone with wild flowers in the crevices, unvisited except by stray sheep for a thousand years, make understandable the excitement and the love of ruins that ignited the neo-classic style.

But my enthusiasm was genuinely ignited by the first glimpse of Didyma. A biblical scene of great beauty presented itself – with men (in black pleated smocks) threshing in a pale yellow world of grain. A donkey was silhouetted against a landscape of yellow fields and the black spikes of cypresses, while other creatures, big and small, rested in the shade from the high sun. Through the olive trees the twin columns, soaring into the blue, showed us the way to the Temple of Apollo, fallen, as pagan temples and statues should, in the presence of the Christ Child.

At Hieropolis, 250 bumpy kilometres inland, the brilliant orange of the fallen masonry makes one think that the flames of its sack have not yet died. This strange colour effect is not the only unusual attribute of the ruins, for we arrived at eventide, dust-coloured and travel-stained, to join immediately a dozen other blissful bathers bobbing up and down in the hot spring waters which are said to banish all ailments. The effect is that of swimming in hot sparkling soda water. With the stars above and the distant lights of Denizli, one felt oneself part of the universe. The pool was strewn with column sections above and under the water, making convenient resting places, but adding to the strangeness of the evening.

The small remote village of Aphrodisias has an architectural grandeur: even the lowliest farmhouse or barn is based upon the classical with columns of wood emulating the stone – with capitals hewn in imitation of the Ionian. But most romantic of all

sights is the agora. A line of fluted columns stands half-hidden in a copse of delicately twitching sapling poplar. The effect was almost too pretty – like those fake ruins so popular in Regency England.

A trip to Sidé, east of Antalya along the coast, illustrates the full variety of pleasures to be enjoyed in spots along the southern coast. There are delights for the eye and soul, the body, and the palate. The museum, formerly an old Roman bath, is beautiful in its maize colour, arrangement, and serried ranks of torso fragments. But the heat is overwhelming so that one takes to the incredibly warm, salty, buoyant soup of a bay in which Cleopatra swam with Mark Antony. With the building of the main road from Denizli, Sidé will doubtless become a Marbella, Costa Smeralda or Poggio of the future.

Looking at Turkey as a whole we are struck by the diversity and multiplicity of the country's riches. This varied past has left a varied present. Connoisseurs of travel, writers, poets and the wealthy few with yachts at their disposal have been singing the praises of this comparatively little-known land of enormous beauty. Now the word is abroad, and it is obvious Turkey will be the goal of the more enlightened traveller. It would be as well to hurry.

SOURCES

The abbreviations AV, BV, and FV stand for American *Vogue*, British *Vogue* and French *Vogue*; cf, t, a, b, c, l, r, stand for clockwise from, top, above, below, centre, left, right. Articles, photographs and illustrations were frequently used in more than one edition, and the editions acknowledged here are not necessarily those in which they appeared originally. All articles, photographs and illustrations are by Sir Cecil Beaton unless otherwise credited.

2 BV Nov 11 36
4 AV April 13 29
7 Beaton's Vogue BV Jul 58

INTRODUCTION: VOGUE'S
BEATON (pp.8-28)
8 (a) BV Nov 30 (b) BV Feb 8 28
9 BV Jan 23 29
10 BV AV Feb 15 32
11 BV Oct 3 28
12 AV Feb 1 38
13 AV Jul 15 31
15 BV May 28 30
17 Patrick Procktor BV May 76
18 David Hockney BV Dec 69
19 Erwin Blumenfeld BV Mar 45
20 FV Jan/Feb 47
21 (t) Miller & Harris AV Mar 1 32;
 (cfr) BV Oct 13, 37, Remie Lohse
 AV May 34, BV Mar 7 34, BV
 Jul 22 36, Pamela Murray BV
 Nov 33
22 (al) George Platt-Lynes BV Mar
 45 (ar) John Rawlings BV Mar
 45 (bl) Horst P. Horst BV Feb 49
 (br) Louise Dahl-Wolfe BV Mar
 45
23 Irving Penn BV Jul 51
24 BV 36
25 (t) AV Nov 15 42 (cfr) Roger
 Schall BV Sep 1 37, Early Apr
 24, Norman Parkinson BV Oct 1
 71, Patrick Lichfield AV Feb 15
 69, Dominique Olida FV Mar
 79, Charles Biasiny BV Jun 61
26 Ronald Traeger BV Nov 1 65
 (Men in Vogue no.1)
27 Ray Williams AV Mar 15 63
28 Manfredi Bellati BV Jun 68

1 HOW ONE LIVES (pp.29-56)
29 BV Jul 10 29
30 Text AV Aug 1 28; AV Mar 16 29
31 (a) BV Oct 2 29 (b) AV Nov 24 28
32 Text AV Mar 15 31; (a) BV Mar
 17 37 (b) AV Mar 15 31
33 AV Apr 1 31; BV Mar 17 37
34 Text BV Apr 15 32; (a) BV Mar
 17 37 (b) BV Apr 27 32
35 Text BV Feb 72; BV Apr 27 32
36 AV Feb 1 37
37 BV May 2 28
38 (a) BV Aug 8 28 (bl&r) BV Jun 27
 28
39 BV Aug 8 28
40 BV Sep 18 29

41 (l) BV Oct 16 29, (ar) AV Dec 15 37
 (c) AV Jun 1 33, (br) BV Jun 26 29
42 (cftr) BV Sep 18 29, BV Early Jul
 27, BV Jul 24 29, BV May 2 28
43 (cfl) BV Dec 11 29, BV Nov 28
 28, BV Dec 11 29, BV Early Jul
 27, BV Sep 18 29
44 AV Mar 16 29
45 AV May 1 35
46 AV Apr 15 31
47 AV Apr 15 31
48 AV Feb 15 37
49 AV Aug 15 31
50 AV Jul 64
51 BV Jan 8 36
52 BV Dec 26 34
53 BV Oct 28 36
54 BV Nov 51
55 (l) BV Nov 51 (r) BV Feb 72
56 AV Apr 15 66

2 BEATON AT WAR (pp.57-92)
57 BV Nov 40
58 Text AV Oct 41
59 Text BV Jan 44
60 Text BV Jul 41; BV Nov 40
61 BV Nov 40
62 Text AV Aug 1 42
63 Text BV Oct 43
65 Text BV Oct 42
66 Text AV May 15 44
67 BV Apr 44
68 Text BV May 44
69 AV Jun 44
70 Text BV Jun 44
71 Text AV Nov 15 44
73 BV Jul 41
74 BV Dec 40
75 (a) BV Nov 41 (b) AV May 42
76 (l&ar) AV Oct 1 41 (c&br) BV Jan 44
77 AV Jan 1 45
78 (a&bl) AV Jul 1 41 (br) AV Aug 1 42
79 BV Oct 43
80 BV Jul 41
81 BV Jan 41
82 AV Jun 44
83 AV Nov 15 44
84 AV Sep 1 44
85 BV Jan 43
86 BV Jan 43
87 BV Nov 42
88 BV Jun 44
89 BV Sep 45
90 BV Jun 45
91 BV Jun 45
92 BV Oct 45

3 PEOPLE (pp.93-124)
93 BV Aug 5 31
94 Text BV Feb 45
95 Text BV Feb 60
96 Text AV Sep 15 65
97 Text BV Dec 69
98 Text BV Oct 69
99 BV Aug 8 28
101 BV Oct 3 28
102 (a) BV May 16 28 (b) BV Nov 2 27
103 BV Sep 2 31
104 FV Aug 29
105 AV May 25 29

106 BV Jan 20 37
107 (al-r) BV Nov 26 30; BV Sep 41;
 BV Dec 73
108 AV Feb 15 71
109 BV Jun 9 37
110 AV Feb 1 52
111 BV Oct 45
112 (a&br) BV Jul 42 (l) BV Nov 45
113 AV Jan 1 65
114 BV Apr 41
115 BV Jul 49
116 AV Jul 46
117 AV Jan 1 71
118 AV Mar 15 67
119 AV Mar 15 67
120-1 AV Sep 15 65
122 BV Dec 69
123 AV Feb 1 70
124 FV Apr 52

4 A WINDSOR ALBUM (pp.125-
152)
125 BV Jul 53
126 Text AV Feb 1 37
127 Text AV Jul 1 37
128 Text BV Jun 53
129 AV Jul 15 32
130 Text BV Jul 53; BV Jul 53
132 BV Jul 53
133 AV Nov 1 49
134 AV Feb 1 37
135 AV Jun 1 37
136 AV Jun 1 37
137 AV Jul 1 37
138 (l&ar) BV Jun 53 (br) AV May 1 42
139 AV Nov 1 54
140 AV Nov 1 49
141 BV Jan 43
142 BV Oct 30 35
143 (al) BV Oct 30 35 (ar&b) BV Aug 53
144 BV Aug 49
145 (r) BV Aug 41 (bl) AV Aug 15 41
 (bc) BV Jun 53 (br) BV Aug 53
146 BV Nov 54
147 BV Nov 50
148 BV Jul 53
149 BV Jul 53
150 AV Oct 1 67
151 AV Nov 15 65
152 BV May 77

5 FASHION (pp.153-184)
153 AV Mar 1 32
154 Text BV Dec 12 28; BV Dec 12 28
155 Text AV Apr 1 31; BV Dec 12 28
156 Text BV Jun 8 32; BV Jun 8 32
157 Text BV Jan 46; Text BV Jun 59
158 Text BV Mar 15 67; (a) BV Sep
 19 28 (b) BV Nov 24 28
159 BV Oct 1 30
160 BV Aug 21 29
161 AV Dec 15 44
162 AV Jul 1 35
163 AV Mar 1 51
164 BV Aug 46
165 AV May 15 34
166 (a) AV Jun 15 34 (bl&r) AV Apr 1 34
167 AV Nov 1 44
168 BV Sep 16 36
169 BV Apr 41

170 BV Jan 8 36
171 (al) BV Jul 22 36 (bl) AV Jun 1 35
 (r) AV May 15 41
172 BV Sep 30 36
173 AV Sep 1 36
174 BV Sep 41
175 AV Dec 15 45
176 BV Jan 50
177 BV Jun 64
178 BV Oct 1 67
179 BV Apr 15 73
180 BV Mar 15 67
181 BV Nov 54
182 AV Jun 48
184 FV Mar 79

6 STAGE AND SCREEN (pp.185-
212)
185 BV Sep 17 30
186 Text BV Sep 17 30; BV Sep 17 30
187 Text BV Jun 10 36; BV Jul 11 28
188 Text BV Dec 43; BV Jun 13 28
189 Text BV Mar 46; BV Nov 14 28
190 Text BV Oct 54; AV Jun 58
191 Text AV Jun 70; BV May 28 30
192 AV Feb 16 29
193 BV Jun 26 29
194 BV Apr 3 29
195 BV May 1 35
196 (a) BV Jul 50 (b) BV Sep 19 28
197 BV Aug 83 (Taken for *Vogue* in 51)
198 AV Jul 46
200 BV Oct 54
201 AV Mar 1 49
202 BV Aug 5 36
203 BV Mar 46
204 BV Jan 64
205 AV Apr 15 63
206 FV Oct 56
208 BV Apr 1 80 (Taken for *Vogue* in
 36)
209 AV Jun 70
210 AV May 67
211 AV Apr 1 64
212 FV Aug 79

7 THE JOYS OF TRAVEL (pp.213-
236)
213 BV Sep 4 29
214 Text AV Jan 5 29; AV Jun 8 29
215 Text AV Dec 1 32 (a) AV Feb 15
 32 (b) BV Oct 26 32
216 Text AV Apr 15 34; BV Oct 26 32
218 Text AV Nov 1 35
221 BV Mar 65
222 BV Mar 65
223 AV Dec 15 42
224 BV Aug 44
225 (a&bl) BV Jun 44 (bc&r) BV Aug 44
226 AV Apr 15 52
227 AV Apr 15 52
228 AV Oct 1 68
229 AV Oct 1 68
230 BV Mar 65
231 BV Oct 15 75
232 BV May 79
233 Text BV Sep 44
234 Text BV Mar 54; BV Nov 11 36
235 BV Nov 11 36
236 Text AV Mar 15 65

INDEX